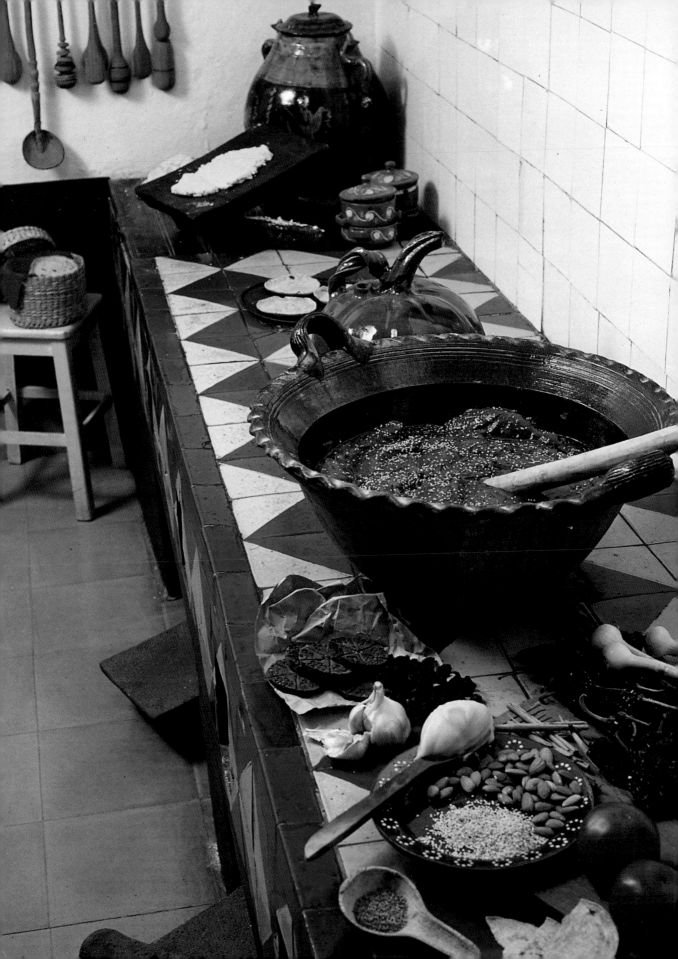

Frida's Fiestas

RECIPES *and* REMINISCENCES

of Life with

FRIDA KAHLO

GUADALUPE RIVERA
AND
MARIE-PIERRE COLLE

PHOTOGRAPHS BY IGNACIO URQUIZA

RECIPES ADAPTED BY LAURA B. de CARAZA CAMPOS

TEXT TRANSLATED BY KENNETH KRABBENHOFT

RECIPES TRANSLATED BY OLGA RIGSBY

BOOK DESIGN BY JULIO VEGA

CLARKSON POTTER/PUBLISHERS
NEW YORK

We thank Banco de Mexico, which operates the Diego Rivera Fiduciary, and Dolores Olmedo, director of the Frida Kahlo Museum, for opening the doors of the Blue House.

We are very grateful to Juan-Carlos Pereda and to Martha Sanches Fuentes from the Tamayo Museum, who helped us with the permits, as well as to Blanca Garduña from the Museum Studio Diego Rivera, and to the owners of reproduced paintings as well as photographers who allowed us to reproduce their work.

We also would like to thank our agent, Barbara Hogenson, and Leyla Morrissey for their dedication, and last but not least, our editor, Roy Finamore, who believed so much in our book.

A list of credits for other copyrighted material appears on page 224.

Published by Clarkson N. Potter, Inc., 201 East 50th Street, New York, New York 10022.
Member of the Crown Publishing Group. Random House, Inc.
New York, Toronto, London, Sydney, Auckland

CLARKSON N. POTTER, POTTER and colophon are trademarks of Clarkson N. Potter, Inc.

Manufactured in Japan

Library of Congress Cataloging-in-Publication Data
Rivera Marin, Guadalupe
Frida's fiestas / Guadalupe Rivera and Marie-Pierre Colle ; photographs by
Ignacio Urquiza ; recipes adapted by Laura Caraza ; text translated by Kenneth Krabbenhoft ;
recipes translated by Olga Rigsby ; book design by Julio Vega.
p. cm.
Includes index.
1. Cookery, Mexican. 2. Holiday cookery. 3. Menus.
4. Kahlo, Frida. 5. Rivera, Diego, 1886–1957. I. Colle, Marie-Pierre.
II. Title.
TX716.M4R55 1994
641.5972—dc22 93-19284
CIP
ISBN 0-517-59235-5

10 9 8 7 6 5 4 3 2 1

First Edition

Assistant photographer: Rene Lopez; Stylist: Jessica Fletcher;
Assistant to Marie-Pierre Colle: Carla Zarebska

Publisher's note: All equivalents listed in the recipes are approximate.

*We dedicate this book
to Andrea Valeria, who—at a meal
where these traditional dishes
were served—strongly motivated
us to make this book.*

*We dedicate it also to
Marie-Pierre's son, Eric, as well
as to Lupe's five grandchildren—
Luis, Juan, Fernanda, Paolina,
and Rodrigo—great-grandchildren
of Diego Rivera.*

Guadalupe Rivera
and Marie-Pierre Colle

***Page 1:** A corner of Frida's kitchen, decorated with blue and yellow tiles from Puebla.
Frida's name is spelled out in tiny mugs on the wall. **Frontispiece:** A typical Puebla mole.
The ingredients are arranged on the wood stove in the kitchen of the Blue House.*

CONTENTS

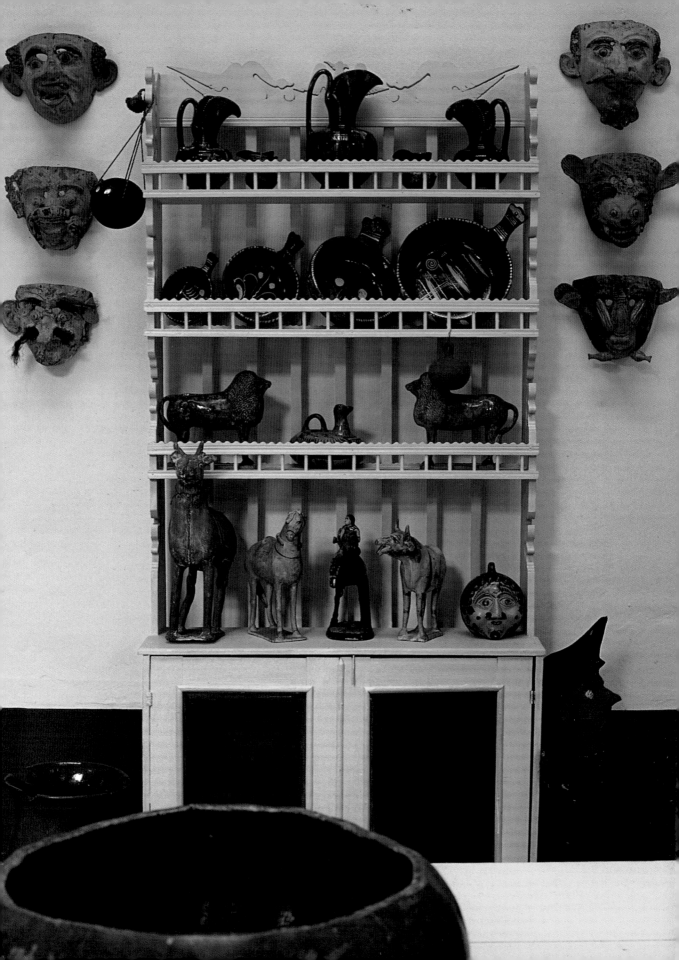

A FAMILY STORY

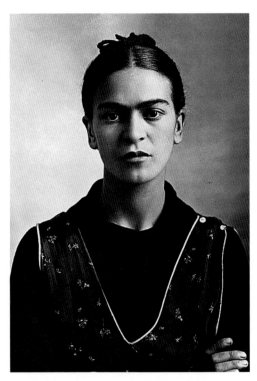

Frida Kahlo was a student at the National Preparatory School when she first met my father, Diego Rivera. Diego had just returned from a ten-year stay in Europe and was painting his first murals, which were located in the amphitheater of the school, formerly the Jesuit Colegio de San Ildefonso.

José Clemente Orozco, David Alfaro Siqueiros, and Rufino Tamayo were working on murals in the

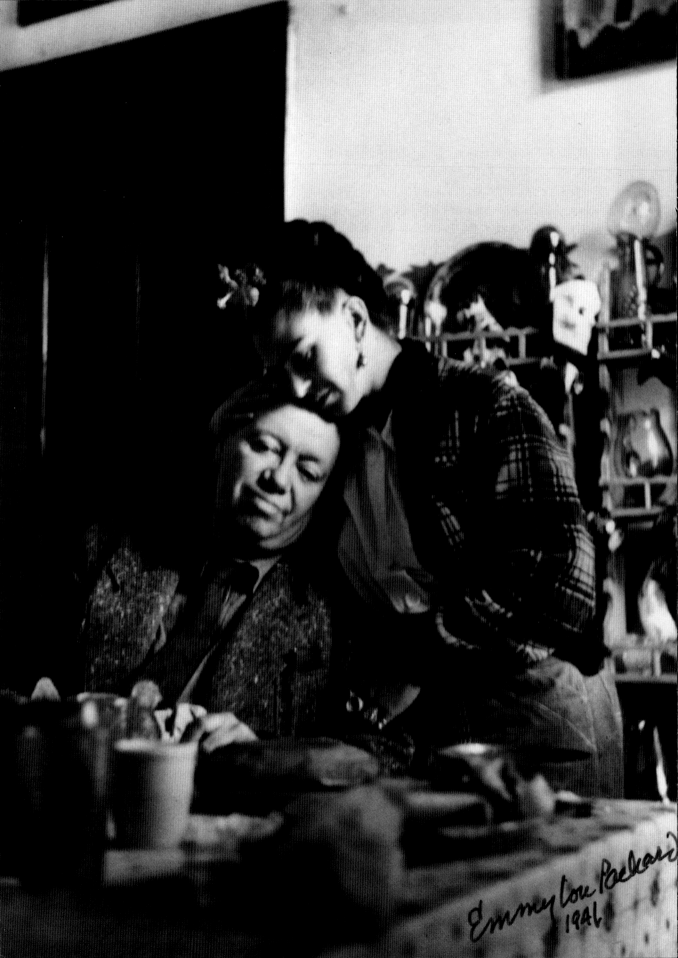

Emmy Lou Packard
1941

old cloister of the school. All of the painters, including Diego, were the object of verbal and physical attacks from the students, who were opposed to the murals and sought to destroy them any way they could.

Diego had chosen several of the most beautiful women in Mexico City's artistic and intellectual circles to serve as models for his allegory on the Creation. One of them was Lupe Marín (my mother), who had recently arrived in Mexico City from Guadalajara, capital of the state of Jalisco. Lupe and Frida thus met each other through Diego.

When he had completed the amphitheater mural, Diego moved his scaffolds to the headquarters of the newly created Secretary of Public Education to begin work on a new painting there. He lost touch with Frida but continued to see Lupe, whom he married in 1923. I was born the next year, and my sister, Ruth, came along three years later.

Through these years Frida continued her studies at the National Preparatory School, where she was deeply involved with Alejandro Gómez Arias, the brilliant student leader. She was with him in 1925 when a streetcar accident changed the course of her life, forcing her to spend a lonely and tedious year in bed and leaving her forever disabled.

While Alejandro traveled around Europe, Frida took up painting to pass the time. Her first portraits of friends and acquaintances date from this period, as does an especially successful portrait of the absent Alejandro. It was perfectly natural for her to compose her first self-portraits in the style of Sandro Botticelli, whose painting *Primavera* was one of her favorites.

Frida soon determined to switch from the sciences to art. She tucked a few of her canvases under her arm and went off to see Diego. She wanted the Master's opinion of her art and hoped he would take her on as assistant in the ongoing mural project. Diego advised her to keep on painting; he also told her that she could look forward to a very successful artistic career.

As Frida's interview with Diego was drawing to a close, Lupe Marín walked in, bearing lunch on a tray for her husband. She was furious to find them together, and she would have started throwing the lunch plates had not Diego, alarmed and laughing nervously, intervened to keep these angry women, who were clearly fighting over him, safely apart.

Two years after this episode, Diego received a surprise official invitation to attend celebrations that were to be held in the U.S.S.R. in honor of the tenth anniversary of the October Revolution. He was

Page 8: Handmade painted wooden shelves in the dining room. The table is also painted yellow, which was Frida's preferred color for decoration in the Blue House.
Page 9: Frida, photographed in 1932 by her father, Guillermo Kahlo.
Opposite: Diego and Frida photographed in the kitchen of the Blue House in 1941.

also asked to paint a huge mural in the Red Army Palace in Moscow. When Diego left Mexico, he had no idea when he would return. He left my mother in the charge of her former boyfriend, the poet Jorge Cuesta. Not surprisingly, when Diego returned (sooner than expected) he found that Lupe and Jorge were deeply and happily in love, and my parents divorced. Frida and Alejandro Gómez Arias had meanwhile split up. At the instigation of her friend Germán del Campo, Frida had joined the Communist Party and befriended Tina Modotti, who was already famous for her photography and political activism. It was in Tina's house that Frida and Diego met for the third time. Without Lupe to get in the way, they became engaged and were eventually married on August 26, 1929, in the village of Coyoacán on the outskirts of Mexico City.

By this time my mother was happily married to Jorge Cuesta and had, for all intents and purposes, forgotten her rivalry with Diego's female admirers. In fact, she used to get together with Diego's girlfriends to complain about him. And so it was that when Tina offered to hold Diego and Frida's wedding reception at her house, Lupe volunteered to cook some of Diego's favorite dishes.

Tina's patio was lavishly decorated with pendants and streamers, transformed into a festive setting with all the friendly charm of a Mexican village. A mariachi band played nonstop, and the guests sipped tequila and munched on pork rinds with avocado as they waited for the newlyweds to arrive. The crisis came when Lupe could control her jealousy no longer, and emotion triumphed over manners. Lupe began flaunting her own beauty in the face of Frida's physical deformities. She lifted the bride's skirts for all to see the consequences of the polio Frida had suffered as a child and called out; "Your legs are scrawny, but mine—just look at them!" Frida responded by giving Lupe a violent shove; she lost her balance and went tumbling to the ground. Diego had to hold them apart in order to prevent bloodshed.

After the wedding the Riveras moved into a big house in the Juárez quarter of Mexico City, fronting on the very grand Paseo de la Reforma. In those early days of their marriage they shared the house with David Alfaro Siqueiros and his wife, Blanca Luz, and other artist couples. Everyone pitched in to pay the rent.

Dwight Morrow was the United States Ambassador to Mexico at that time. He wanted to improve relations between the two countries in the wake of the Revolution that had swept Mexico between 1910 and 1917. With this in mind, he commis-

Opposite: A page of the notebook in which Frida recorded the sales of her paintings.

Entradas. (Marzo y Abril)

= Del cuadro "Las dos Fridas" comprado para el Museo por Carlos Chávez _____ $ 4 000.00 F.

= El 26 de marzo, Diego me entregó personalmente _____ 500.00 D.

= 1er cheque de Gabriel Orendáin de: $1500.00 (Diego tomó $500.00) y me dió _____ 1 000.00 D.

= 2º cheque de G. Orendáin de: $1000.00 (entregado a Lupe Marín, y que se repartió en dos cant., Lupe tomó $500.00 y me dió _____ 500.00 D.

= Diego me dio personalmente el 9 de Abril, un dia, antes de salir a San José Purúa _____ 800.00 D.

= Último abono del "Opel" (la chinchita) que me compró Carlos Veraza, quien ya me había adelantado en Febrero $500.00, y se cobró el material y mano de obra de la bodega que reconstruyeron en Allende 59, ($460.00) Frida. _____ 540.00 F.

= Cobré con Gabriel Orendáin en efvo. _____ 1 500.00 D.

= Cheque del Colegio Nacional que corresponde a los meses de: Febrero y marzo (Cheque Nº 924385 Serie A. del Banco de México). 1 579.34 D.

= Abono de Gabriel Orendáin, (del que no he dado recibo 700.00 D.

total $ 11,119.34

Diego _____ 6,579.34

Frida _____ 4.540.00

11,119.34

sioned a huge mural dedicated to the story of the state of Morelos, where many prominent political figures—himself included—had weekend homes. With the support of the governor of the state, Morrow asked Diego Rivera to accept the commission. The murals were to be painted on the walls of an ancient palace that had belonged to Hernán Cortés in Cuernavaca, capital of Morelos.

My sister, Ruth, and I went to visit him there. I remember clearly how anxious Frida was to cook and keep house for Diego, when in fact she knew nothing of housekeeping. She had even less of an idea how to look after a kitchen in the tropics, where ants, cockroaches, and numerous other insects came and went at their leisure and generally felt quite at home. But we all survived.

A few months later Diego secured a commitment from President Emilio Portes Gil to finance a mural on themes from Mexican history to be painted in the central stairwell of the National Palace.

By then, relations between my parents and their respective spouses had become friendly enough to encourage joint residency in the same house. So it was that the two couples—and their "appendages" Ruth and Lupe (or Chapo and Pico, as we were nicknamed)—took up residence in a small apartment house that my mother had recently built. My father and Frida lived on the ground floor, and the rest of us on the third floor. The space in between was only symbolically unassigned; in point of fact we constantly met there for meals or to spend the evenings, unless friends dropped by to visit.

My father, who never stopped working, began on the murals in the National Palace while paying sporadic visits to Cuernavaca. At the same time he was engaged in painting murals at the Department of Public Health, where the youngest of the Kahlo girls, Cristina, posed nude for him. Jorge Cuesta divided his time between poetry and his career as a chemist. Frida worked on easel painting. And my mother was in charge of sewing everyone's clothes and teaching Frida how to cook.

The apartments had very small kitchens. One cooked with charcoal and wooden implements, kettles, and earthenware crocks. When Lupe and Frida worked together there was hardly room for both of them. Where Lupe took up space with her height and ample limbs, Frida filled it with her elaborately starched and frilly skirts. They took equal delight in preparing country-style *chiles en frío*, stuffed with chopped meat and bathed in a sweet-and-sour sauce of tomatoes and sliced onions, or the *romeritos* with shrimp *tortitas* and sour prickly pears, or the refried

beans smothered in cheese and garnished with crisp *totopos*. For these were Diego's favorite dishes.

Frida was taught to cook most of these dishes by Lupe, who for her part had learned them from my grandmother Isabel Preciado. Like many ladies of her period, Grandmother relied on a cookbook that was revered as a classic in Guadalajara. It was called *Practical Recipes for Housewives*, and it came in two volumes. Frida would later consult a cookbook in the format of a dictionary that had belonged to her mother. Called *The New Mexican*

Cook, it was a collection of the finest and tastiest traditional recipes. I eventually inherited these books from my grandmother and from Frida, complete with their own recipes and kitchen secrets—the very same ones that appear in this book.

The superficially idyllic life that the Riveras and Cuestas lived together could not last forever. Under considerable pressure from the Mexican government due to his political ideas, Diego accepted an invitation to participate in a project at the San Francisco Stock Exchange and the School of Fine Arts. Frida took advantage

Above: *Two pages from the* Nuevo Cocinero Mexicano, *the cookbook that belonged to Mrs. Matilde Calderón de Kahlo, Frida's mother.*

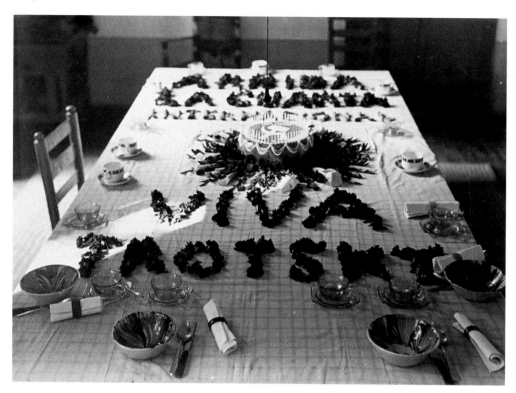

of her new life in California, and the weeks they later spent in New York, to get to know the United States and to experiment with her own painting. Since she and Diego were living in hotels and furnished apartments without kitchens, they had to eat out. In her letters home, Frida spoke of how much she missed Mexican cooking and how hard it was to get used to the monotony of North American food.

Months later, when she had recovered from a spell of bad health and was living in Detroit, Frida went back to cooking her favorite Mexican dishes. She was able to do this because all the necessary ingredients were available in stores she had searched out in the city's Mexican quarter. People stared when Frida arrived at the Detroit Institute of Art bearing a huge basket full of the great Master's food, but his assistants and friends helped themselves and found it very much to their liking.

The Riveras returned to Mexico toward the end of 1933. Their ultramodern house in San Angel, designed by Juan O'Gorman, was ready, and they moved in at once. The furnishings were totally modern, with tables, chairs, and other furni-

Above: In 1937, Frida celebrated León Trotsky's arrival in Mexico with a fiesta, decorating the dining room table in the Blue House with flowers.

ture made from polished steel with cushions and upholstery of fine leather, lemon-green in color. This made a vivid contrast with the red tiles on the roof, the white walls and yellow tile floors covered with *petates* (reed mats). Even more striking was the presence of Diego Rivera's colorful canvases, which took up most of the wall space.

There was an all-electric kitchen, so tiny that it discouraged anyone from cooking in it, so Frida built a second kitchen where she could enjoy making meals. But the Riveras were still not happy. They came to the conclusion that it would be best to refurnish the Blue House in Coyoacán—Frida's family home. San Angel would then function as a studio for them both, while the Blue House would be their home.

In 1942, family events made it convenient for me to go to Coyoacán and live with my father and Frida Kahlo. In the Blue House I had some of the most important experiences of my youth. I met people who had a tremendous impact on my life, but the most important influence of all was learning to see the world through the way Frida and Diego lived.

Frida was an enthusiast; she got the most out of everything. The world around her was more than enough cause for permanent rejoicing. She celebrated saints' days, birthdays, baptisms, and most of the popular holidays, both religious and secular. She got everyone involved—friends and family, students and colleagues—and she loved to mingle with the crowds in the marketplace on traditional holidays. She used to go to Garibaldi Square, where the mariachis—her constant companions in good times and bad—sang her favorite songs, one after another. I had lived a fairly sheltered life until then, so this was a new world for me.

I have put in writing some of the most significant and moving moments of Frida Kahlo's life, the ones that are most indelibly impressed upon my memory. I also speak of Frida's daily life, her habits and personality, and the artistic talent that is so apparent in the works she created between 1940 and 1943. I write about her enthusiasm for food and preparing Diego's favorite dishes. I have called these events *Frida's Fiestas*, although I must admit that my father, myself, and everyone else who knew Frida took part in these celebrations with her. Setting these experiences down on paper has not been terribly painful, nor has it been particularly easy. But I must confess that it gives me great personal satisfaction to see them written down in the words that make up this book.

Guadalupe Rivera

Overleaf: Frida's photo album, on display in the Frida Kahlo Museum.

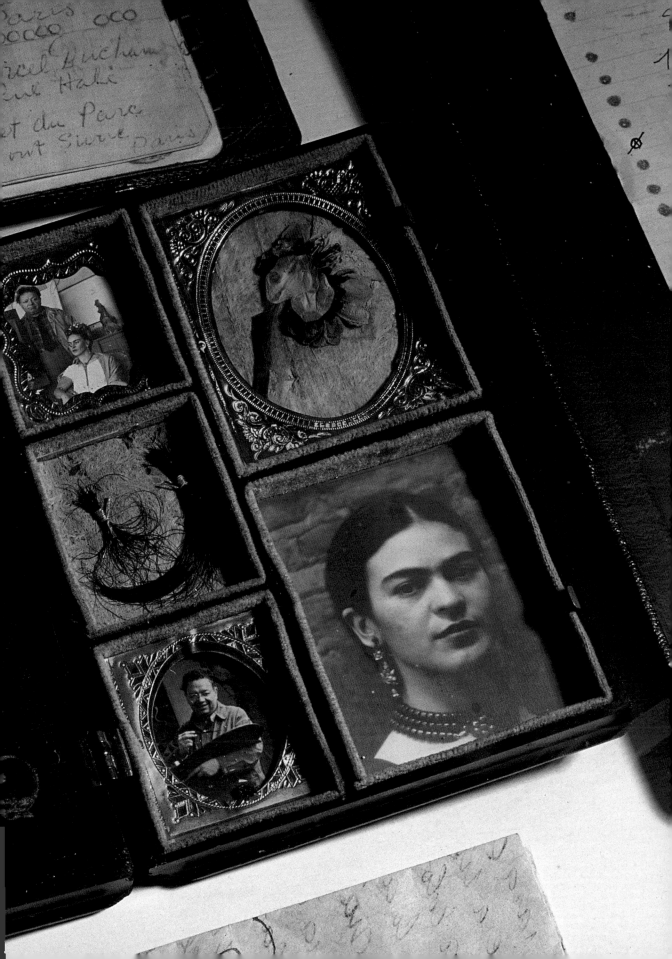

LIFE WITH FRIDA

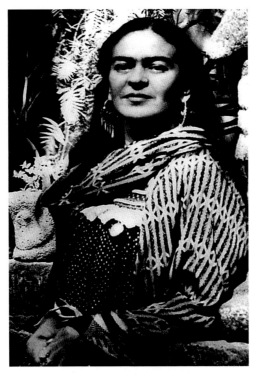

The very first thing Frida and Diego did when they left San Angel to live in Coyoacán was have the front of the house at Londres 127 painted azul añil, the deep matte blue considered to ward off evil spirits, with trim of red and green. It had always had the comfortable feeling of a small-town house, an effect in part of the great variety of plants and animals they kept there. Outside, there were flowers of every color growing in the

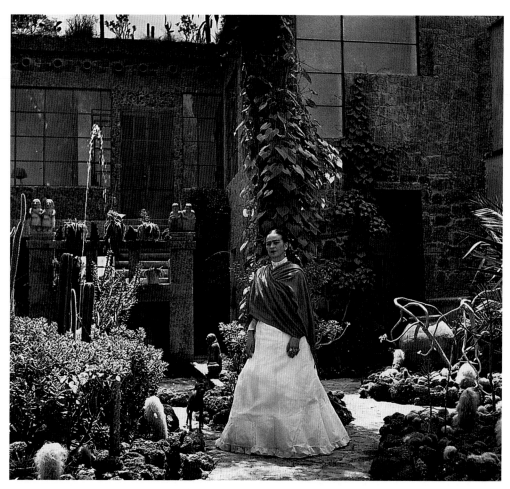

garden and in big planters in the patio, and inside, abundant bouquets of wildflowers and sunflowers in earthenware vases. There were songbirds and parakeets warbling or chattering in their cages, long-haired gray cats and dogs of indistinct color, and a spider monkey called Fulang Chang. All of this, but especially the presence of Frida herself, gave the Blue House in Coyoacán its unique personality and voice.

People congregated mostly in the kitchen. Frida met there with the servants to discuss the day-to-day business of running the house. The stove was decorated with white, blue, and yellow Spanish tiles, and the entwined names of Frida and Diego were spelled out in tiny earthenware

Page 20: The patio of the Blue House. Page 21: Frida in the garden. Above: One of Frida's dogs poses with her in the cactus garden.

jugs on the rear wall. On the wall above the stove hung earthenware pots from Oaxaca, copper kettles from Santa Clara, glasses, cups and pitchers from Guadalajara and Puebla and Guanajuato. The overall effect was typically Mexican. Frida and Diego had purchased these pieces of folk art in their travels around the country, and gradually they put together a living collection of beautiful objects created by the most gifted artisans in the country.

Frida often went further than Diego in expressing her "Mexican-ness." There was nothing new in this, really, since even as a child Frida was known to use words and expressions that were common among what her older sisters called *"la Indiada"* ("the Indians"), a derogatory term for the poor. I have included some of these idiomatic expressions in these pages.

I arrived in Coyoacán in August 1942, a teenager with little luggage. I found Frida in the kitchen. As usual, her outfit took me by surprise. She wore a black *huipil* with red and yellow embroidery and a soft cotton skirt in a floral print that seemed to come alive when she moved. Everything about her, from her hairstyle to the hem of her dress, breathed a kind of roguish glee accentuated by her laughing response to her cook Eulalia's remarks.

Frida could not have been more hospitable. She was always quite affectionate

with me and my sister, Ruth. She called her Chapo and me Pico or Piquitos, the nicknames my father also used. We were very close, and she loved us. Young in spirit and age as well, she looked after us as if we were her flesh and blood.

The morning of my arrival in Coyoacán, Frida had just gotten back from the Melchor Ocampo market, which was quite near the Blue House. She had gone with Chucho, one of those hired hands no respectable village family can do without. *La niña Fridita* ("little Frida"), as Eulalia affectionately called her, was unpacking

Above: La marchanta, *the flower vendor in the Coyoacán market, who sold Frida her favorite flowers.*

fruits and vegetables from a large basket. She examined them carefully one by one, commenting on their beautiful colors and exotic flavors.

At one point she said to me: "Look at this watermelon, Piquitos! It's an amazing fruit. On the outside, it's a wonderful green color, but on the inside, there's this strong and elegant red and white. The *pitaya* is bright red, like a pomegranate sprinkled with black dots. Then there's the *pitahaya*. It is fuchsia on the outside and hides the subtlety of a whitish-gray pulp flecked with little black spots that are its seeds inside. This is a wonder! Fruits are like flowers: they speak to us in a provocative language and teach us things that are hidden."

She also took out a mamey, a melon, a cherimoya, and a bunch of pink bananas (they were her favorites) and put them all in a basket. Then she added a few avocados that looked to be perfectly ripe, not for visual effect but as ingredients for a magnificent guacamole.

I followed her into the dining room and tried to help her set the table, although I was so astonished by what I saw that I could scarcely do a thing. For Frida, setting the table was a ritual, whether she was unfolding the white openwork tablecloth from Aguascalientes, or arranging the simple plates that she had customized with her initials, or setting out Spanish Talavera plates and handblown blue glasses and heirloom silverware. It was as if the shape and color and sound that was particular to each individual object endowed it with life and an assigned place in a harmonious, aesthetically pleasing world.

A few moments later came the act of placing the flower vase in the center of the table. Into the vase went a bouquet that Frida had cut in the garden. It mimicked the flowers she wore in her hair, mimosa and marguerites of different sizes mixed in with little red-and-white roses. To complete the effect she added jasmines, whose perfume gave her such a distinctive fragrance.

Frida grew the plants and flowers herself. She went to the gardens every day to see how they had grown and which were in bloom. These she put in her hair or distributed around the house. I observed all of this magic scene, dazzled by the evidence of my eyes.

I came to my senses briefly when in a friendly and slightly ironic voice she asked me to follow her to her studio. She was perfectly aware that I felt out of place. We picked up the basket of fruit, and after her I went. As soon as we entered the studio, Frida's favorite place in the whole house, I was in the grip of an even greater amazement. A group of her paintings hung on the

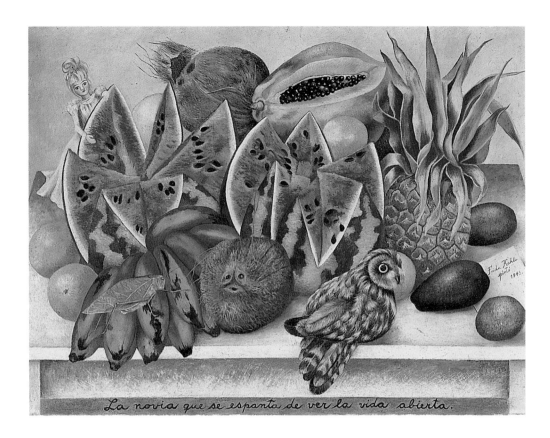

La novia que se espanta de ver la vida abierta.

walls, *The Two Fridas* occupying the place of honor. The painting's strange combination of suffering and fear quite overwhelmed me. Breaking the silence, Frida remarked, "Now that I have fruits like these, Piquitos, and a little owl that lives in the garden, I'll be able to paint again some day! I prefer nature and natural objects to people." True to her word, in 1943 she painted *The Bride Frightened at Seeing Life Opened.* In this work the freshness of a watermelon, the seedy core of a papaya and a little owl's staring eyes speak to us of that openness and liveliness of spirit that Frida lost in the last years of her life.

She also painted a doll from her collection, the one that was dressed as a bride. She must have wanted to recapture the expression of a young woman astonished by the spectacle of life, which was something that she herself had lost at an early age, years before she wore her own wedding gown.

Above: The Bride Frightened at Seeing Life Opened, *1943.*

AUGUST

Frida and Diego's Wedding

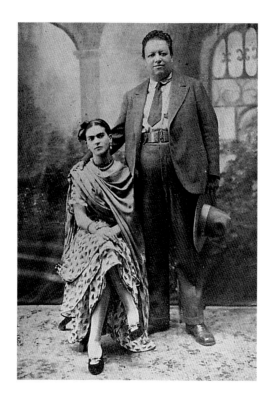

hirteen years before I went to live with them, Frida and Diego were married in the Coyoacán town hall. The date was August 26, 1929. Tina Modotti, bridesmaid and friend of Frida, gave the wedding reception on the terrace of her apartment building. There was a tremendous turnout, although Alejandro Gómez Arias, Frida's first official fiancé, was noticeably absent. The same could not be said of my mother, Diego's second wife.

From that day on, Frida dressed in either the Oaxaca style or the antiquated fashion of the Mexican capital both to please her husband and to reflect her personal preference. The Oaxaca style, as worn by the women of Tehuantepec, is heavy with embroidery, ribbons, and floral motifs—but when Frida dressed formally, sheathed in silk and lace, she was transformed into a lady of the court during the presidency of Porfirio Díaz. In her everyday cotton percale with embroidered hems, Frida became the very image of the muse described by the poet Ramón López Velarde, who wrote about provincial girls "with blouses buttoned to their ears, and skirts down to their ankles."

In her remarkable self-portrait titled *The Two Fridas*, she appears in two different dresses, one a magnificent antique and the other in the Tehuana style—a proud, elegant lady next to a native beauty both similarly wounded by life. To complete her attire, Frida always wore a silk or linen rebozo, choosing a color that matched the rest of her clothes. Her favorite rebozo was a handmade silk one from Oaxaca, raw fuchsia in color.

In keeping with her ongoing commitment to communism, Frida dressed simply for her wedding, like an ordinary country woman. Judging from her clothes alone, she might have been presiding over a ceremony in any small town near Mexico City or in a modest household in the renowned village of Coyoacán.

It was like a fairy tale: the simple terrace of the apartment building where Tina Modotti lived was transformed for one day into a splendid, magical place. Hundreds of brightly colored pendants and streamers dangled from the beaks of papier-mâché doves. "Long live Diego!" "Long live Frida!" "Congratulations!" "Long live love!"

There were paper tablecloths in various colors and napkins in contrasting colors. The place settings were for everyday use: green- and black-painted earthenware from Michoacán with designs of doves and other birds, dogs, and cats.

From her wedding day on, Frida realized that good cooking would be an important part of her life. Master Rivera's bad moods vanished before the delicious dishes that are normally served in a Mexican home, like white or saffron rice, *huauzontles* in different sauces, stuffed chiles in broth, and Oaxaca mole. With the exception of a splendid oyster soup, the wedding banquet was a modest affair. The oysters were served as an entree, thanks to the common Mexican belief that the little mollusks stimulate the appetite—for sex as well as food. I do not know whose idea it was: it could have been Diego's or

Page 27: The official wedding portrait, August 1929.
Page 28: A corner of Tina Modotti's terrace, with tequila and lemons ready to be served.

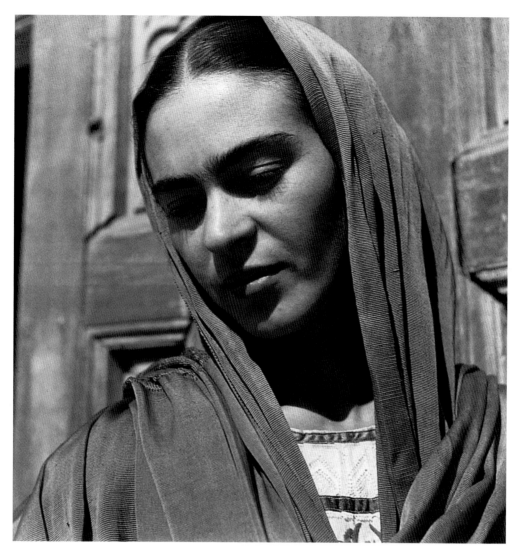

Frida's—or even my mother's.

The guests had their choice of dishes prepared by Lupe Marín and cooks who were brought in from the marketplace near Tina's home. Lupe was responsible for the Mexican rice, the white rice with plantains, the *huauzontles* in green and red sauce, and the chiles stuffed with picadillo or with cheese. The other cooks made the famous oyster soup, the mole, and the desserts served in individual casseroles, as one should do with a good *torreja* or an

Above: Frida photographed in 1937 in one of her favorite rebozos.

even better *capirotada*. All of the guests ate at least one slice of the delicious wedding cake that Frida had ordered from the finest bakery in Coyoacán. The cake was decorated with white icing doves and roses and topped by the newlyweds rendered in sugar paste. The cake bride wore a beautiful white tulle dress, and the cake bridegroom a top hat, tails, and gloves. Of course this couple had nothing in common with the actual bride and groom. They were more like their formal, conservative antithesis.

At that time Diego believed that only the bourgeoisie used silverware. So for the soup there were blue-enameled metal spoons, the most common kind for sale in the market, but the rest of this wonderful food had to be eaten with the sole aid of tortillas.

Plain pulque, celery- and prickly pear-flavored pulque, and the obligatory complement of tequila flowed like rivers throughout the banquet. The result was a lot of raucous fun, punctuated with song after song and endless cheers. As luck had it, neither Rivera nor any of his friends pulled out their pistols to follow the revolutionary painters' time-honored practice of celebrating important events in their lives by firing live rounds into the air, instead of setting off fireworks.

Ever since their artist days at the National Preparatory School, Rivera along with his friends and colleagues David Alfaro Siqueiros and Xavier Guerrero were in the habit of wearing revolvers or pistols strapped to their waists and drawing them on the slightest pretext, to express their pleasure or annoyance. The wedding could very well have been another such occasion. Fortunately, it turned out otherwise.

By nighttime a number of guests had stayed behind either by design or because they were immobilized by all the beer, pulque, and tequila they had drunk. They were more than happy to serve themselves heaping portions of pozole and all kinds of tostadas, beginning with pig's feet and chicken with avocado.

The Riveras' honeymoon took them to Cuernavaca, where Master Diego was to paint the murals in the Hernán Cortés palace. Among the many individuals represented in these paintings are two heroes of the history of Morelos state, Emiliano Zapata and José María Morelos y Pavón. Zapata, shown standing by his horse, in time became a legendary figure, while Morelos, holding his sword on high, is today as always the very definition of the hero.

While Diego worked at re-creating the tropical landscape of that city of never-ending spring, Frida applied herself to cooking, cleaning, ironing, and other chores typical of a Morelos housewife.

Opposite: Capirotada, *a traditional dessert, served in a green pressed glass bowl from Puebla.* **Overleaf:** *Diego and Frida's wedding banquet table, re-created on Tina Modotti's terrace.*

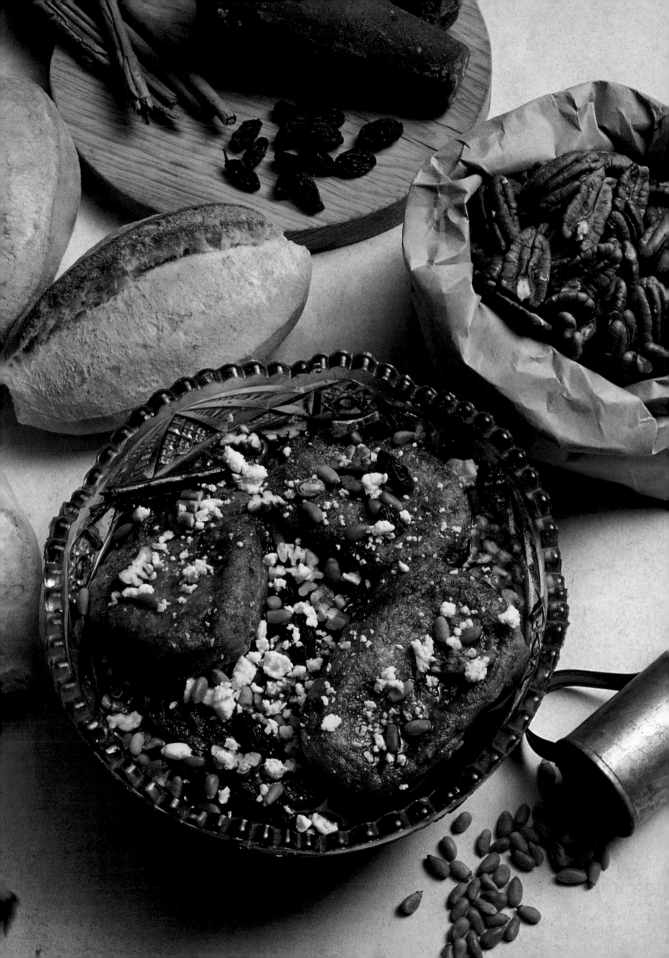

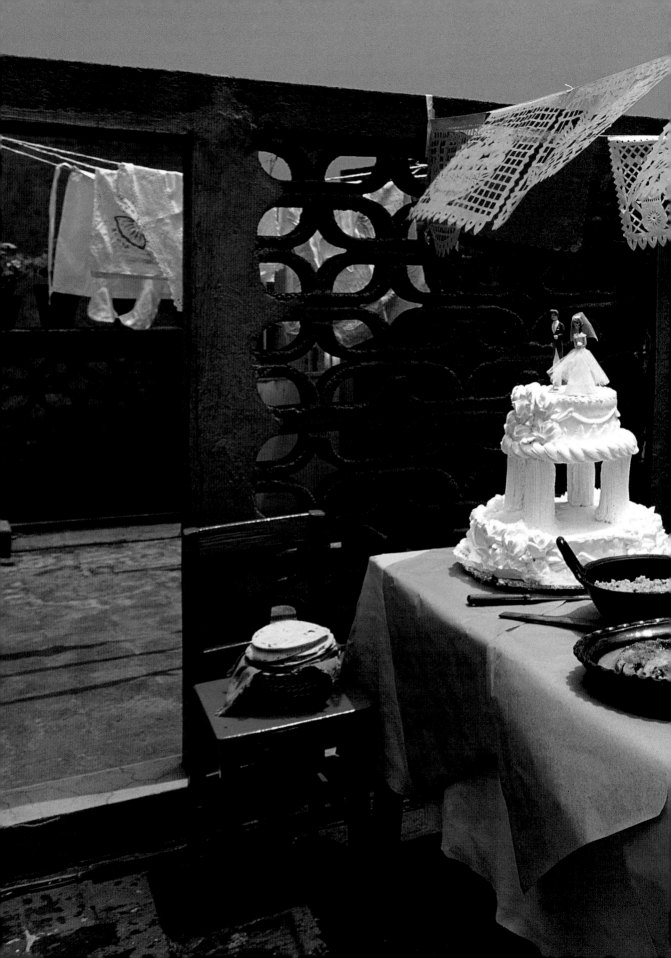

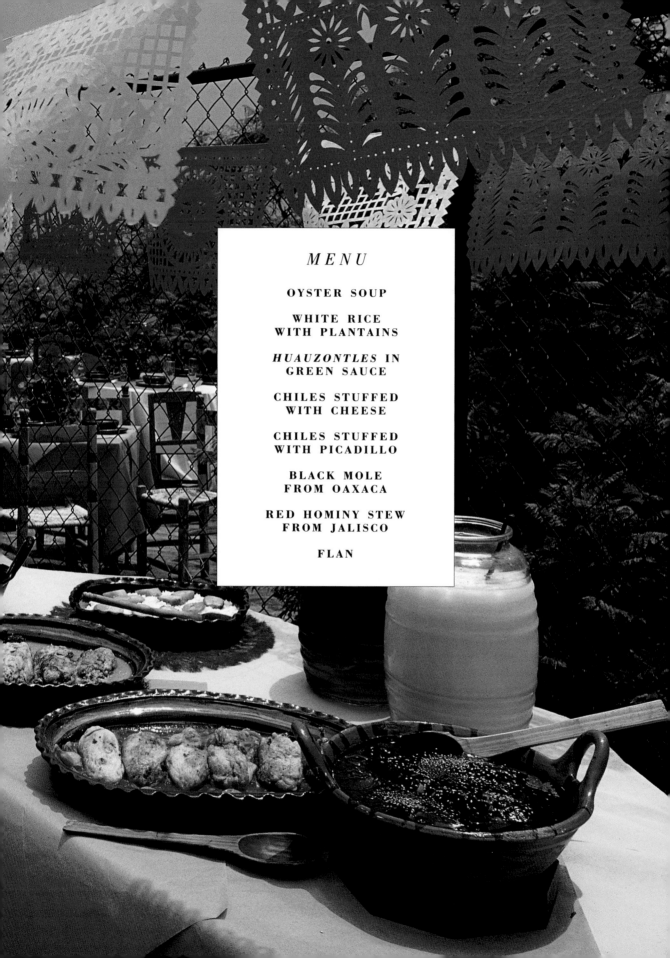

MENU

OYSTER SOUP

WHITE RICE
WITH PLANTAINS

HUAUZONTLES IN
GREEN SAUCE

CHILES STUFFED
WITH CHEESE

CHILES STUFFED
WITH PICADILLO

BLACK MOLE
FROM OAXACA

RED HOMINY STEW
FROM JALISCO

FLAN

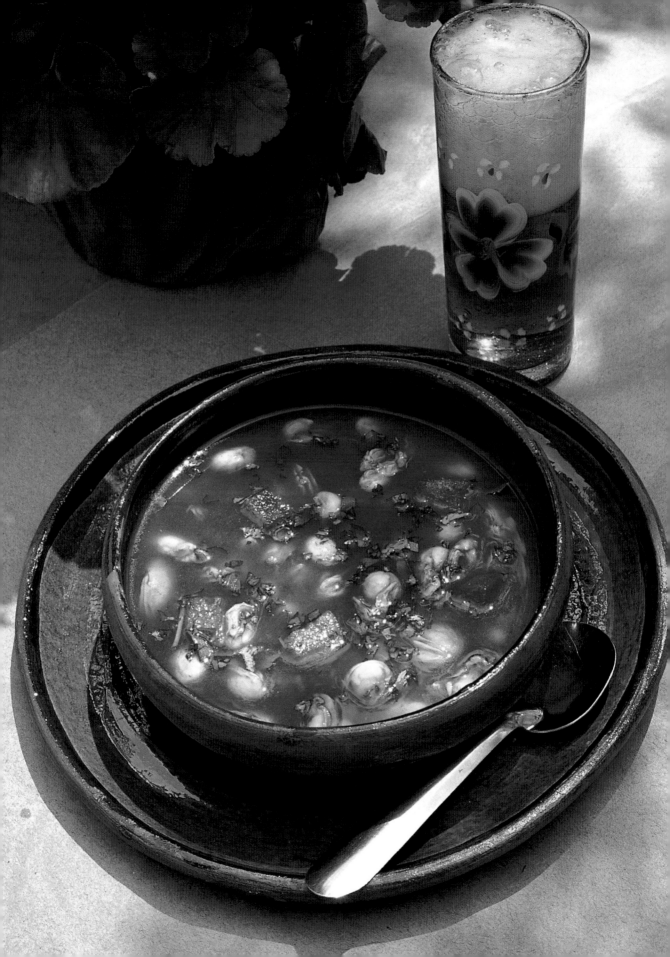

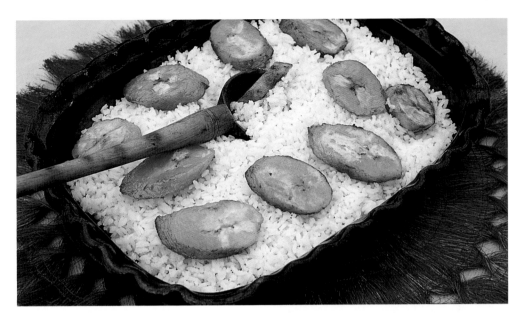

OYSTER SOUP

(8 servings)

1 large onion, chopped

2 garlic cloves

4 tablespoons butter

3 tablespoons flour

2 tomatoes, peeled
and chopped

Salt and pepper

3 quarts oysters, shucked,
with their liquid

2 quarts/2 l chicken broth

¼ cup/30g chopped parsley

2 crusty rolls, cubed and fried

Sauté the onion and garlic in the butter until translucent. Stir in the flour and cook for a few seconds. Add the tomatoes and salt and pepper to taste and simmer for about 10 minutes, until thickened. Drain the oysters, reserving the liq- uid. Add the oyster liquid and chicken broth to the saucepan, bring to a boil, then simmer for a few minutes. Add the oysters and parsley and simmer a minute more.

Pour the soup over the bread cubes in a soup tureen. Serve piping hot.

WHITE RICE WITH PLANTAINS

(8 servings)

4 ripe plantains

Corn oil

2 recipes White Rice
(see page 56)

Peel the plantains and slice them diagonally. Fry the plantains in hot oil, turning once, until golden. Drain on brown paper. Top the rice with the fried plantains.

Opposite: The Oyster Soup is served in pottery from Michoacán; the hand-painted glass with beer is from Puebla. Above: White Rice with Plantains, served in green pottery from Michoacán.

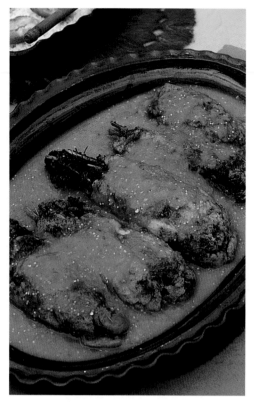

1 medium onion,
finely chopped

3 or 4 jalapeño chiles

½ cup/125ml water

1 small bunch cilantro

2 tablespoons lard or corn oil

Cook the *huauzontles* in salted water for about 30 minutes, or until tender. Drain, cool slightly, and squeeze out the excess water. Stuff bits of cheese between the small stems, then dust lightly with flour. Beat the egg whites until stiff. Beat the yolks with a pinch of salt. Gently fold the yolks and whites together to make a batter. Dip the floured *huauzontles* in the batter and fry in hot lard until golden. Drain on brown paper. Place the *huauzontles* in Green Sauce and serve hot.

To make the Green Sauce, combine all the ingredients except the lard in a saucepan. Simmer until the tomatillos are tender and cooked through. Let cool slightly, then puree. Simmer the sauce in hot lard until the flavors are well blended.

HUAUZONTLES IN GREEN SAUCE

(8 servings)

2 pounds/1k *huauzontles*, well
cleaned, stems trimmed

1 pound/500g Oaxaca cheese,
crumbled (or muenster)

Flour

5 eggs, separated

Lard or corn oil

GREEN SAUCE

2 pounds/1k tomatillos

2 garlic cloves

CHILES STUFFED WITH CHEESE

(8 servings)

16 poblano chiles, roasted,
peeled, deveined, and seeded

4 cups/450g queso fresco (or
mild feta)

Flour

5 eggs, separated

Corn oil or lard

Above: Huauzontles *in Green Sauce.*

TOMATO BROTH

3 tablespoons olive oil

1 onion, thinly sliced

2 carrots, peeled
and thinly sliced

10 medium tomatoes, roasted,
peeled, seeded, and chopped

½ cup/125ml vinegar

3 tablespoons sugar

Salt and pepper

2 teaspoons dried oregano

Stuff the chiles with cheese and dust lightly with flour. Beat the egg whites until stiff. Beat the yolks with a pinch of salt and fold together with the egg whites to make a batter. Dip the stuffed chiles in the batter and fry in very hot oil until golden. Drain on brown paper. To serve, place the chiles in the Tomato Broth.

To make the Tomato Broth, heat the olive oil and sauté the onion and carrots until the onion is translucent. Add the tomatoes, vinegar, sugar, and salt and pepper to taste. Simmer for about 10 minutes. Stir in the oregano and continue to cook for 10 minutes more, or until the broth is flavorful and the tomatoes are cooked through.

CHILES STUFFED WITH PICADILLO

(8 servings)

16 poblano chiles, roasted,
peeled, seeded, and deveined

Flour

5 eggs, separated

Corn oil or lard

Tomato Broth (see above)

PICADILLO

3 pounds/1,500g ground pork

1 large onion, halved

3 garlic cloves, chopped

Salt and pepper

6 tablespoons lard

1 small onion, finely chopped

3 carrots, finely chopped

2 zucchini, finely chopped

1 pound/400g tomatoes,
chopped

1 cup/75g shredded cabbage

¾ cup/100g blanched
almonds, chopped

½ cup/60g raisins

Stuff the chiles with the Picadillo, then dust them with flour. Beat the egg whites until stiff. Beat the yolks lightly with a pinch of salt and gently fold together with the whites to make a batter. Dip the chiles into the batter and fry in hot oil until golden. Drain on brown paper. To serve, place the chiles in the Tomato Broth.

To make the Picadillo, cook the pork with the onion halves, garlic, and salt and pepper to taste for about 20 minutes. Drain off the liquid and discard the onion. Heat the lard in another pan and sauté the chopped onion, carrots, and zucchini until the onion is translucent. Add the tomato, cabbage, almonds, raisins, pork, and salt and pepper to taste. Simmer for about 20 minutes, or until the mixture has thickened and the tomato is cooked through.

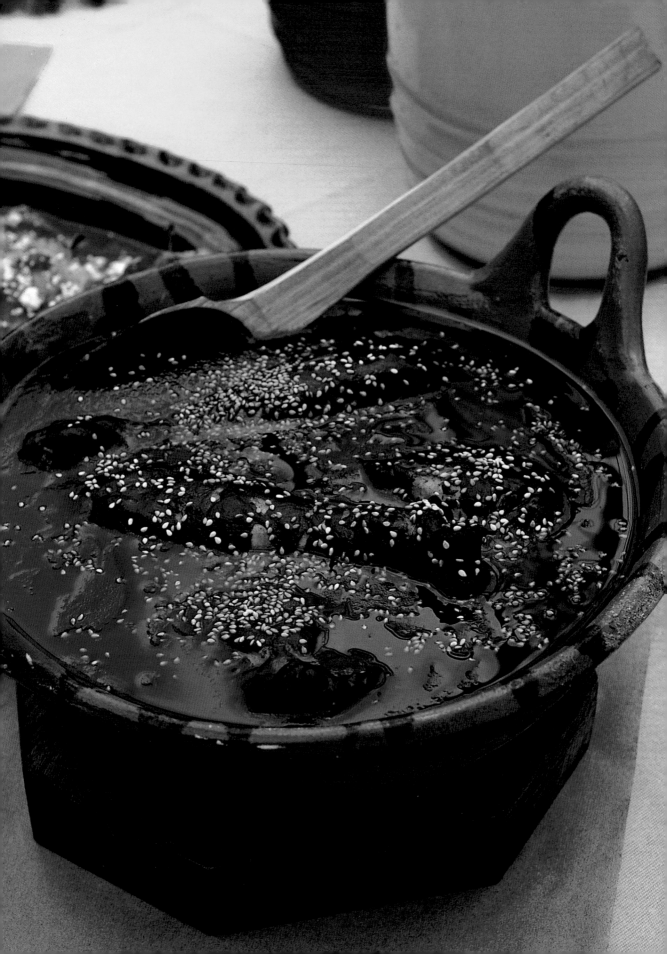

BLACK MOLE
FROM OAXACA

(16 to 20 servings)

1 pound/500g chihuacle chiles

½ pound/250g mulato chiles,
seeded and deveined,
seeds reserved

½ pound/250g pasilla chiles,
seeded and deveined,
seeds reserved

¾ pound/375g lard

2 large onions, roasted

1 head garlic, roasted

3 stale tortillas

2 slices egg bread

¾ cup/100g blanched almonds

½ cup/75g shelled peanuts

1 cinnamon stick

½ cup/70g sesame seeds

½ cup/60g shelled
pumpkin seeds

Pinch of anise seeds

1 teaspoon cumin seeds

1 teaspoon dried thyme

1 teaspoon dried marjoram

2 teaspoons dried oregano

10 coriander seeds

10 black peppercorns

8 cloves

¾ cup/100g raisins

3 large bars Mexican chocolate
(or semisweet chocolate)

4 pounds/2k ripe tomatoes,
roasted and peeled

1 pound/500g small
green tomatoes

8 tablespoons lard

Sugar and salt

2 *guajolotes* (small turkeys) or
4 large chickens cut into
pieces and cooked in a strong
broth with carrots, onions,
and herbs

Quickly fry the chiles in hot lard, being careful not to let them burn. Place the fried chiles in a large saucepan in hot water to cover. Bring to a boil, then simmer until soft.

In the same hot lard, sauté the onions and garlic until translucent. Add the tortillas, bread, almonds, peanuts, cinnamon, reserved chile seeds, sesame seeds, pumpkin seeds, anise seeds, cumin seeds, thyme, marjoram, oregano, coriander seeds, peppercorns, cloves, raisins, and chocolate. Sauté for a few minutes. Puree this mixture with the tomatoes and the chiles. Strain the puree and cook in 8 tablespoons lard. Stir in sugar and salt to taste and 2 cups/500 ml of the turkey broth. Simmer for 20 minutes.

Add the turkey, and simmer for 20 to 25 minutes to blend flavors. If the mixture is too thick, add more turkey broth as needed.

Note: Chihuacles are special chiles from Oaxaca; you can substitute cascabel chiles.

Opposite: *The famous Black Mole from Oaxaca,
sprinkled with sesame seeds.*

RED HOMINY STEW FROM JALISCO

(10 servings)

1½ pounds/700g
dried hominy

1 head garlic

2 pounds/1k loin of pork

1 pound/500g pork
cut from the leg

1 onion

Salt

3½ ounces/100g ancho chiles,
seeded, deveined, and soaked
in hot water

3½ ounces/100g guajillo
chiles, seeded, deveined, and
soaked in hot water

ACCOMPANIMENTS

1 head lettuce, shredded

Dried oregano

12 radishes, thinly sliced

Chopped onions

Lime wedges

20 tostadas

Piquín chile

Rinse the hominy well and place in a saucepan with water to cover. Add the garlic and simmer over low heat until tender.

Cook the meats separately in water to cover with the onion and salt, until tender. Drain and reserve the cooking liquid. Cut the meat into large chunks. Puree the chiles with their soaking water. Strain and add to the hominy. Stir the meat and some of the cooking liquid into the hominy. Add salt, bring to a boil, then sim-mer about 20 minutes, until the stew is quite thick. Remove and discard the garlic.

Serve the stew mounded on a platter. Surround it with the various Accompaniments.

FLAN

(6 to 8 servings)

¾ cup/145g sugar
(for caramel)

1 quart/1 l milk

1 cup/190g sugar

1 vanilla bean, split lengthwise

4 egg yolks

6 eggs, lightly beaten

Cook the sugar to caramelize it, then pour it into an earthenware mold, turning it around so that the bottom and sides of the mold are covered with caramel.

Heat the milk with the cup of sugar and the vanilla for about 10 minutes. Let cool slightly, then add the egg yolks and the beaten eggs. Mix thoroughly. Remove and discard the vanilla bean. Pour the egg mixture into the caramel-lined mold.

Place the mold in a larger pan of hot water and bake in a preheated 350°F/175°C oven for about 1½ hours or until set. Cool completely before unmolding.

Opposite: Pozole, *Red Hominy Stew from Jalisco.*

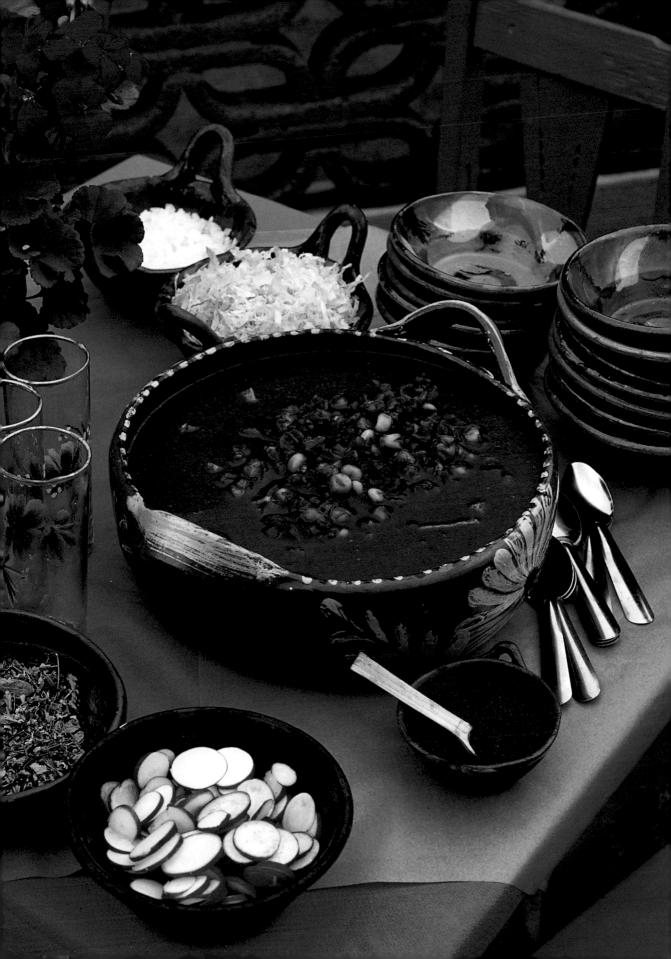

SEPTEMBER

The National Holidays

or Frida as for all Mexicans, September was "the patriotic month." She threw herself into the festivities with her customary energy and excitement. At the beginning of the month she started buying little flags of green, white, and red cloth and distributing them around the house. She stuck them in the fruit centerpieces at meals, in her still lifes, and in the planters that lined the U-shaped hallway leading to the garden.

She liked to buy little papier-mâché caps modeled on late-nineteenth-century Mexican Army hats. She also bought wooden swords and cardboard bugles in green, white, and red and made gifts of them to the children who lived in huts hidden among the cornfields by the house.

For me, the 1942 holidays were unforgettable. On September 15, we went to the Mexican Night that the authorities of Coyoacán organized every year at the Centenary Park. The next morning we watched the military parade in the center of town, and we ended the day with a grand dinner to which my father had invited his old friends, comrades all in the Nationalist struggles.

This was a dinner for politicians. Among those in attendance were ex-President Emilio Portes Gil, Narciso Bassols, several times member of the presidential cabinet, the former Secretary of Agriculture Marte R. Gómez, the economist Gilberto Loyo, the engineer Juan de Dios Bojorques, and, of course, Juan O'Gorman, the young architect and revolutionary painter.

Frida began her preparations for "going to the chapel" with don Diego on the afternoon of September 15. She dressed as the richest matron from the Isthmus of Oaxaca, choosing an authentic Tehuana dress with a traditional red-embroidered yellow *huipil*, a black silk brocade skirt with a white flounce, and a golden yellow rebozo, also of silk. She put flowers in her hair and wore eight of her favorite rings and the golden chain that my father had bought for her in Tehuantepec.

When night fell we took a stroll through the cobblestone streets of old Coyoacán in the company of friends. We headed for Centenary Park, where the annual fair was held. There were rides, fireworks, little cardboard bulls bristling with firecrackers, and the star attraction, the sideshow, where comedians poked fun at the politicians and local gentry while the audience sang raunchy songs in accompaniment.

This sideshow held special charm for Frida. From the moment she set foot in it, she did her best to add to the ongoing exchange of wisecracks and jokes. My father was delighted to be there; he, too, joined the action and laughed hard at his young wife's witty remarks. The actors soon figured out who they were and began improvising on the themes of Frida's beauty and her fat husband's ugliness. The audience roared. I felt mortified and embarrassed for my father, but he took it all in stride, putting up gallantly with the teasing.

When the show was over we melted into the dense crowd pressing toward the concessions that had been set up around the garden. We intended to try each and

Page 45: A tricolor rebozo tied in a bow, for the Independence Day celebrations. Page 46: Prickly Pears with Anise (see recipe on page 61).

every one of the Mexican delights that the women from the market were peddling.

Early the next morning we piled into my father's Ford station wagon. My father wanted to watch the parade in the center of town and make sketches.

We got home in time for Frida to set the table and prepare for the arrival of don Diego's friends. Since all of them were Nationalists and authentic patriots, Frida had asked Eulalia, her wonderful cook, to make some of the dishes that were customary at the time of the National Holidays, especially a number of Frida's personal favorites: a kind of fish soup made with snapper, "national flag rice," and chiles in walnut sauce. The ingredients that go into all of these dishes are the colors of the Mexican flag.

There is an interesting story about the origin of chiles in walnut sauce, the most famous dish of Puebla cuisine. It is said that one of the first presidents of Mexico visited the capital of the state (also called Puebla) one September early in the nineteenth century, shortly after the struggle for political independence had been won. In their determination to please him, the women of Puebla invented something unique to add to the feast of regional dishes: famous chiles in walnut sauce. These are basically poblano chiles stuffed with picadillo, covered in a sauce of fresh-ground nuts, and garnished with pomegranate seeds. In honor of the President of Mexico, the dish combined the green of the chiles, the white of the ground nuts, and pomegranate red.

Frida set the table with her best white Puebla ware, which featured a cobalt blue rim and the initials F and D in the same color. She brought out blue blown-glass tumblers and pitchers in the same style filled with patriotically colored drinks—the green lime water, white rice water, and red Jamaica flower water.

In September the markets abound in green, white, and red prickly pears from the country's semiarid regions, and the limes are said to be sweeter and juicier there. Frida chose a Tehuantepec bowl decorated with flowers for the centerpiece. She made it into a still life composed of the above-mentioned fruits stuck with little Mexican flags and two or three quartered pomegranates. As if by magic, the centerpiece became one of Frida's paintings. The guests were clearly delighted by these specialties of the house. In the end, it was impossible to know whether they were more entertained by the endless conversation, during which everyone restated their revolutionary ideals and seconded the great painter Rivera's views on the current crisis in Mexican politics, or by the painter Kahlo's splendid cooking.

Overleaf: The entrance to Centenary Park in Coyoacán, where Frida would go for morning strolls. Pages 52–53: The dining room of Antonio and Francesca Saldivar's Colonial house, where Frida's Independence Day fiesta was re-created.

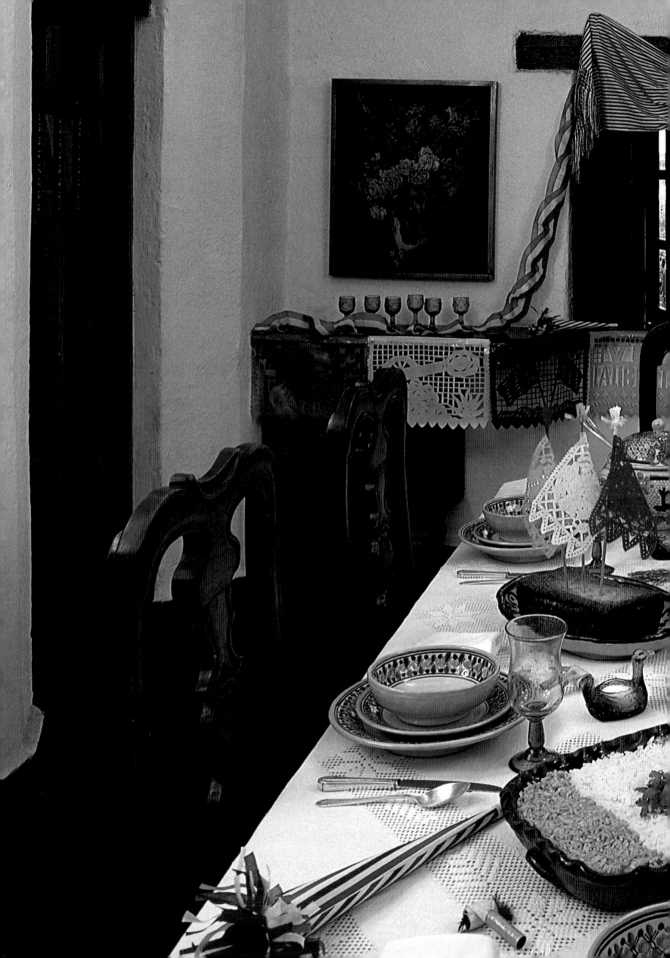

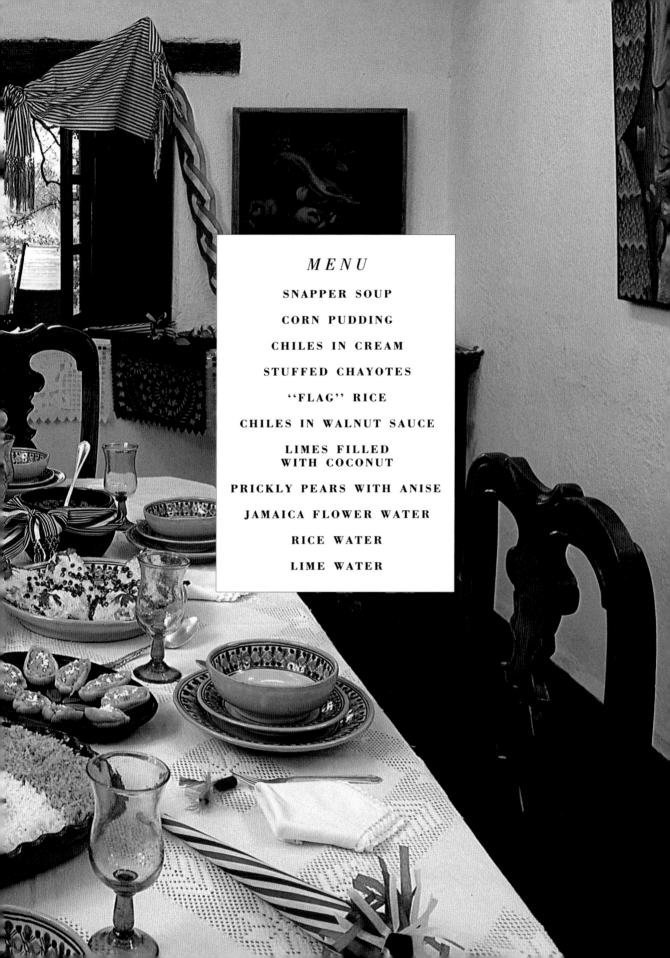

MENU
SNAPPER SOUP

CORN PUDDING

CHILES IN CREAM

STUFFED CHAYOTES

"FLAG" RICE

CHILES IN WALNUT SAUCE

**LIMES FILLED
WITH COCONUT**

PRICKLY PEARS WITH ANISE

JAMAICA FLOWER WATER

RICE WATER

LIME WATER

SNAPPER SOUP

(8 servings)

3 pounds/1,500g red snapper,
cut in chunks

1 fish head

Salt

Dried oregano

1 onion, chopped

4 tablespoons lard

3 large tomatoes, roasted,
seeded, and chopped

6 serrano chiles

Place the snapper and fish head in a large kettle with water to cover and season to taste with salt and oregano. Simmer for about 20 minutes. Drain the fish and set aside, reserving the cooking broth but discarding the head.

In another pan, sauté the onion in hot lard until translucent. Add the tomatoes and chiles and cook until thickened. Add the fish broth and simmer until the flavors are blended.

To serve, place the snapper chunks in a tureen and cover with the hot broth.

CORN PUDDING

(6 to 8 servings)

12 tablespoons/190g butter

1 cup/190g sugar

7 to 8 cups/1k corn kernels,
preferably a few days old

½ cup/110 ml milk

5 tablespoons/50g flour

1 tablespoon baking powder

1 teaspoon salt

5 eggs, separated

Cream the butter and sugar. Puree the corn kernels with the milk. Sift the flour with the baking powder and salt. Beat the egg yolks with the flour until well mixed. Thoroughly combine the butter, corn, and egg mixtures. Beat the egg whites until stiff and gently fold into the corn mixture. Butter a baking dish or ring mold. Fill with the batter and bake in a preheated 350°F/175°C oven for 45 to 50 minutes, until the top is golden and a toothpick inserted in the center comes out clean.

Serve with Chiles in Cream.

Note: You can make a sweet pudding by adding about 1 pound/450 g of chopped candied fruit and nuts (pineapple, angelica, lemon, dates, and pine nuts) to the mixture before folding in the egg whites.

CHILES IN CREAM

(6 to 8 servings)

4 tablespoons/65g butter

1 large onion, thinly sliced

8 poblano chiles, roasted,
peeled, seeded, deveined, and
cut in strips

2 cups/500 ml cream

Salt and pepper

Heat the butter in a skillet and sauté the onion until translucent. Add the chile strips and sauté for a minute. Stir in the cream and salt and pepper to taste and heat through.

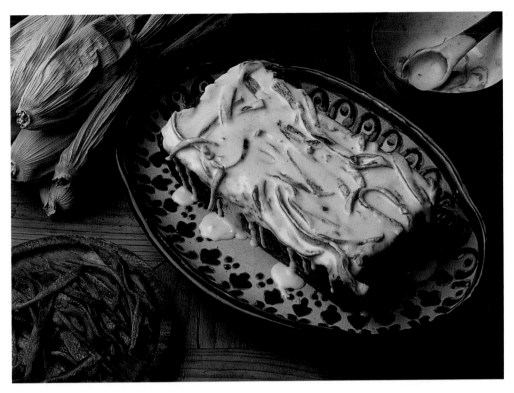

STUFFED CHAYOTES

(8 servings)

12 chayotes (mirlitons)
Fresh bread crumbs

SAUCE

1 medium onion, finely chopped

2 garlic cloves, minced

4 tablespoons/65g butter

2 teaspoons chopped parsley

2 medium tomatoes, simmered for 5 minutes, peeled, and chopped

½ cup/60g raisins

12 olives, pitted and chopped
Salt and pepper

Cook the chayotes in boiling salted water until just tender. Remove from the water, let cool, and cut in half lengthwise. Use a spoon to remove the pulp and add it to the prepared sauce. Stuff the empty shells with the sauce, top with bread crumbs, and bake in a preheated 350°F/ 175°C oven for 15 to 20 minutes, until the chayotes are hot and the bread crumbs are golden.

To make the sauce, sauté the onion and garlic in the butter until translucent. Stir in the parsley, tomatoes, raisins, olives, and salt and pepper to taste. Simmer until very thick, 15 to 20 minutes.

Above: *Corn Pudding under a blanket of Chiles in Cream, served on a plate from Puebla.*

GREEN RICE

(4 servings)

1 cup/115g rice

2 tablespoons lard or
3 tablespoons corn oil

½ small onion, finely chopped

3 poblano chiles, deveined,
pureed with ¼ cup water, and
strained

1¾ cups chicken broth

¼ cup chopped cilantro leaves

Juice of ½ lime

Salt

Soak the rice in very hot water for 15 minutes. Drain it; rinse it in cold water; then drain very well. Sauté the rice in hot lard or oil for a minute or so. Add the onion. When the rice sounds like sand as it is stirred, add the pureed chiles and continue to cook until thickened. Add the broth, cilantro, lime juice, and salt to taste. When the liquid comes to a boil, cover, lower heat, and simmer until tender, about 20 minutes.

WHITE RICE

(4 servings)

1 cup/115g rice

2 tablespoons lard or
3 tablespoons corn oil

½ small onion, grated

1 garlic clove

1 celery stalk

Juice of ½ lime

2 cups/500ml chicken broth

Soak the rice in very hot water for 15 minutes. Drain it; rinse it in cold water; then drain very well. Sauté the rice in hot lard or oil for a minute or so. Add the onion and garlic. When the rice sounds like sand as it is stirred in the pan, add the celery, lime juice, and chicken broth. Bring to a boil, cover, lower heat and simmer until tender, about 20 minutes. Discard the celery and serve.

RED RICE

(4 servings)

1 cup/115g rice

2 tablespoons lard or
3 tablespoons corn oil

1 tomato pureed with ½ onion,
1 garlic clove, and salt and
pepper

1 celery stalk

1 parsley sprig

1⅓ cups chicken broth

Juice of ½ lime

Soak the rice in very hot water for 15 minutes. Drain it; rinse it in cold water; then drain very well. Sauté the rice in hot lard or oil until it sounds like sand when stirred in the pan. Add the tomato puree and sauté until thickened. Add the celery, parsley, broth, and lime juice. When the mixture comes to a boil, cover, reduce heat and cook until tender—about 20 minutes. Discard celery and parsley before serving.

Opposite: "Flag" Rice (one recipe each of Green, White, and Red Rice) arranged on a green pottery platter from Michoacán.

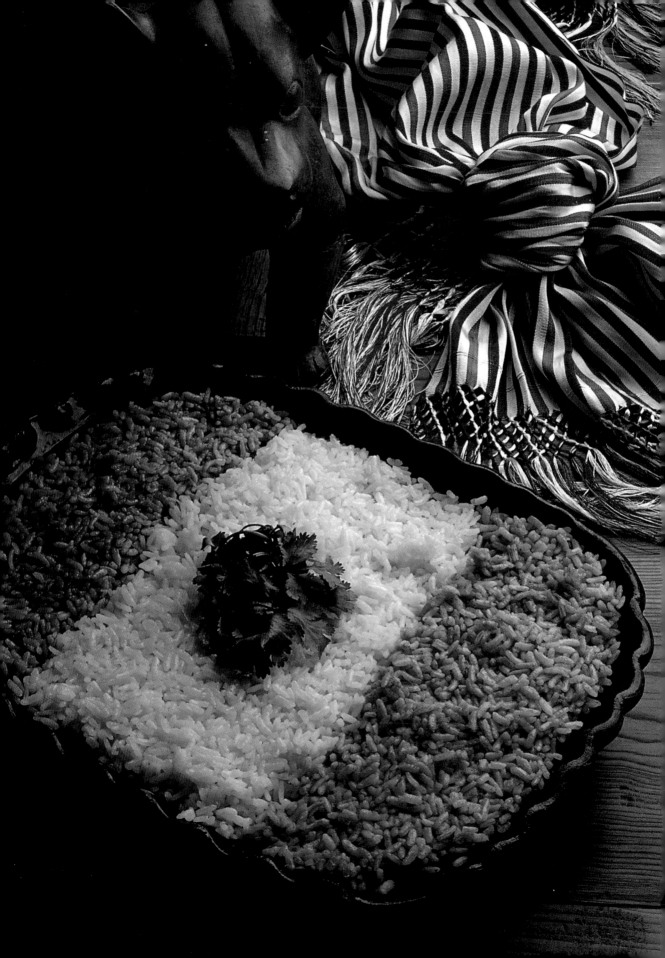

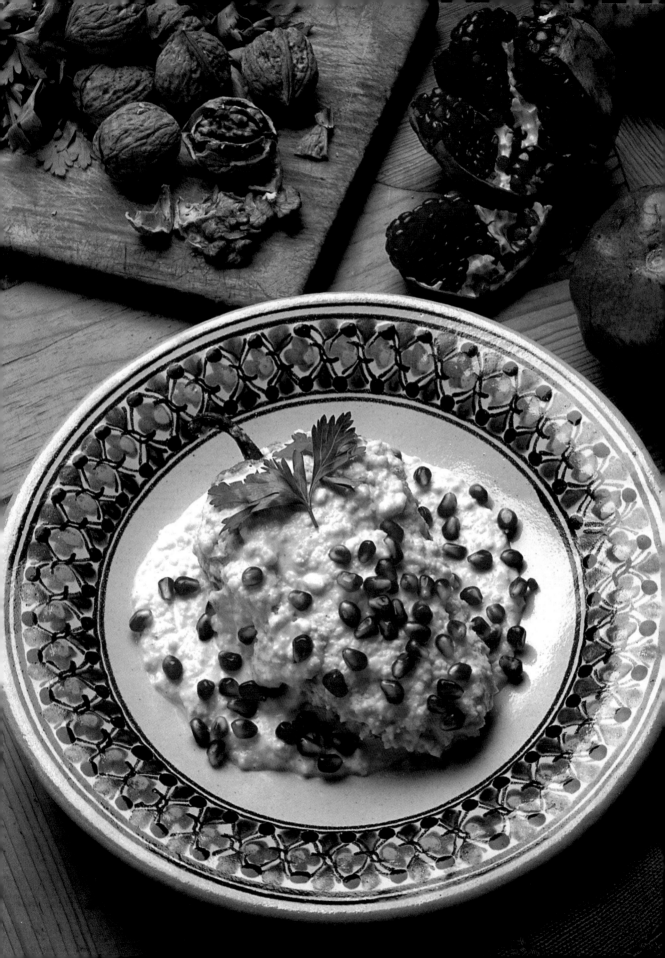

CHILES IN
WALNUT SAUCE
(6 servings)

12 poblano chiles, roasted,
seeded, and deveined

Flour

6 eggs, separated

1 teaspoon salt

Corn oil

3 pomegranates, seeded

Parsley

FILLING

2 pounds/1k ground pork

1 onion, quartered

2 garlic cloves

8 tablespoons/125g butter

1 medium onion, finely
chopped

4 cups/1l tomato puree

1 apple, peeled and
finely chopped

2 peaches, peeled and
finely chopped

2 plantains, peeled and
finely chopped

¼ cup/60g candied citron,
finely chopped

¼ cup/30g raisins

½ cup/70g blanched almonds,
coarsely chopped

1 tablespoon sugar

Salt and pepper

WALNUT SAUCE

2 cups/225g walnut halves

½ cup/70g blanched almonds

1 cup/125g queso fresco
(or feta)

½ cup/125ml half-and-half

¼ cup/60ml sherry

1 tablespoon sugar

1 teaspoon salt

Rinse the chiles and pat them dry. Spoon some of the filling inside each one, being careful not to overstuff. Spread the flour on a plate and turn each chile in the flour to coat lightly. Beat the egg whites until stiff. Beat the egg yolks with the salt. Gently fold the yolks and whites together to make a batter. Dip the chiles into the batter to cover completely.

Heat about ½ inch of oil in a heavy skillet. Fry the chiles, one or two at a time, until lightly browned. Drain on brown paper.

The chiles can be served cold or at room temperature. Dip the chiles in the Walnut Sauce until completely covered. Arrange the chiles on a platter. Cover with a little more sauce, if needed. Sprinkle with pomegranate seeds and sprigs of parsley.

To make the filling, place the pork, quartered onion, and garlic in a saucepan. Cover with water and boil for 20 minutes. Drain and set aside, discarding the onion and garlic.

Heat the butter in a large skillet and sauté the chopped onion for about 4 minutes, until translucent. Add the tomato puree and cook for 10 minutes, stirring occasionally. Add the meat, fruit, citron, raisins, almonds, sugar, and salt and pepper to taste. Cook over medium heat for about 10 minutes.

To make the Walnut Sauce, puree all the ingredients. If the sauce is too thick, add more half-and-half.

Opposite: Chiles en Nogada, *Chiles in Walnut Sauce, served on a* talavera *dish from Puebla.*

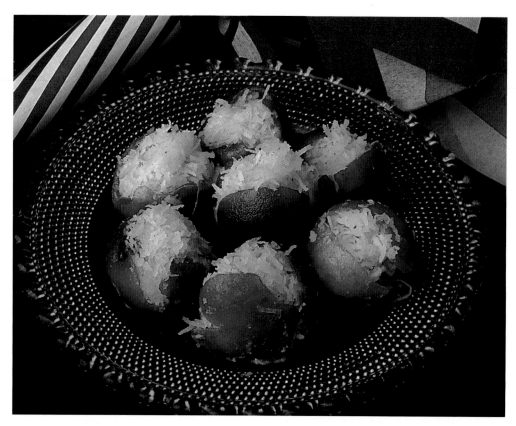

LIMES FILLED
WITH COCONUT

(8 servings)

16 limes
1 tablespoon baking soda
3 cups/570g sugar
3 cups/750ml water

COCADA
1 cup/190g sugar
1 cup/250ml water
**1 coconut, peeled and
finely grated**

In a nonreactive saucepan, simmer the limes in water to cover until slightly softened. Pour the contents of the saucepan into a clay pot. Sprinkle with the baking soda, cover, and let stand overnight. The next day, drain the limes. Cut a small slice from the tops and carefully hollow them out. Discard the pulp and return the limes to the clay pot with enough hot water to cover. Cover with a dish towel and a tight-fitting lid.

The next day, drain the water and replace it with fresh hot water. Let stand, covered, as above. Repeat this process for 3 or 4 days, until the limes are no longer bitter.

Combine the sugar and water in a copper

*Above: The Limes Filled with Coconut are arranged on a pressed
glass plate from Puebla.*

pot. Bring to a boil and add the limes. Simmer until the syrup is quite thick. Let cool overnight.

To serve, remove the limes from the syrup and fill with *Cocada*.

To make the *Cocada*, combine the sugar and water in a saucepan and bring to a boil. Stir in the coconut and cook, stirring constantly, until thick. Let it cool completely.

PRICKLY PEARS WITH ANISE

(8 servings)

16 white prickly pears, peeled and sliced in rounds

½ cup/125ml sweet anise liqueur

10 tablespoons/120g superfine sugar

Ground cinnamon

Arrange the prickly pear rounds on a serving platter. Drizzle with anise liqueur, sprinkle with sugar, and refrigerate for at least 1 hour. At serving time, dust with ground cinnamon.

JAMAICA FLOWER WATER

(8 to 10 servings)

3 cups/100g dried Jamaica flowers

16 cups/4 l water

1¼ cups/230g sugar

Rinse the Jamaica flowers thoroughly and drain well. Simmer with 8 cups/2 l of water for 10 minutes. Remove from the heat and let stand for 30 minutes. Strain, reserving the infusion and discarding the flowers. Combine with the remaining 8 cups/2 l of water and the sugar. Stir until the sugar dissolves. Serve cold or with ice.

RICE WATER

(8 to 10 servings)

3 cups/675g rice

3 cups/750 l milk

3 cinnamon sticks, broken in pieces and lightly toasted in a skillet

1¼ cups/230g sugar

6 cups/1,5 l water

Soak the rice in water to cover by at least an inch for 3 hours. Drain the rice and puree it with the milk and cinnamon. Strain the mixture, discarding the rice and reserving the liquid. Dissolve the sugar in the water. Combine the rice liquid with the sugared water. Serve cold or with ice.

LIME WATER

(8 to 10 servings)

1¼ cups/230g sugar

4 to 6 cups/1 to 1,5 l water

4 pounds/2k limes, juiced

Green food coloring

Combine the sugar and water and stir to dissolve. Add the lime juice and a few drops of green coloring. Serve very cold or with ice.

OCTOBER

Pico's Birthday

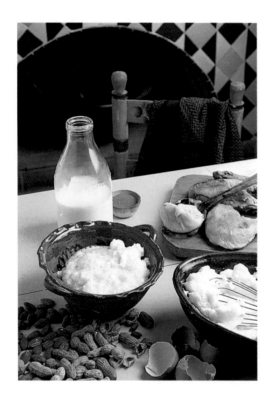

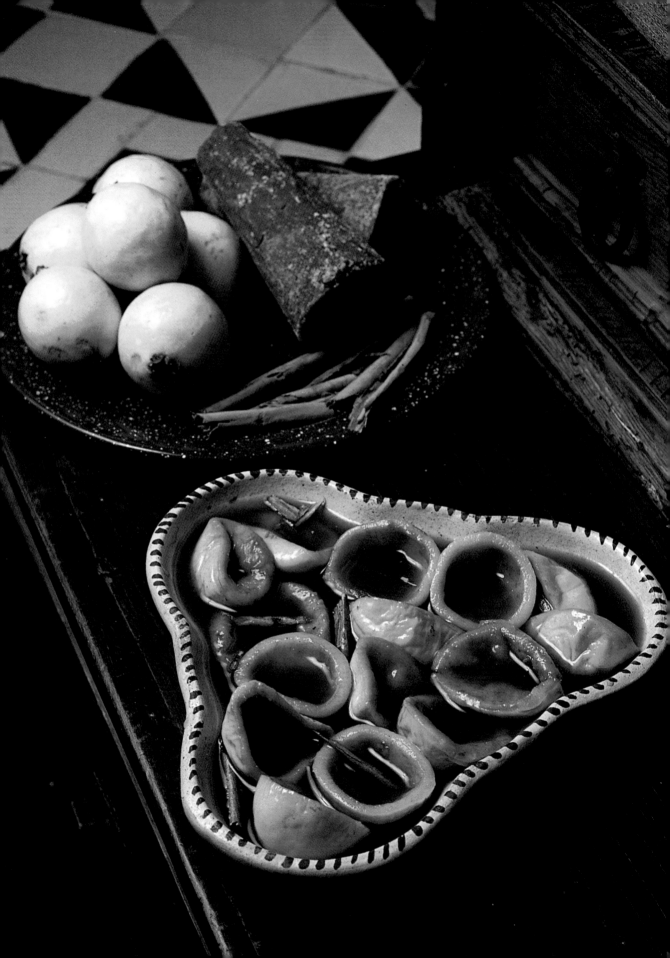

s the days passed, my already warm relationship with Frida grew deeper. I went home from the Law School for lunch every morning at about the time that Frida, who by then had finished painting for the day, was busy preparing the midday meal. On some days, my father would come back to the Blue House for lunch, but on other days Frida would send a basket of food over to his studio at San Angel.

The preparation of this box lunch was a ritual in itself. The blue pewter dinner pail was divided into compartments, each of which contained one of "Dieguito's" ("Little Diego's") favorite dishes. Frida would add freshly made tortillas and bread that was still warm and fragrant from the oven. She saved the fruits for last, using them with fresh-cut flowers to provide an ornamental touch. When Eulalia had brought tasty pulque from Ixtapalapa, "*la niña Fridita*" would include it in an earthenware jar. For a covering, Frida chose colorfully embroidered white napkins that featured floral themes and whimsical birds. Occasionally there was lettering, too, that spoke of love, with expressions like "*Felicidades mi amor.*"

When Frida felt bored and lonely she would carry the pail herself. Arriving at my father's studio, she would busy herself setting up a little table in some out-of-the-way corner. She would then share the contents of the basket with the Master. I always thought this was proof of the affection that Diego and Frida felt.

Toward the middle of the month, as my birthday drew near, I decided that the best way to celebrate was by inviting some of my university friends to dinner—in particular my boyfriend Luis Echeverría, who was at that time a leader of the student political movement and who later became president of Mexico. Given the intensity of our romantic involvement, I thought he should get to know my father. With typical adolescent bashfulness I told Frida of my idea, and she not only seconded it but also brought Diego around to our point of view.

There were eight of us college students, boys and girls, seated around the table dominated by the imposing figures of Diego and Frida. As usual, Master Rivera sat at the head of the table while Frida, at his right, kept an eye on the kitchen door. She orchestrated the entire affair by simply keeping an eye on that door.

Chucho, the handyman, acted as waiter. Dressed like a simple farmhand, his old felt hat pushed back on his head, he brought the food and cleared the table. It was clear to family and guests alike that he had had no training for this job, and when he nearly spilled the soup or dropped a plate on the floor there was nothing to be done about it.

That was the day my father tried to convince us that it was useless to study law. He employed his usual tactic of baiting his adversaries, claiming that in the future there would be no need for lawyers, because all differences of opinion would be resolved in a spirit of peace and harmony, as in the most ideal utopia.

Frida laughed at our shocked expressions, especially young Echeverría's, be-

Page 63: Some of the ingredients for Fried Chicken with Peanut Sauce (see recipe on page 73). Page 64: Guavas Poached in Syrup (see recipe on page 74) in a white hand-painted pottery dish from Tzintzuntzán.

cause she was especially fond of him. But Frida somehow managed to shield us from Diego's rantings; she may well have been remembering her own student days. My boyfriend was very serious and had little patience for jokes. In this he was like all of my friends, who were just beginning to take themselves seriously as students, with all the intellectual pretentiousness that this included. They found the dinner conversation very disconcerting.

Not surprisingly, each and every one of my father's remarks went off like a bombshell, and with each one I shrank a little farther into my seat. Fortunately, Frida intervened before things got too heated—and before I lost my boyfriend to political squabbles about which I cared very little. She started telling funny stories about her adventures in student politics, her opposition to the mural painters at the National Preparatory School, and the jokes she had once made about the recently repatriated painter Diego Rivera and his fiancée Lupe Marín. Little did she imagine that years later the three of them would have a life in common, and that the daughters of Diego and Lupe would eventually also be part of her life.

The jokes and gossip that Frida wove into her stories had the effect of calming everyone down. The dinner, which could have had truly tragic consequences for my love life, came to a peaceful end, and our hostess invited us all to have coffee and pastries in her studio. This transition removed us from the political arena of the university to the world of Frida's imagination, where life and violent death were one and sexual symbolism took the form of strange, disturbing flowers and fruits.

The unease we felt in the presence of her work became more pronounced when she showed us the most powerful of her paintings. In these pieces it was not the sexual symbolism that disturbed us so much as the expression of Frida's profound solitude and pain, which made it impossible for her to experience a fulfilling love. But in the end, thanks to the wonderful food prepared by the lady of the house —especially the old family recipes—my birthday was a success.

Frida made a superb stew of pork, liver, and kidneys in a sauce of pulque and serrano chiles. My grandmother Isabel had invented this dish and made it for the peasants who worked in her father's fields in Zapotlán el Grande, in the state of Jalisco, the ancestral seat of the Preciado and Marín families. The rest of the recipes for that dinner came from the same area: *jocoque* soup, macaroni with spinach sauce, chicken with nut sauce. For dessert there were guavas and doughnuts and a special quince paste with almond cookies.

Overleaf: On the patio of the Blue House, a lunch basket such as one Frida would prepare for Diego while he was painting murals. **Pages 70–71:** *Macaroni with Spinach Sauce (see recipe on page 72).*

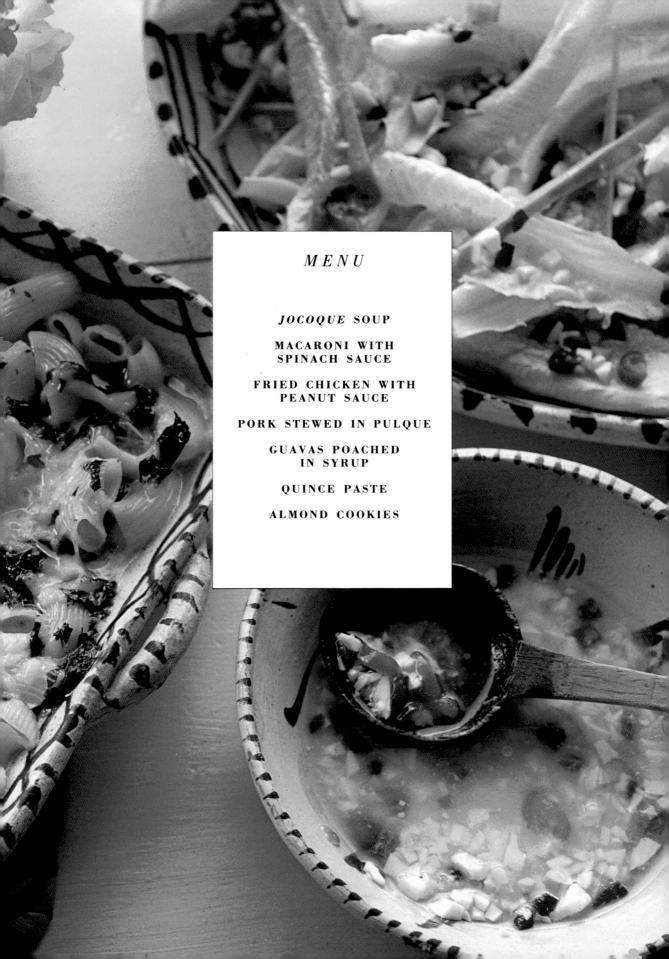

MENU

JOCOQUE SOUP

MACARONI WITH
SPINACH SAUCE

FRIED CHICKEN WITH
PEANUT SAUCE

PORK STEWED IN PULQUE

GUAVAS POACHED
IN SYRUP

QUINCE PASTE

ALMOND COOKIES

JOCOQUE SOUP

(8 servings)

JOCOQUE TORTE

2 egg whites

4 egg yolks

2 cups/500 ml *jocoque*
(or sour cream)

4 tablespoons/30g flour

2 tablespoons/30g sugar

Salt

BROTH

1 medium onion, thinly sliced

½ pound/225g carrots, peeled
and sliced in thin rounds

4 tablespoons olive oil

½ pound/225g zucchini, sliced
in thin rounds

2 large tomatoes, roasted,
peeled, pureed, and strained

2 parsley sprigs

2 oregano sprigs

2 quarts/2 l chicken broth

To make the Jocoque Torte, lightly beat the egg whites and yolks together. Combine with the *jocoque*, flour, sugar, and salt to taste. Pour in a greased rectangular or square pan. Set the pan in a shallow pan of hot water. Bake in a preheated 350°F/175°C oven for about 20 minutes. The torte is done when a toothpick inserted in the center comes out clean.

At serving time, unmold the torte and cut into 8 squares. Place the squares in a soup tureen and cover with the broth. Or place each square in an individual soup bowl and top with the broth.

To make the broth, sauté the onion and car-

rots in olive oil until the onion is translucent. Add the zucchini and sauté a minute more. Add the tomatoes and continue to cook until thickened. Add the parsley, oregano, and chicken broth and boil for 5 minutes.

MACARONI WITH SPINACH SAUCE

(8 servings)

3 pounds/1,500g fresh spinach

Salt and pepper

3 to 4 serrano chiles, chopped

3 tablespoons butter

3 tablespoons flour

2 cups/500ml hot milk

1 cup/250ml cream

2 pounds/1k macaroni

1 cup/120g grated
parmesan cheese

Wash the spinach thoroughly and discard the stems. Cook the spinach (with the water that clings to leaves) with salt to taste and the chiles. Remove from the heat, cool slightly, and puree.

Melt the butter, stir in the flour and cook briefly. Add the milk, cream, and salt and pepper to taste, stirring with a whisk so the mixture will not lump. Let the sauce thicken for a few minutes, then stir in the spinach puree.

Cook the macaroni in boiling, salted water until al dente. Drain thoroughly. Pour some of the spinach sauce on the bottom of a buttered ovenproof dish. Add the macaroni and the remaining sauce. Sprinkle with grated cheese and bake in a preheated 350°F/175°C oven for 20 minutes, until the cheese is golden brown.

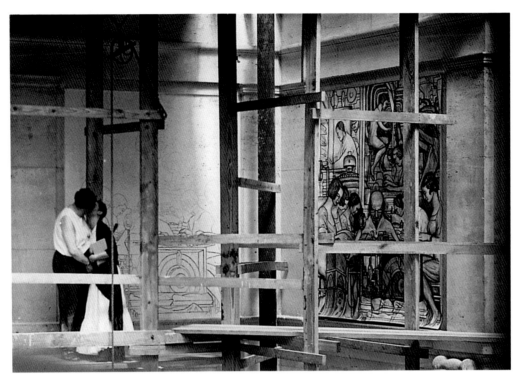

FRIED CHICKEN WITH PEANUT SAUCE

(8 servings)

2 chickens, cut in parts

Salt and pepper

Lard or corn oil

6 eggs, separated

2 cups/240g cracker crumbs

Ground cinnamon

PEANUT SAUCE

1 cup/150g peanuts, roasted and peeled

1 cup/150g blanched almonds

1 quart/1 l milk

1 or 2 tablespoons sugar

Salt

Season the chicken with salt and pepper to taste. Fry in an inch of hot lard or oil, turning occasionally, until golden and cooked through. Drain on brown paper.

Beat the egg yolks until thick. Beat the egg whites until stiff and combine with the yolks to make a batter. Coat the chicken parts with cracker crumbs, then dip into the batter. Fry briefly in the lard and drain on brown paper.

To make the sauce, puree all the ingredients and strain. Simmer in a skillet until hot.

Place the chicken in the sauce and simmer for a few minutes. Turn onto a serving platter, dust with cinnamon, and serve.

Above: Diego and Frida embrace on the scaffolding in front of Diego's Detroit murals.

PORK STEWED
IN PULQUE

(8 servings)

2 pounds/1k boneless
loin of pork

1½ pounds/750g pork liver

8 small veal kidneys

Salt

2 tablespoons lard or corn oil

2 onions, chopped

3 pounds/1,500g tomatoes,
peeled, seeded, and chopped

8 serrano chiles, chopped

1 teaspoon dried marjoram

10 allspice berries

¼ cup/30g chopped parsley

4 cups/1 l pulque (or beer)

1 tablespoon sugar

Cut the pork, liver, and kidneys into medium

chunks. Cook the pork chunks in water to cover until tender, about 45 minutes. In a separate pan, cover the liver and kidneys with water and bring to a boil. Drain the liver and kidneys and add them to the pork. Add salt to taste and simmer until all the meats are tender, about 20 minutes.

Heat the lard and sauté the onions until translucent. Add the tomatoes, chiles, marjoram, allspice, parsley, pulque, and salt to taste. Cook about 15 minutes. Add the stewed meats and sugar and cook for 10 minutes, or until the sauce has thickened and the flavors are blended.

GUAVAS POACHED
IN SYRUP

(8 servings)

1 pound/450g *piloncillos*,
chopped (or 2½ cups dark
brown sugar)

Above: Slices of Quince Paste alternate with slices of panela
cheese on a wooden board.

2 cinnamon sticks

4 cups/1 l water

**4 pounds/1,800g not-too-ripe
guavas, peeled, halved,
and pitted**

In a large saucepan, heat the *piloncillos* and cinnamon in the water, stirring until the sugar dissolves and the syrup comes to a boil. Add the guavas. Let the mixture simmer until the guavas are tender and the syrup has thickened, about 20 minutes. Serve cold or at room temperature.

QUINCE PASTE

(8 servings)

2 pounds/1k quinces

4½ cups/850g sugar

2 cups/500ml water

Wash the quinces thoroughly and cut in quarters. Place in a saucepan with water to cover and simmer until tender, about 45 minutes. Drain, peel, and remove the cores, then puree in a blender while still warm.

Combine the sugar and water in a deep saucepan. Cook, stirring constantly, until the sugar dissolves. Continue to cook, without stirring, until a candy thermometer registers 235°F/115°C or until a small amount of syrup, when dropped into cold water, forms a soft ball. Add the quince puree and stir constantly until mixture pulls away from the pan, about 1 hour longer.

Pour mixture into molds. Let stand about 4 days. Unmold the paste, and, if possible, let stand in the sunshine so it will dry and set.

Note: This is a very popular dessert that is generally served with slices of panela cheese. You could use Monterey Jack or cream cheese.

ALMOND COOKIES

(8 servings)

2 cups/280g flour

1½ cups/280g cornmeal

2¼ cups/400g sugar

**1⅓ cups/200g blanched
almonds, toasted and ground**

**14 ounces/420g butter,
softened**

6 egg yolks

**50 blanched almonds
or raisins**

FRENCH MERINGUE

4 egg whites

**¾ cup/60g confectioners'
sugar, sifted**

Sift the flour and cornmeal onto the counter or into a bowl. Make a well in the center and add the sugar, ground almonds, butter, and egg yolks. Knead all the ingredients together to form a dough. Shape bits of dough into little balls and place on buttered baking sheets. Press an almond or a raisin in the center of each ball and bake in a preheated 350°F/175°C oven for 15 to 20 minutes, until golden. Let cool, then top each cookie with a dollop of French meringue and an almond or raisin.

To make the French meringue, beat the egg whites until stiff and gradually fold in the confectioners' sugar.

NOVEMBER

The Day of the Dead

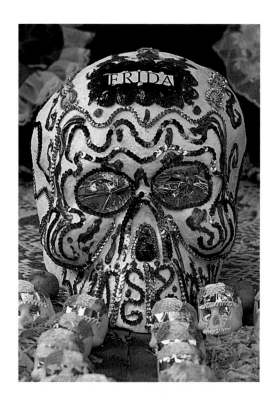

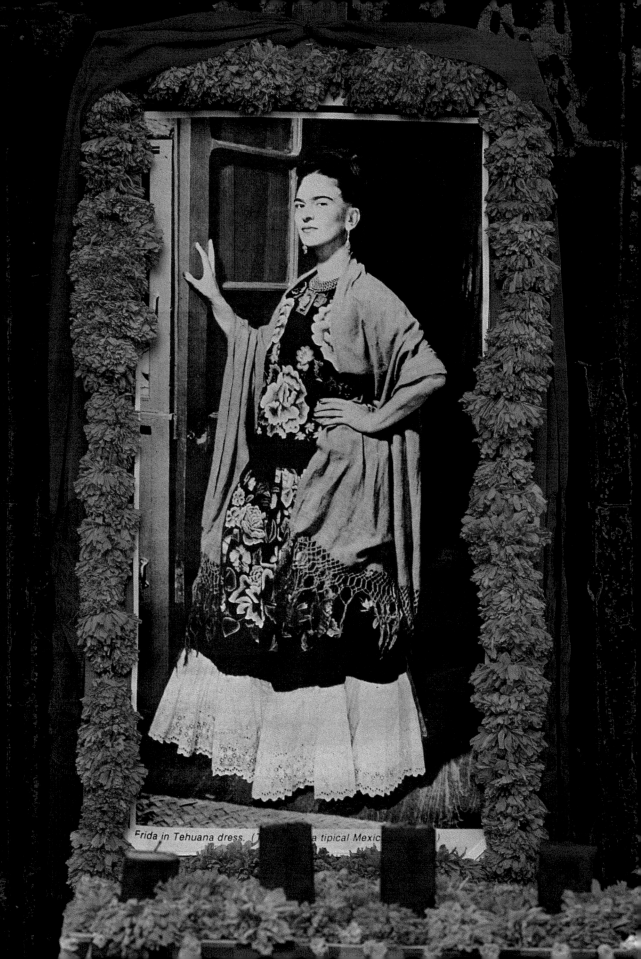

Frida in Tehuana dress. (T... a típical Mexic...)

n the last day
of October, the Blue House moved into high gear. The
night before, Inés the carpenter had put the finishing
touches on the table that would hold our offerings to
the family dead, among them Frida's mother, donã
Matilde. This was in keeping with one of the Mexican
people's most ancient and deeply rooted customs.

Since donã Matilde had been born in Oaxaca,
Frida asked the carpenter to build the table according

to the custom of that beautiful southern state, and Inés followed the instructions to the last detail. The holiday would take place on two consecutive days: November 1, which honors the dead children of the family, and November 2, the Day of the Dead, also known as the Day of the Faithful Departed.

Inés had begun cutting zempazuchitl flowers from the family garden on the night of October 31. Some of these he scattered over the table, so that "when the little angels return they will be greeted by the brilliance and shining colors of these flowers the color of the sun." He strung other flowers together into garlands which he then placed on three wooden chests already decorated with golden flowers. The chests stood at the head of the table.

"Fridu," as I liked to call her, had already been to the Coyoacán market for the necessities: fruit for the punch, chiles and other ingredients for the moles. She also bought tamales and other dishes dear to her mother, since popular belief had it that the family dead, doña Matilde among them, would come on November 2 to enjoy their favorite foods, which should be properly prepared and attractively served.

In the afternoon Frida and I went to the old Merced neighborhood in the center of town to collect her friend Carmen Sevilla, a great artist with papier-mâché. Her ca-laveras (sugar skulls) and dancing skeletons were valued by connoisseurs of this popular genre as authentic works of art.

Frida decorated the offering table with the smallest of the dancing skeletons and sugar figurines of lambs, chickens, bulls, and ducks, along with other cala-veras. The ones that Carmen Sevilla had made decorated the dining room walls and Frida's studio. The house was transformed into a place where death was an object of wonder and respect, but also something we lived with every day.

The first day of the festival Eulalia placed children's food on the table—mugs of atole, plates of beans and mildly seasoned food, fruit and sweets. Frida provided dessert: sugar paste candies, pumpkin smothered in traditional brown sugar syrup, and sugar skulls with the names of the family dead written on their heads in sugar letters.

Year after year the confectioners made sugar skulls in all sizes, from truly astonishing life-size ones to bite-size miniatures for the children. Frida bought four of the largest and had the names of Matilde, Guillermo, Diego, and Frida written on them as a tribute to her parents, her husband, and herself. The names of the adult members of Frida's family were written on medium-size skulls, while the smallest bore the names of Isolda and Toñito (her

Page 77: A calavera *decorated with Frida's name.*
Page 78: *The centerpiece of a Day of the Dead offering for Frida.*

sister Cristina's children), Ruth and Lupe —the four youngest people in the house. Huge pumpkins were decorated with little silver and gold flags, and the center of the table was occupied by a Oaxaca platter piled with Frida's mother's favorite fruits and nuts in season: sugar cane, limes, mandarin oranges, peanuts, and jícamas. These, too, were decorated with little colored flags. Finally, Frida placed sugar paste figurines here and there on the table and, for the final touch, set candles at the four corners of a mock grave fashioned of paper flowers.

The following day, November 2, the altar was dedicated to the Faithful Departed, with special attention to doña Matilde. Early in the morning Frida placed a picture of her mother on the mock grave. This was her part in the ritual. It fell to Inés and Eulalia to remove the offerings to the children and replace them with adult food and sweets.

Traditional foods were served throughout the day. Breakfast consisted of *atole* and chocolate, Dead Man's Bread, cookies in the shape of little bones, beans, tortillas and pasilla chile sauce, along with the brown corn *tlacoyos* that Matilde Kahlo had so enjoyed. The midday meal consisted of yellow and red moles, Oaxacan beef jerky, red rice with dried shrimp, chicken sautéed in chile pipián, pumpkin in syrup, sweet potatoes in *sancocho*, tamales in plantain leaves, white *atole* and fresh fruit.

At that time Frida was teaching painting at La Esmeralda, a public art school dedicated to furthering the tradition of Mexican mural painting. Some of Frida's students were painting the exterior walls of a small pulque shop at the corner of Centenario and Londres Streets in Coyoacán. "*La Rosita*" ("Rosy"), as the owner of the *pulquería* was known, had agreed to let Frida's students Estrada, Bustos and Fanny Rabel use her walls to practice mural painting.

The students paid Frida a visit on November 3. She was quite proud of the offering and invited them in to see it and to eat their share of the food that was left on the table "after the departed had paid their respects." It was traditional for the living to finish the remaining food and sweets, down to wiping the plates clean.

Contrary to the usual practice, on this Day of the Dead alcoholic beverages were allowed. Frida's students contributed a delicious fresh pulque that the owner of the *pulquería* had insisted they take to their illustrious teacher. Frida also urged people to drink whisky and brandy, a practice she had picked up in New York and Paris. But when my father returned home, Frida switched to drinking tequila.

Overleaf: For the Day of the Dead, a corner of the Diego Rivera Studio Museum was transformed with a special offering for Frida.

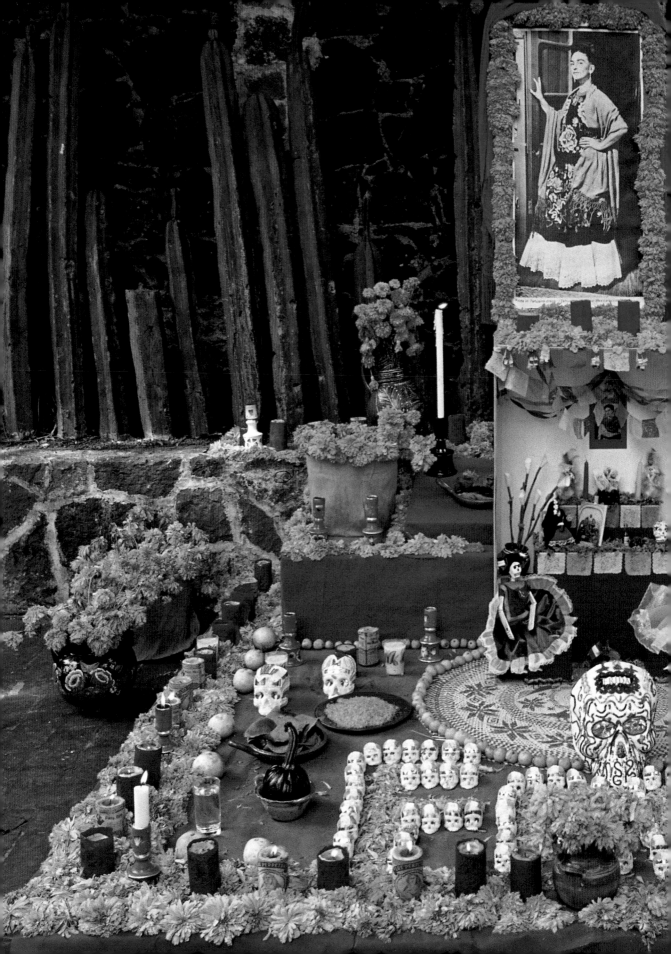

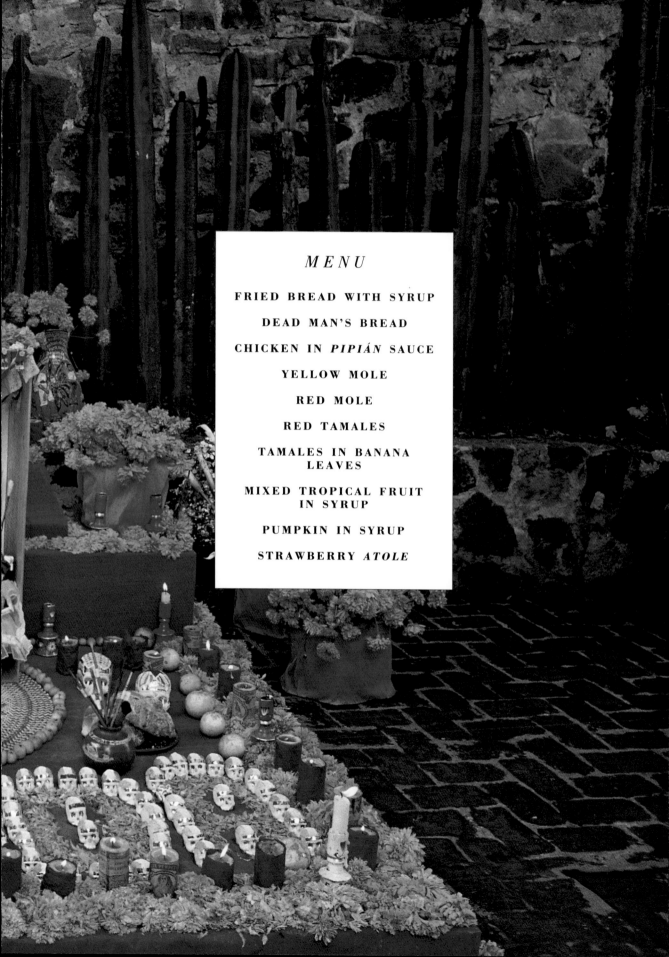

MENU

FRIED BREAD WITH SYRUP

DEAD MAN'S BREAD

CHICKEN IN *PIPIÁN* SAUCE

YELLOW MOLE

RED MOLE

RED TAMALES

TAMALES IN BANANA LEAVES

MIXED TROPICAL FRUIT IN SYRUP

PUMPKIN IN SYRUP

STRAWBERRY *ATOLE*

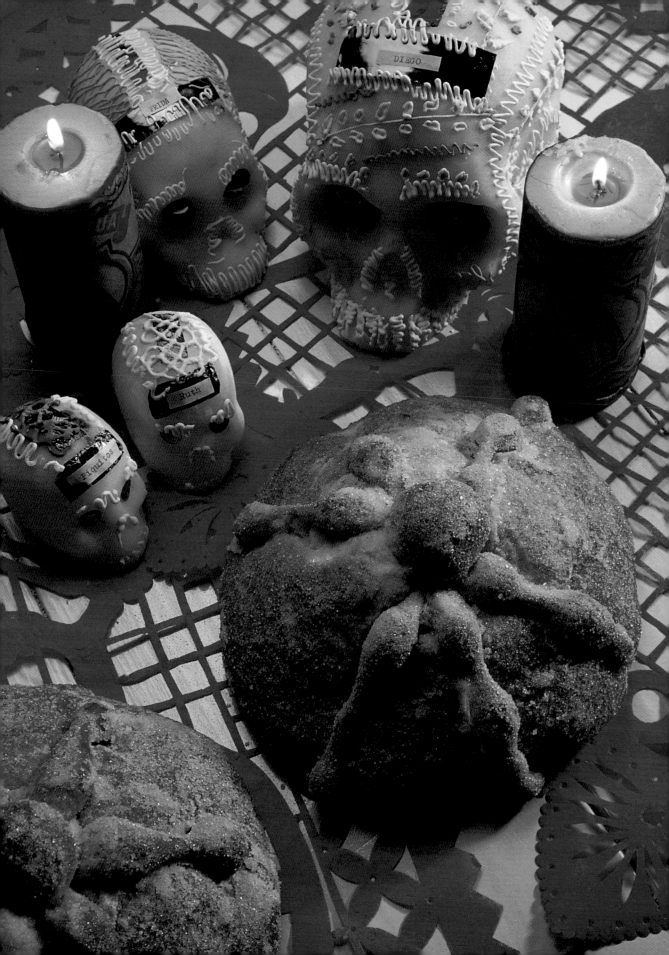

FRIED BREAD
WITH SYRUP

(8 servings)

1 loaf egg bread, preferably
a day old

2 cups/500ml warm milk

3 tablespoons sugar

3 eggs

Oil

SYRUP

½ cup/100g sugar

2 cups/500ml water

1 cinnamon stick

1 star anise

1 cup/250ml white wine

Cut the bread in ¾-inch slices. Arrange in a deep bowl. Combine the warm milk and sugar and pour over the bread. Soak for 20 minutes.

Beat the eggs lightly as for an omelet. With a slotted spoon, remove each bread slice from the milk mixture, dip in the beaten eggs, and fry in hot oil until golden. Drain on brown paper. Arrange the fried bread slices on a large serving platter and pour the hot syrup over them.

To make the syrup, cook the sugar with the water, cinnamon, and anise for about 8 minutes. Stir in the wine and cook for 5 minutes more. Remove from the heat and cool slightly.

Note: For the egg bread, you can use the recipe for Dead Man's Bread. Instead of making balls, fill loaf pans about two-thirds full with the dough, let rise for 1½ hours, then bake for

about 40 minutes until the bottoms sound hollow when tapped.

DEAD MAN'S BREAD

(30 pieces)

7½ cups/1k flour, sifted

2 cups/400g sugar, plus
additional for dusting

1 cup plus 2 tablespoons/250g
vegetable shortening or butter

2 packages active dry yeast
dissolved in 5 tablespoons
warm milk

12 small eggs

1 tablespoon lard

2 teaspoons ground cinnamon

2 teaspoons vanilla extract

½ cup/125ml milk

Mound the flour on the counter or in a bowl and make a well in the center. Place the sugar, shortening, yeast, eggs, lard, cinnamon, vanilla, and milk in the well. Work into a dough and knead until the dough pulls away from the counter. If the dough is too soft, knead in more flour. Shape into a ball, grease and flour it lightly, and place in a greased bowl. Let stand in a warm place for 2½ hours, or until doubled. Cover with a towel and refrigerate overnight.

Shape the dough into balls the size of a peach. Decorate the tops with strips of dough to look like bones. Place the rolls on greased baking sheets and let rise in a warm place for about 1½ hours, or until doubled in bulk.

Dust with sugar and bake in a preheated 350°F/175°C oven for 30 minutes, or until the bottoms sound hollow when tapped.

Opposite: *Dead Man's Bread and* calaveras
for the Day of the Dead.

CHICKEN IN *PIPIÁN* SAUCE

2 chickens, cut into parts

6 cups/1,5 l water

2 carrots, cut in half
lengthwise

1 onion, quartered

2 garlic cloves

1 bay leaf

1 celery stalk

2 parsley sprigs

4 teaspoons salt

4 black peppercorns

SAUCE

1 cup/150g sesame seeds

1 cup/150g blanched almonds

1 tablespoon corn oil or lard

2 teaspoons powdered
chicken bouillon

6 güero chiles

¾ cup/170g olives

2 teaspoons capers

Cook the chicken with the water, vegetables, and seasonings in a large saucepan until tender. Strain, reserving the broth. Skin and bone the chicken.

To make the sauce, toast the sesame seeds lightly in a skillet, stirring constantly. Puree the sesame seeds with the almonds and 2 cups of the chicken broth. Heat the oil, add the blended mixture, and cook for 5 to 8 minutes, until thickened. Add 2 to 3 more cups of the broth and the chicken bouillon and simmer for 5 minutes more. Add the chiles, olives, capers, and chicken. Simmer for 10 minutes more and serve piping hot.

YELLOW MOLE

(8 servings)

2 pounds/1k boneless pork

2 pounds/1k pork bones

6 cups/1,5 l water

1 carrot, cut in half

2 onions, cut in half

3 garlic cloves

4 teaspoons salt

4 black peppercorns

SAUCE

18 guajillo chiles

½ cup/125ml water

2 pounds/1k tomatillos, peeled

3 green tomatoes, chopped

2 garlic cloves, peeled

1 onion, chopped

3 tablespoons lard or corn oil

5 *acuyo (hierba santa)* leaves

1 avocado leaf

Salt

1 pound/500g green beans,
ends trimmed

6 zucchini, cut in strips

DUMPLINGS

¼ pound/125g lard

½ pound/250g masa harina

Salt

Cook the pork meat and bones in water with the vegetables and seasonings until tender, about 1 hour. Strain, reserving the cooking liquid. Slice the meat.

To make the sauce, roast the chiles on a griddle. Remove the seeds and veins. Boil in

the water for about 3 minutes. Let stand for 10 minutes, drain, and puree with the tomatillos, green tomatoes, garlic, onion, and 1½ cups pork broth. Heat the lard in a saucepan until very hot. Add the pureed mixture, the *acuyo* leaves, avocado leaf, and salt to taste. Cook for 20 minutes over low heat, adding more broth if needed. Add the green beans, zucchini, and dumplings, and continue to cook for 20 minutes more, or until vegetables are tender.

To make the dumplings, beat the lard thoroughly with the masa harina and add salt to taste. Shape into small balls and use your finger to poke a hole in the center of each.

RED MOLE

(8 servings)

3 pounds/1,500g loin of pork

1 onion, quartered

1 garlic clove

1 bay leaf

Salt

SAUCE

8 ancho chiles

8 guajillo chiles

3 tomatoes, roasted and peeled

8 allspice berries

3 cloves

1 cinnamon stick

⅔ cup/90g sesame seeds, toasted

1 ripe plantain, peeled and cut into chunks

1 medium onion, chopped

3 tablespoons lard

Salt

3 acuyo (*hierba santa*) leaves, chopped

8 medium potatoes, peeled and cut in cubes

DUMPLINGS

½ pound/250g masa harina

¼ pound/125g lard

Salt

Combine the pork, onion, garlic, bay leaf, and salt to taste in a saucepan, and add enough water to cover. Cook until the meat is tender, about 1 hour. Drain the meat, let cool slightly, and slice. Reserve the broth.

To make the sauce, roast the chiles on a griddle for a few seconds. Remove the seeds, then soak for 20 minutes in very hot water. Puree the chiles with their soaking water and strain. Puree the tomatoes, allspice, cloves, cinnamon, two-thirds of the sesame seeds, and the plantain. Strain.

Sauté the onion in hot lard until translucent. Add the tomato mixture and cook for 5 minutes more. Add the chiles and salt to taste. Cook for 5 minutes more. Add the *acuyo* leaves, cubed potatoes, and enough of the meat broth to make a medium-thick sauce. Cook about 20 minutes until the potatoes are tender. Add the sliced meat. Gently stir in the dumplings. Cook for 10 minutes more. To serve, sprinkle with the rest of the sesame seeds.

To make the dumplings, beat the masa harina thoroughly with the lard and salt to taste. Shape into little balls and poke a small hole with your finger in the center of each.

Overleaf: Red Mole *(recipe this page) and Chicken in* Pipián *Sauce (recipe opposite).*

RED TAMALES

(8 to 10 servings)

FILLING

1 pound/500g boneless pork,
cut in chunks

4 garlic cloves, peeled

1 onion peeled

2 ounces/60g ancho chiles,
seeds removed

2 cups/500ml hot water

1 tablespoon lard

Salt

MASA

2 pounds/1k masa harina

¾ cup plus
2 tablespoons/200g lard

2 teaspoons baking powder

Salt

40 dried corn husks, soaked in
cold water and drained well

Place the meat in a saucepan with water to cover. Add 2 of the garlic cloves and the onion. Cook, covered, until tender, about 45 minutes. Drain, reserving the broth. Shred the meat and set aside.

Soak the chiles in the hot water for 10 minutes. Puree with the remaining 2 garlic cloves. Sauté the puree in hot lard for 3 minutes. Add the shredded meat, season with salt to taste, and cook for 3 minutes more, until thickened.

To prepare the masa, beat the masa harina with 1 cup of the pork broth for 10 minutes. In another bowl, beat the lard very thoroughly until spongy. Add to the beaten masa harina with the baking powder and a tablespoon of salt. Beat well. Spread 1 tablespoon of this mix-

ture on each corn husk and top with a small amount of the pork filling. Fold the long edges of the husks toward the center to enclose the filling, then fold the ends up to shape each tamale into a tightly wrapped package.

Pour water into a *tamalera* or large steamer. Place a layer of corn husks on the bottom, then stand the filled tamales upright around the edge of the steamer. Cover and cook for 1 hour, until the tamales are cooked through. To test, remove and open a tamale; the filling should separate easily from the husk.

TAMALES IN
BANANA LEAVES

(8 servings)

FILLING

1 pound/500g boneless pork
or chicken

2 onions

2 garlic cloves

Salt

1 tablespoon corn oil or lard

2 cups/1k pureed tomatoes,
drained

3 tablespoons chopped
cilantro

TAMALES

1 pound/500g masa harina

½ cup/125g lard

Salt

3 large banana (or plantain)
leaves

Place the meat in water to cover, with 1 onion cut in half, 1 garlic clove, and salt to taste. Cook slowly until very tender. Let cool, drain,

and shred the meat with two forks.

Heat the oil in a large saucepan. Sauté 1 finely chopped onion and 1 minced garlic clove until translucent. Add the meat and sauté for 2 minutes. Add the tomatoes, cilantro, and salt to taste. Simmer for about 10 minutes, until the tomato is well cooked and thickened.

To make the tamales, set aside 2 tablespoons of the lard. Beat the masa harina with the remaining lard and salt to taste for about 5 minutes, until the mixture is spongy.

Hold the banana leaves over an open flame for a few seconds until they soften and become pliable. Cut 1 large leaf into 6-inch squares. Grease the outside surface of the squares with the reserved lard. Place a portion of masa on each square and top with 1½ tablespoons of the filling. Fold the edges of the squares toward the center, enclosing the filling and making a tightly wrapped rectangular package. If you like, tie each one with a strip of leaf.

Place a layer of leaves in the bottom of a *tamalera* or large steamer. Cover the leaves with water. Arrange the tamales in the *tamalera* or steamer, cover, and steam for 1 hour, until cooked through.

Above: *A dish of Tamales in Banana Leaves.*

MIXED TROPICAL
FRUIT IN SYRUP

(8 servings)

½ pound/250g *piloncillo*, cut
in chunks (or 1¼ cups dark
brown sugar)

4 cups/1 l water

1 cinnamon stick

12 large *tejocotes*

4 3-inch pieces sugar cane,
peeled and cut in strips

3 oranges, peeled and sliced

6 guavas, cut in half
and seeded

Boil the sugar, water, and cinnamon for about
15 minutes, until the mixture thickens slightly.
Add the fruit and cook for 15 minutes more or
until the fruits are tender. Remove from the
heat and cool completely before serving.

PUMPKIN IN SYRUP

(8 to 10 servings)

1½ cups/370ml water

4 pounds/2k *piloncillo* (or
10½ cups dark brown sugar)

1 pumpkin
(about 10 pounds/4,5k)

Combine the water and sugar in a saucepan.
Cook over low heat, stirring often, to make a
syrup.

Peel the pumpkin and cut it in chunks. Re-
move the fibers and seeds. Score the pulp in
diamond shapes. Arrange the pumpkin chunks
in a large enamel saucepan, placing the first
layer skin side up and the remaining layers skin

side down. Add the syrup, cover, and cook over
medium heat for about 2½ hours, until the
pumpkin is well soaked in syrup and has turned
a deep caramel color.

STRAWBERRY *ATOLE*

(8 servings)

1¼ cups/170g masa harina

6 cups/1,5 l water

2 cups/225g strawberries,
washed and hulled

¾ cup/140g brown sugar

Dissolve the masa harina in 4 cups of the water.
Let stand for 15 minutes. Strain.

Puree the strawberries with 2 cups of water
and the sugar. Drain.

Combine both mixtures in a large saucepan
and cook, stirring constantly, until thickened.
Serve piping hot.

Above: *Strawberry* Atole *in a hand-decorated
mug and plate from Guanajuato.* ***Opposite:*** *Mixed
Tropical Fruit in Syrup.*

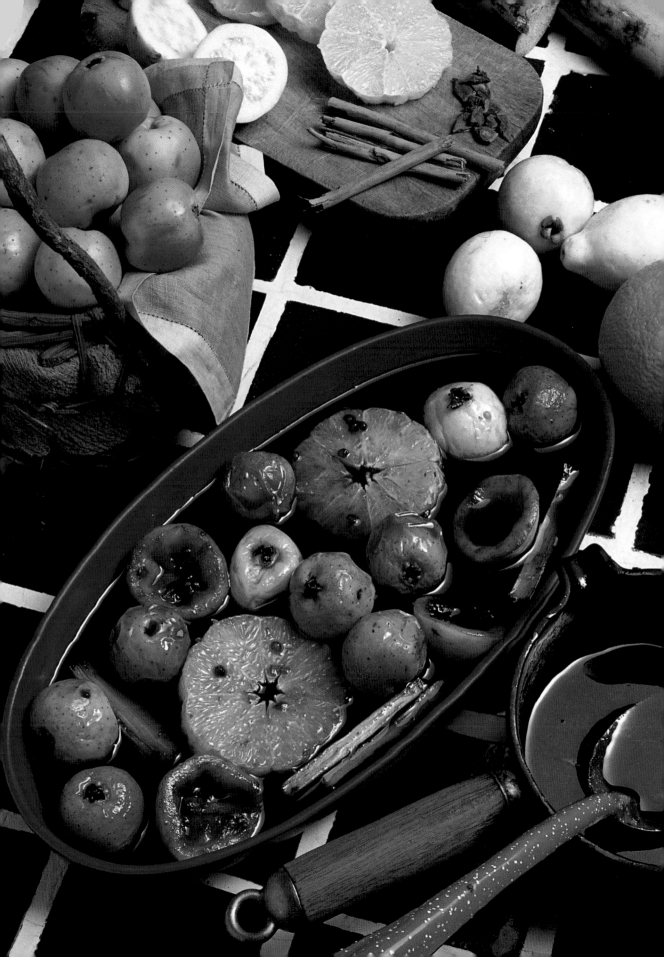

DECEMBER

The *Posadas*

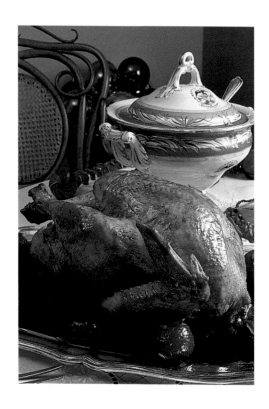

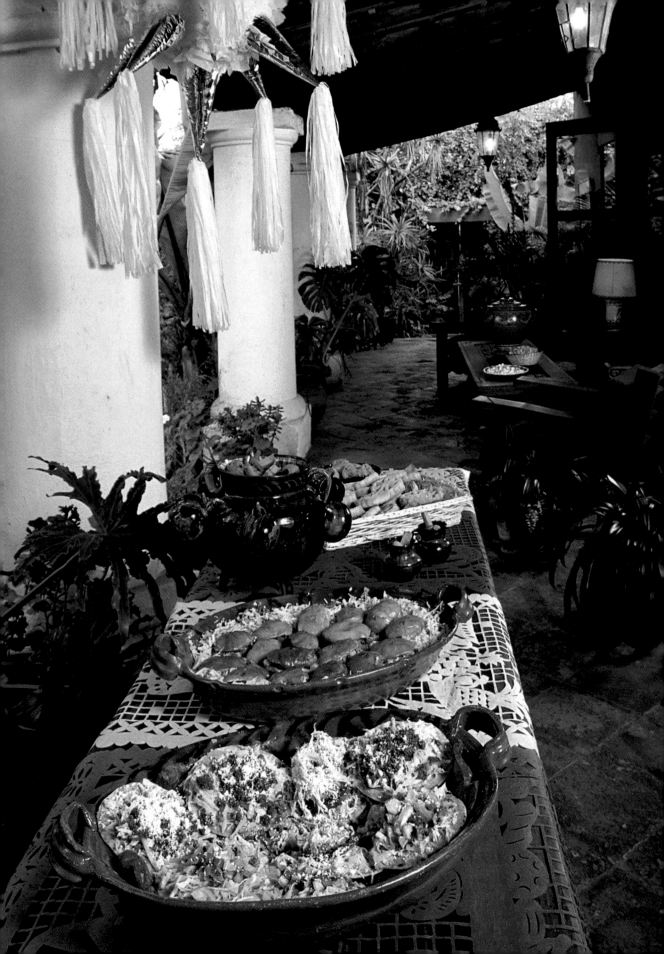

rida grew up in Coyoacán in the cloistered religious atmosphere of turn-of-the-century Mexico. Then as now a series of celebrations took place beginning on December 12, the feast day of the Virgin of Guadalupe, patron saint of Mexico. These festivities are part religious and part secular, but they all have to do with the cult of Mary and the birth of her son, Jesus. In the Blue House December was particularly festive because of the fuss

made over Diego Rivera's birthday on December 8, which is also the feast of the Immaculate Conception. Some of Diego's friends called him "Concho" in keeping with the tradition of naming boys and girls born on this day "Concho" and "Concha," the male and female diminutives of "Concepción."

From December 16 to Christmas Eve there was a celebration every night in one neighborhood or another of Coyoacán. In these festivities, called *posadas* (literally, "inns"), children and adults enacted rituals that were part secular, part religious. Afterwards, they broke piñatas. Then sweets and traditional toys were handed out and a special meal was served. On December 24—*Noche Buena* in Spanish—it was customary to eat a special Christmas salad and *guajolote*, as the turkey is called in Mexico. In the past the meal was served after midnight mass. The thanksgiving mass, also called "the rooster's mass," was held on December 31; it was customary to serve the dinner after twelve o'clock, so that one could bring in the New Year by eating twelve grapes in rapid succession, one for each stroke of midnight.

The next holiday took place on January 6. This was the feast of the Epiphany, featuring the *rosca de Reyes* (Epiphany cake). Whoever found the miniature baby Jesus

in his slice was obliged to host the tamale dinner on Candlemas, February 2.

Frida was delighted by all of the year-end festivities; perhaps they brought back happy memories. Whatever the reason, during the time I lived with her and my father she followed the traditional practices down to the last detail.

In the winter of 1942 Frida was very far from neglecting the *posadas*, *roscas*, and neighborhood children. She took special care in celebrating each and every one of the December holidays. From Diego's birthday to February 2, the doors of the Blue House stood wide open to children, neighbors, the rowdy Kahlo family, and any friends who lived in the area.

On the day before the first of the *posadas* that Frida organized in 1942, we made the customary visit to La Merced market, where we purchased three piñatas, shaped like a boat, a star, and a rose, along with everything we needed to fill them—the *tejocotes*, limes, oranges, and peanuts that would fall to the ground when the children broke the piñatas open with sticks. We also bought little woven palm-frond baskets in several colors to use for the food and modest toys that would be handed out at the end of the party.

The *posada* began when the children from Londres Street separated themselves from those who had come from other parts

Page 95: Christmas Turkey (see recipe on page 106); the tureen belongs to the Rivera family. Page 96: Christmas posada at Lupe Rivera's house. On the table are Stuffed Pambazos and tostadas (see recipes on page 108) and Sugared Fritters (see recipe on page 110).

of Coyoacán and came into the patio of the Blue House. The others, who stayed outside, asked the ones inside for a room at the inn *(posada)* to spend the night, and they refused.

The words of the exchange go like this:

(outside) En el nombre del cielo
os pido posada,
pues no puede andar
mi esposa amada.

(inside) Aquí no es mesón
sigan adelante,
yo no he de abrir
no sea algún tunante.

(outside) No seaís inhumano
dadnos caridad,
que el Dios de los cielos
te lo premiará.

(inside) Ya se pueden ir
y no molestar,
porque si me enfado
os voy apalear.

(outside) Venimos rendidos
desde Nazaret,
yo soy carpintero
de nombre José.

(inside) No me importa el nombre
dejenme dormir,
pues que yo les digo
que no hemos de abrir . . .

When the doors finally opened so the "holy pilgrims" could enter the make-believe inn, the boys and girls dashed to the spot where the piñatas hung, anxious to be blindfolded so they could whack the piñatas until they burst open and dropped their contents to the ground.

Afterwards there was food for the children and for the adults, who began arriving after dark. Frida brought in three of the best specialty cooks from the Coyoacán market to help prepare the meal. While they were busy frying the *pambazos*, tostadas, and the fillings of chorizo, chicken, and beans in green or red sauce, other women prepared tortillas. Stuffed with squash blossom, pigs' feet, cheese or potatoes, they would be fried on the spot, so the guests could enjoy freshly made quesadillas of every conceivable kind.

Frida's reasons for celebrating Christmas Eve in the traditional fashion had more to do with the local holiday spirit than with religious belief. Her first idea was to take a stroll through Centenary Park before going to her older sister Matilde's house for dinner. Frida led me, Ruth, and a group of friends on a visit to the fair that had moved into the Park for the Christmas holiday. On our way we saw booths offering sweets from all over the country, while Frida searched out special Christmas toys to add to her collection.

She was especially fond of cardboard dolls in acrobat outfits and colorful rag dolls with black cloth hair that looked like ancient wigs. The smaller the doll the more it was to her liking. She also bought

flew up over her head at the top of every turn, and the crowd down below yelled themselves blue in the face when the wheel came around and her skirts fell into place. This was how the people of Coyoacán discovered that the famous painter did not wear underpants. Imagine the scandal!

To make the evening complete we attended midnight mass, which was considered even more outrageous than the wheel of fortune. No one paid any attention to the sermon, distracted as they were by "that godless Communist Frida Kahlo" who sat there listening to the priest just as calm as she could be.

It was after midnight when we arrived at Matilde's house. My friends were truly amazed by Frida's energy and enthusiasm, but the best was yet to come. My father had not had dinner; he was dying of hunger and in the worst of moods. Throwing his doctor's advice, his diet, and his medication out the window, he set out to devour everything Maty could provide. Determined to offend everyone present, he sat at the head of the table cursing the Catholic Church and the servants of God with a lack of manners and sharpness of tongue that were unusual even for him. The ensuing uproar guaranteed that a traditional Rivera-style Christmas had indeed been celebrated. We drank a toast of excellent cider and went home happy.

inexpensive puppets that were sold in booths or at special stands where there was a little bit of everything.

What she loved most, though, were the whistles. They came in various sizes and made different sounds. She used them to call for Chucho, Eulalia, and Inés, and she created quite a stir when she did. On that Christmas Eve she stuck a few whistles in her purse and blew on them vigorously the whole time we wandered around.

Eventually we braved all obstacles and made it to the fair. We went on I don't know how many rides: the carousel, the whip, bumper cars, and the wheel of fortune. On the last of these, Frida's skirts

Above: A detail of one of Frida's Tehuana costumes.

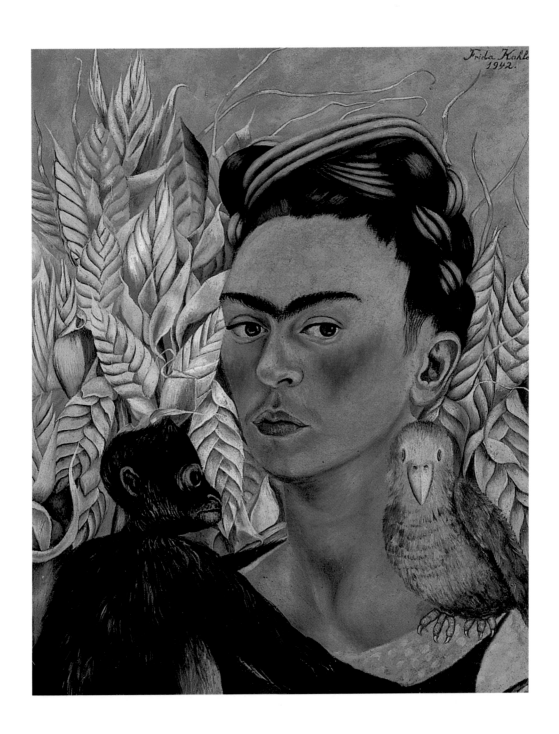

Above: Self Portrait with Monkey and Parrot, *1942.*
Overleaf: *Christmas supper in Guadalupe Rivera's house.*
The two niches are filled with a collection of antique
porcelain and still lifes that once belonged to Frida.

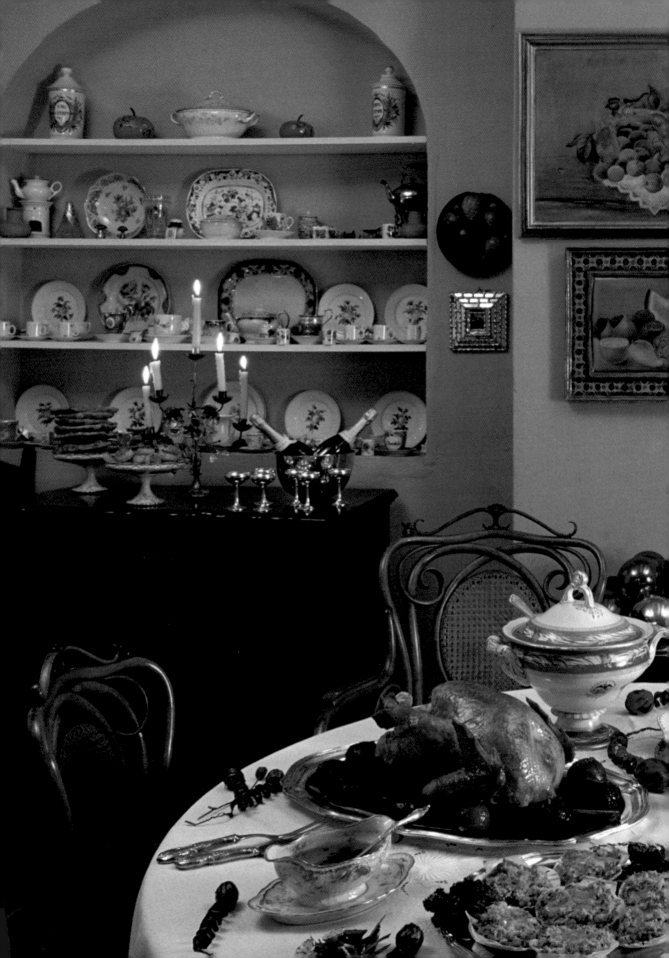

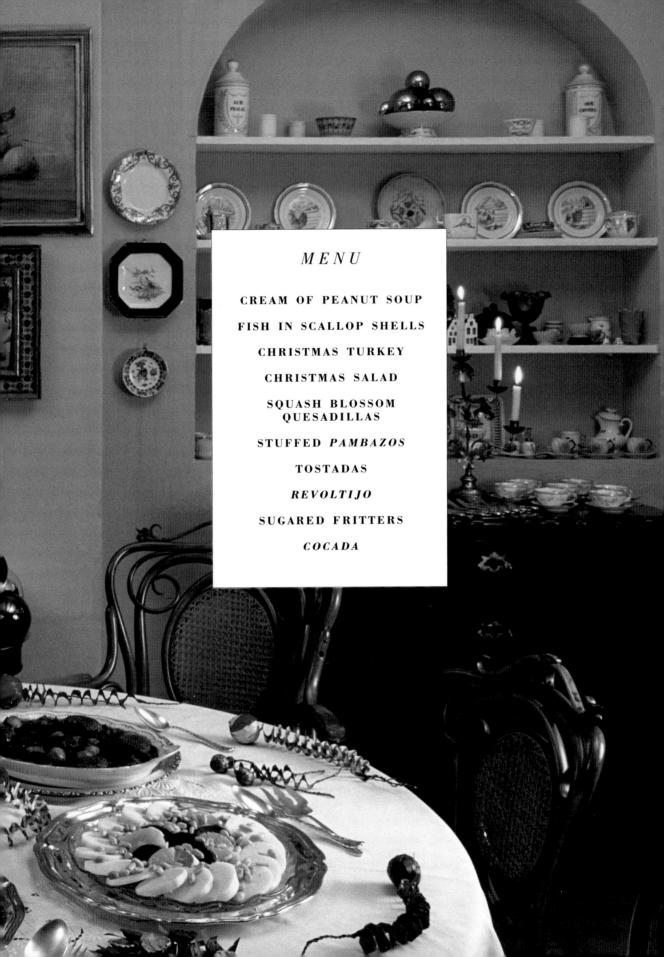

MENU

CREAM OF PEANUT SOUP

FISH IN SCALLOP SHELLS

CHRISTMAS TURKEY

CHRISTMAS SALAD

**SQUASH BLOSSOM
QUESADILLAS**

STUFFED *PAMBAZOS*

TOSTADAS

REVOLTIJO

SUGARED FRITTERS

COCADA

CREAM OF PEANUT SOUP

(8 servings)

1 large tomato
½ medium onion
¼ cup/60ml water
3 tablespoons corn oil
2 cups/300g shelled peanuts
Salt and pepper
4 cups/1 l chicken broth
1 cup/250ml cream
Finely chopped parsley
Shelled peanuts

Puree the tomato and onion with the water. Drain.

Heat the oil in a large saucepan and sauté the peanuts for a minute, stirring constantly. Remove the peanuts with a slotted spoon. In the same oil, sauté the tomato mixture, season to taste with salt and pepper, and cook until thickened.

Grind the peanuts with the chicken broth and add to the saucepan. Cook for 10 minutes over low heat. Stir in the cream and correct seasonings, if needed. Serve hot, garnished with chopped parsley and peanuts.

FISH IN SCALLOP SHELLS

(8 servings)

1½ pounds/750g fresh *robalo*, *guachinango*, or other firm white fish
2 onions
1 bay leaf
6 black peppercorns
2 cloves
2 teaspoons salt
Juice of ½ lime
4 cups/1 l water

SAUCE

1 large onion, chopped
4 tablespoons oil
3 jalapeño chiles, chopped
3 large tomatoes, peeled, seeded, and chopped
2 tablespoons chopped parsley
Salt and pepper

4 tablespoons/65g softened butter
Bread crumbs

Place the fish with the onions, seasonings, lime juice, and water in a saucepan. Bring to a boil, simmer for 10 minutes, and remove from heat. Strain the fish, let it cool, and flake it.

To make the sauce, sauté the onion in the oil until translucent. Add the chiles, sauté for a few seconds, then add the tomatoes and parsley. Season with salt and pepper to taste and cook until thickened. Gently stir in the fish and simmer for a few minutes to blend the flavors.

Butter 8 scallop shells or individual oven-proof plates. Fill with the fish mixture. Sprinkle with bread crumbs and dot with butter. Bake in a preheated 350°F/175°C oven for 10 minutes and serve.

Opposite: Fish in Scallop Shells.

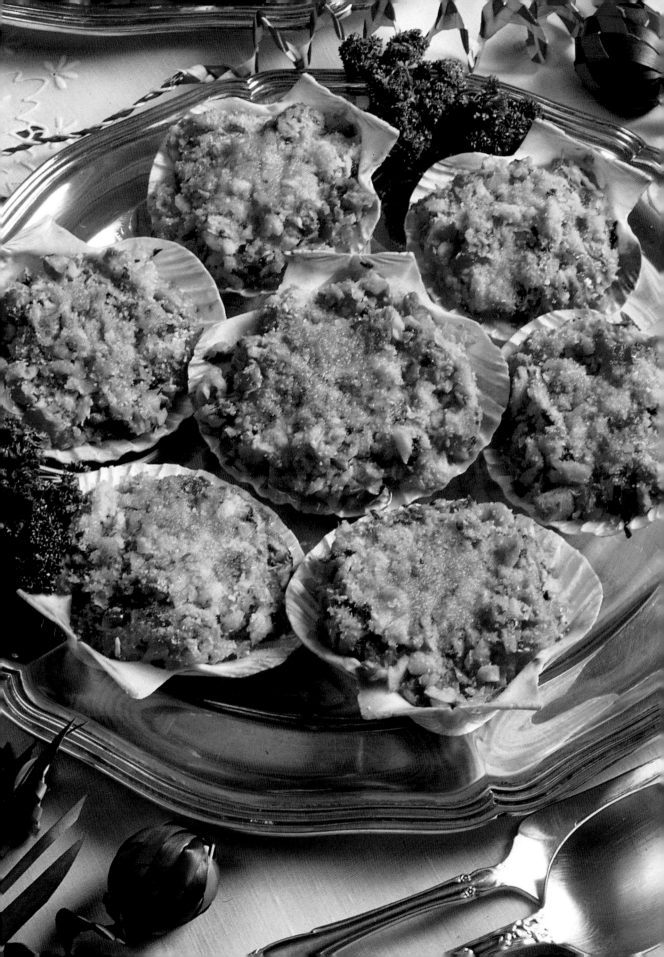

CHRISTMAS TURKEY

(10 servings)

1 small turkey (about 13 or 14 pounds/6k)

Salt and pepper

1 cup/250g butter, softened

STUFFING

4 hard rolls

1½ cups/375ml milk

1 large onion, chopped

⅓ cup/100g lard

Turkey giblets, washed and chopped

3 cups/400g chopped celery

2 tart apples, peeled and chopped

15 pitted prunes, chopped

⅓ cup/70g chopped walnuts or pecans

½ teaspoon dried thyme

Salt and pepper

Wash the turkey thoroughly. Dry well, inside and out. Rub the surfaces with salt and pepper. Stuff the turkey and rub with half the butter. Place the turkey breast-side down on a wire rack in a roasting pan. Roast in a preheated 425°F/220°C oven for 15 minutes. Turn the turkey breast-side up and roast it for 15 minutes more. Remove from the oven and brush all surfaces with the remaining butter. Return to the oven for 3½ to 4 hours until the juices run clear when the thigh is pierced, basting every 20 minutes.

To make the stuffing, break up the rolls and soak them in milk until soft. Press to drain well. Sauté the onion in hot lard until translucent. Add the giblets, sauté for a few minutes, then stir in the celery, apples, prunes, and nuts. Cook for 2 minutes, then stir in the drained bread, thyme, and salt and pepper to taste. Cook for a few minutes until the mixture is dry. Remove from the heat and cool slightly before stuffing the turkey.

CHRISTMAS SALAD

(8 servings)

2 medium jícamas, peeled and sliced

2 oranges, peeled and sliced

2 medium beets, cooked, peeled, and sliced

¾ cup/100g shelled peanuts, chopped

VINAIGRETTE

6 tablespoons olive oil

3 tablespoons vinegar

1 teaspoon honey

Salt and pepper

Arrange a circle of sliced jícama around the edge of a large round serving platter, then the orange slices and, in the center, the beet slices. Drizzle with the vinaigrette and sprinkle with peanuts.

To make the vinaigrette, combine all the ingredients in a jar with a tight-fitting lid. Shake to blend well.

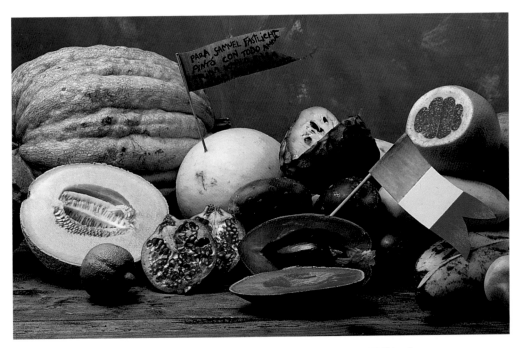

SQUASH BLOSSOM QUESADILLAS

(4 servings)

1 pound/500g masa harina

Salt

Oil

Water

Corn oil or lard

FILLING

1 medium onion, finely chopped

3 serrano chiles, finely chopped

2 tablespoons oil

5 cups squash blossoms, stems and pistils removed and discarded, blossoms chopped

1 cup/250ml water

Salt

Combine the masa harina with enough salt, oil, and water to form a smooth dough. Shape the dough into thin tortillas. Place some filling in the center of each tortilla, fold it over, and press the edges together to seal. Fry in hot oil, one or two at a time. Drain thoroughly on brown paper and serve hot.

To make the filling, sauté the onion and chiles in hot oil until the onion is translucent. Stir in the squash blossoms, cook for 1 minute, then add water and salt to taste. Cook briefly to blend the flavors and thicken the mixture. Remove from heat.

Note: Quesadillas can also be filled with Oaxaca cheese or any other cheese that melts.

Above: A still life with the Mexican flag, after a painting by Frida.

STUFFED *PAMBAZOS*

(8 servings)

PAMBAZOS

3¾ cups/500g flour

½ teaspoon cream of tartar

3 teaspoons baking powder

1 tablespoon salt

7 tablespoons/100g butter or
vegetable shortening

4 eggs

½ cup/125ml milk

STUFFING

1 large onion, chopped

1 tablespoon lard

1 pound/500g chorizo,
crumbled

3 potatoes, peeled, cut in
cubes, and cooked

3 chipotle chiles, pickled or in
marinade, chopped

Salt

GARNISH

2 ripe avocados, mashed

1 head romaine, shredded

VINAIGRETTE

6 tablespoons olive oil

3 tablespoons vinegar

1 teaspoon sugar

Salt and pepper

To make the pambazos, sift the dry ingredients together. Cut in the butter until the mixture resembles small peas. Add the eggs and enough of the milk to make a smooth dough.

Roll out on a floured surface. Cut the dough into 4- or 5-inch circles. With a rolling pin, shape the circles into ovals. With a sharp knife carefully score a cross on the center of each oval—be careful not to cut all the way through the dough. Fry in hot oil or lard until golden and puffed. Drain on brown paper. Fill the hollowed center with the stuffing. Garnish with avocado and the lettuce dressed with vinaigrette. Serve hot.

To make the stuffing, sauté the onion in hot lard until translucent. Add the chorizo and cook until soft. Add the potatoes, chiles, and salt to taste. Continue to cook until the flavors are blended and the mixture has thickened.

To make the viniagrette, combine the ingredients in a jar with a tight-fitting lid and shake well.

TOSTADAS

(8 servings)

24 tortillas

Oil

1½ cups refried beans
(see page 151)

Green sauce
(see page 38)

1 head romaine lettuce,
shredded

3 chilled pig's feet in tomato
sauce, chopped (see page 215)

1 chicken breast, cooked and
shredded

4 chorizos, crumbled and fried
in a small amount of oil

Sliced tomato

Avocado slices

Sour cream

**Añejo cheese, grated
(or aged cheddar)**

Salt and pepper

Place the tortillas in a hot oven until toasted. Fry in hot oil until crisp and drain on brown paper. Spread the tortillas with refried beans. If the beans are too thick, thin with a little water. Top with green or red sauce to taste and shredded lettuce. Add the chopped pig's feet to 8 tostadas, chicken to another 8, and chorizo to the rest. Top the chicken and chorizo but not the pig's feet with tomato slices. Top all with avocado slices, sour cream, and grated cheese. Sprinkle with salt and pepper to taste and serve.

REVOLTIJO

(8 servings)

2 pounds/1k romeritos, well washed

6 nopales, cut in strips

14 guajillo chiles

2 ancho chiles

2 cups water

1 tomato, roasted

1 small onion, roasted

1 garlic clove, peeled

4 tablespoons lard

1½ pounds/750g small potatoes, cooked and peeled

5 ounces/150g dried shrimp, soaked

6 ounces/180g fresh shrimp, cleaned

SHRIMP PATTIES

2 eggs, separated

4½ ounces/125g dried shrimp powder

1 tablespoon bread crumbs

Oil

Cook the *romeritos* in salted water for 15 minutes and drain well. Cook the nopales in salted water for 15 minutes and drain well.

Roast and devein the chiles. Place in a saucepan with the water. Bring to a boil, simmer briefly, then puree the chiles and cooking water. Strain. Puree the tomato, onion, and garlic. Strain. Heat the lard in a large saucepan. Add the pureed tomato and cook for a few minutes until thickened. Add the pureed chiles and cook for about 10 minutes. Add the *romeritos*, nopales, potatoes, dried shrimp, and fresh shrimp and cook for 5 minutes. Stir well, then add the Shrimp Patties. If mixture is too thick, thin with a small amount of broth.

To make the Shrimp Patties, beat the egg whites until stiff. Beat the egg yolks thoroughly. Gently stir the yolks into the whites. Add the shrimp powder and bread crumbs. Shape the mixture into patties and fry in hot oil until golden. Drain on brown paper.

SUGARED FRITTERS

(12 to 15 fritters)

3 to 4 cups/420 to 550g flour
1½ teaspoons baking powder
1 tablespoon sugar
½ teaspoon salt
4 tablespoons /60g butter,
melted
2 eggs
½ cup/125ml milk
Lard
Sugar and cinnamon

Sift 3 cups/420g of the flour with the baking powder, sugar, and salt. In a separate bowl, combine the butter with the eggs and milk. Slowly beat in the flour mixture to form a smooth dough. Gradually add more flour, beating vigorously, until the dough is stiff. Roll out on a lightly floured surface. Shape into small balls about the size of a walnut and brush with melted lard. Cover and let stand for 20 minutes.

Roll out the balls until they are thin and flat. Let stand for 10 minutes.

Fry in hot lard until golden. Drain on brown paper and sprinkle with a mixture of sugar and cinnamon.

Note: If you like, serve the fritters with a syrup made from *piloncillo* or dark brown sugar, a stick of cinnamon, and water.

COCADA

(6 servings)

4 cups/1 l milk
2½ cups/450g sugar
1 coconut, peeled and grated
6 egg yolks, beaten

Boil the milk and sugar until thickened. Add the coconut. Simmer for 30 minutes, then remove from the heat. Gradually add the egg yolks, beating with a whisk until the mixture thickens to the consistency of a pudding. Pour into an ovenproof dish and bake in a preheated 350°F/175°C oven until lightly golden.

Above: A locket with a portrait of Frida.
Opposite: Sugared Fritters and Christmas candies
served on antique porcelain confectioners.

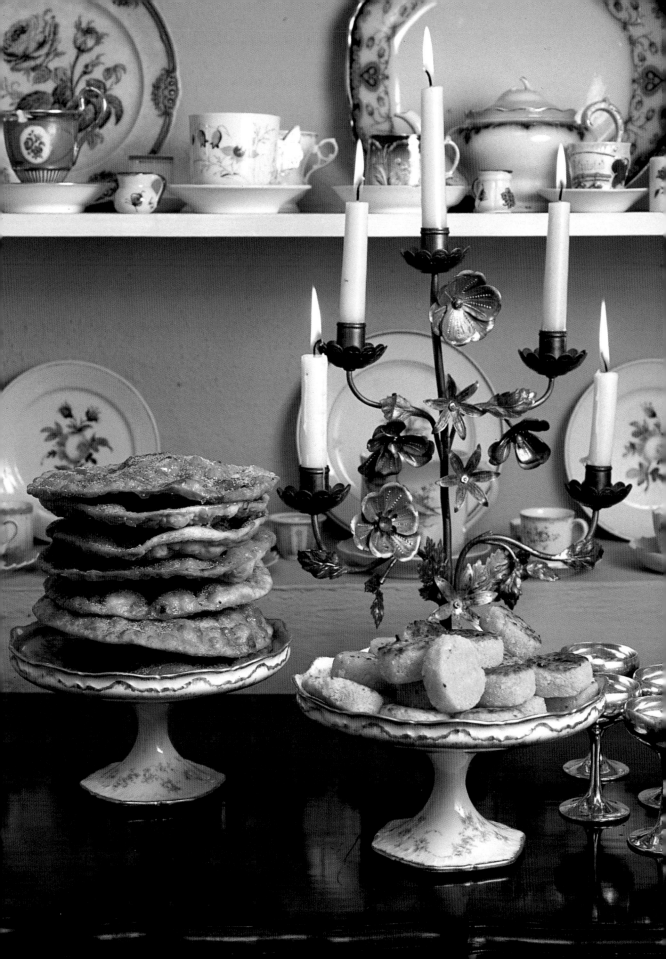

JANUARY

La Rosca de Reyes

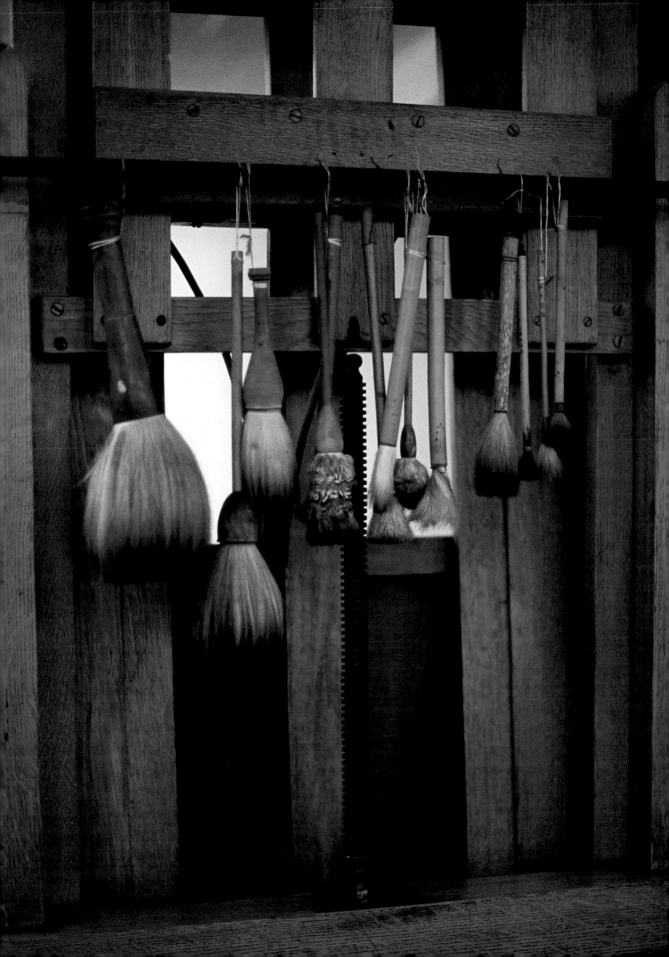

n the eve of the Epiphany—Feast of the Three Kings—Frida decided that, in the name of family tradition, there had to be a get-together in the Blue House to cut the *rosca de Reyes* (Epiphany cake). She informed everyone of her plan and assigned us all a task. Since she grasped at any pretext for making a trip to town, she determined to buy the *rosca* at La Flor de México, one of the finest coffee shops.

The shop stood at the corner of two famous streets: Venustiano Carranza and Bolívar. It was an area that attracted the most powerful members of the old aristocracy, which dated back to the days of Porfirio Díaz. Staunch defenders of the status quo and bitter critics of the Revolution, this privileged elite gravitated toward the renowned district's coffee shops at the end of a day spent shopping or looking after its investments.

Frida, who had been aware of la Flor de México's reputation since she was a child, stormed defiantly into the place, which was overflowing with *le tout Mexique* who had come to La Flor to drink café au lait and chocolate with their *rosca de Reyes* and pastries. She loved to "*épater les bourgeois*," as my father often said, especially those members of what she called "the would-be aristocratic petite bourgeoisie." Her entrance caused a sensation. The extravagantly ornate Tehuana attire and pre-Hispanic jewelry caught the attention of the audience, and when she was soon identified as "the Communist painter, wife of that ogre Diego Rivera," nasty remarks began to fly. For us simply to be there was cause for hostility. I tried my hardest to turn invisible, but Frida only laughed and said in a loud voice, "Don't fall apart on me, Piquitos. The only thing you can do with people like this is tell them to go to hell."

A waitress in a black dress and white collar, apron, and cap showed us to a corner table on the outside patio, an area that was almost always closed. It was an unbelievable setting. Huge ferns and azaleas of every color competed with the honeysuckle and jasmine vines that climbed the archways, infusing the place with their unique and powerful aroma.

The rays of the setting sun warmed us as we waited for the chocolate to have the same effect. Frida ordered the biggest and most expensive *rosca* on the list. While we waited for it to be wrapped, we had sweet sherry and a snack of those cookies that are called cat's tongues.

Two of the Rivera and Kahlo families' oldest and dearest friends came into the coffee shop: the painter Jesús "Chucho" Reyes and the incomparable Jesús Ríos y Valles, whom Frida had been calling "Chucho Landscapes" since elementary school (Chucho is a diminutive of Jesús and Ríos y Valles translates into English as "Rivers and Valleys"). From the moment they sat down with us we were in paroxysms of laughter. This further outraged the good ladies and gentlemen who until our arrival had been enjoying an atmosphere of peace and quiet as they dunked their egg bread in handsome porcelain mugs.

Page 113: Torta de Cielo *(see recipe on page 122) served in green pottery from Oaxaca.* Page 114: *Frida's brushes still hang from her easel in the studio of the Blue House.*

Before we knew it, it was dark. Frida invited the two Chuchos back to Coyoacán with us. The Kahlo clan awaited us impatiently. Don Guillermo was beside himself with annoyance at his daughter's latest escapade.

Frida's sisters Luisa, Adriana, and Matilde were afraid of their father's anger. Cristina tried to persuade Frida to say she was sorry. Adriana's husband, Veraza—"*el güerito*" ("the blond boy")—managed to aggravate the situation by tripping against the dining room table. It was such a ludicrous accident that we all broke into laughter, and don Guillermo stormed out in an even worse humor.

When the incident was behind us, we cut the *rosca* from La Flor de México. Cristina's son Toñito, the youngest person present, cut the first slice; the rest of us followed in strict chronological order. The figurine was in Adriana's slice, so she was automatically required to throw the party on February 2, the Virgen de la Candelaria's feast day, when tradition dictated that everyone eat tamales of all different kinds.

Frida and I and Chucho Reyes and Chucho Landscapes watched a parade of specialties pass before our eyes—"watered" chocolate or chocolat au lait, cocoa, black or lemon tea, ham rolls, *torta de cielo*, tacos with sour cream, *flautas*, red and green chalupas, and a tremendous variety of desserts, cookies, and little pastries. These were all dishes that Frida had ordered to complement the *rosca*. Of all these dishes the ones that made the greatest impression on the guests were the *torta de cielo* and the tacos with sour cream—two of the Blue House's most frequently praised recipes. We used to make the *torta de cielo* at my father's house in Guanajuato. It is a typical regional dish with a twist specific to that city: the top layer is scrambled egg sprinkled with sugar. In Mexico this is considered an unusual side dish for a formal dinner.

The tacos were also made according to an old recipe from the days when sour cream fermented at home (nowadays people substitute yogurt). Other recipes were typical of Guadalajara and Puebla cuisine, making for a meal that reflected the diversity of Mexican cooking.

Frida provided a surprise at the end, when she suddenly appeared bearing two enormous platters. These were her favorite desserts, macaroons and *gaznates* (fried cookies), which she herself had made. Chucho Landscapes proposed that we toss a coin the way they used to do in elementary school—whoever got "heads" won a *gaznate*, "tails," a macaroon. Amid great hilarity we played this game until the platters were empty and the feast of Epiphany was over.

Overleaf: The ingredients for a rosca de Reyes, *the traditional dessert for the feast of the Epiphany.*

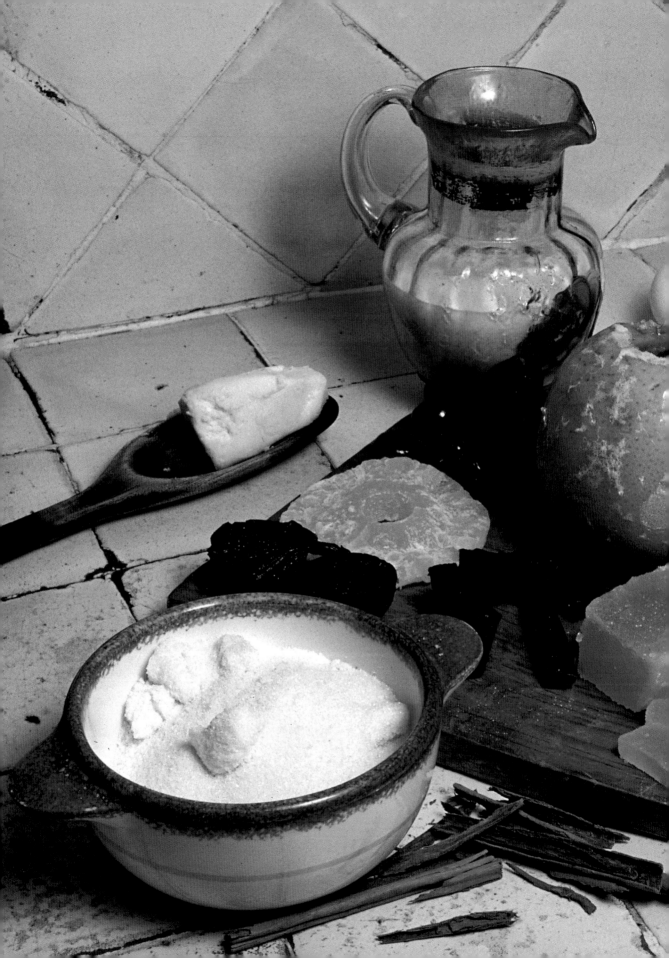

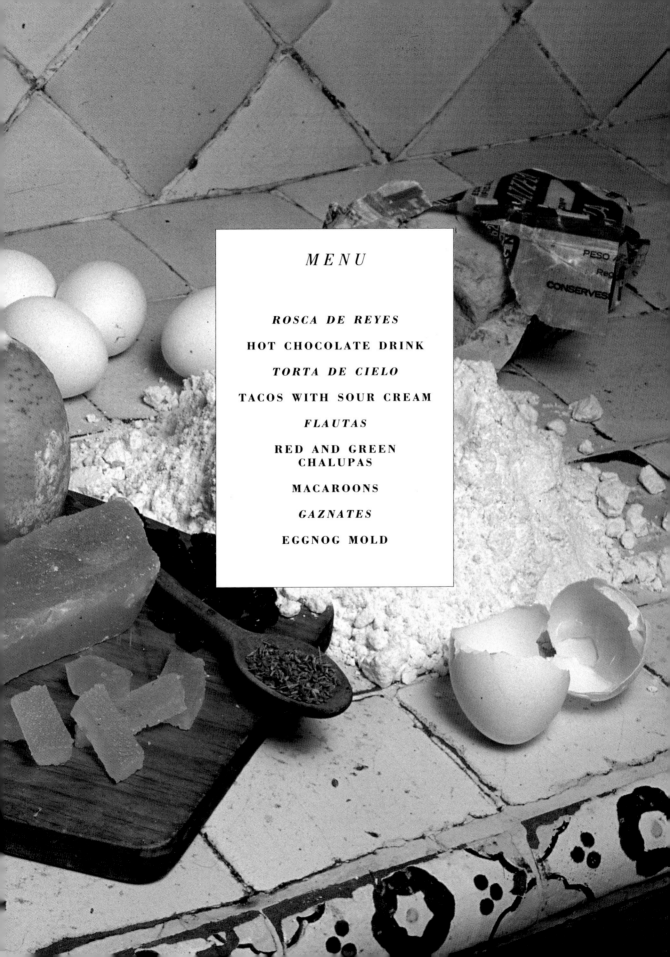

MENU

ROSCA DE REYES

HOT CHOCOLATE DRINK

TORTA DE CIELO

TACOS WITH SOUR CREAM

FLAUTAS

RED AND GREEN
CHALUPAS

MACAROONS

GAZNATES

EGGNOG MOLD

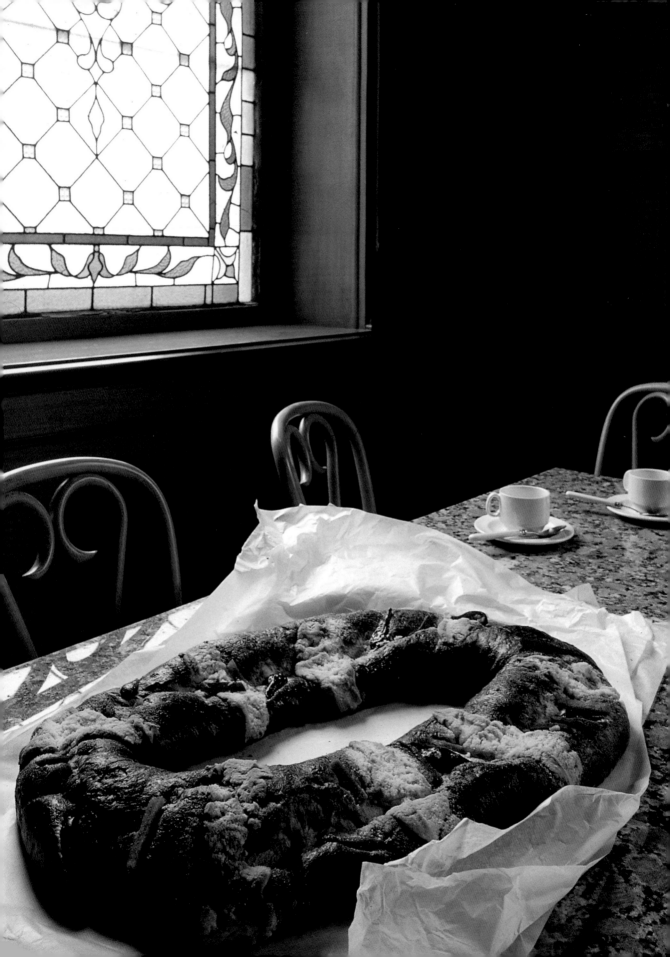

ROSCA DE REYES

3½ cups/450g flour

1 envelope active dry yeast
dissolved in 5 tablespoons
warm milk

¾ cup/150g sugar

7 eggs

4½ ounces/125g butter,
softened

¼ cup/60ml warm milk

Salt

2 teaspoons ground cinnamon

¼ teaspoon anise seeds

¾ cup/90g raisins

1 teaspoon vanilla extract

1 small porcelain doll

3 ounces/60g dried figs, cut
in strips

⅓ cup/60g candied cherries

½ cup/60g candied citron, cut
in strips

½ cup/60g candied orange,
cut in strips

½ cup/60g candied lemon, cut
in strips

1 beaten egg

Sugar

Mound the flour on the counter or in a bowl and make a well in the center. Fill the well with the softened yeast, sugar, eggs, butter, milk, a pinch of salt, the cinnamon, anise, raisins, and vanilla. Mix into a dough and knead for about 20 minutes until the dough pulls away from the counter. Shape the dough into a ball. Brush it with softened butter, and place in a greased bowl. Cover with a cloth and let rise in a warm place for 2½ to 3 hours, until doubled in bulk.

Place the dough on a floured surface, knead lightly, and shape into a ring. Poke the doll into the dough and arrange the ring on a buttered baking sheet. Decorate the ring with candied fruit and let it rise again for 1½ hours, until doubled in bulk. Brush with beaten egg, sprinkle with sugar, and bake in a preheated 375°F/190°C oven for 40 minutes, or until done. You know the *rosca* is done when the bottom sounds hollow when tapped.

HOT CHOCOLATE DRINK

(8 servings)

2 quarts/2 l milk

½ pound/225g Mexican
chocolate, cut in chunks (or
semisweet chocolate flavored
with cinnamon)

Sugar

Heat the milk with the chocolate, stirring constantly, until the chocolate is dissolved. Add sugar to taste and simmer for a few minutes more. Beat vigorously with a whisk until foamy, then pour immediately into cups.

Opposite: A rosca de Reyes *photographed in a Porfirian-style dining room in Mexico City.* **Above:** *A detail of the wall decoration in the dining room of the Blue House.*

TORTA DE CIELO
(8 servings)

6 eggs, separated

2 tablespoons sugar

**1 recipe white rice
(see page 56)**

**1 recipe picadillo
(see page 136)**

Beat the egg whites with the sugar until stiff. Beat the egg yolks and fold carefully into the whites. Reserve ⅓ of this egg mixture.

Fold the remaining egg mixture into cold or lukewarm rice. Place half of the rice in a greased round or rectangular baking dish. Spread with the picadillo. Make another layer with the remaining rice. Spread with the reserved egg mixture and sprinkle with sugar.

Bake in a preheated 350°F/175°C oven for 20 to 25 minutes, until everything is hot and the egg mixture has puffed slightly.

TACOS WITH SOUR CREAM
(8 servings)

3 pounds/1,500g tomatillos

½ cup/125ml water

6 serrano chiles, roasted

Salt

Lard or corn oil

24 tortillas

1 pound/500g panela (or feta) cheese, cut in strips

2 cups/500ml sour cream

Simmer the tomatillos with the water until tender. Puree the tomatillos with the chiles and salt to taste. Heat 2 tablespoons lard in a saucepan, add the puree and simmer for about 5 minutes, until the sauce is thickened.

Heat lard in a skillet. Dip the tortillas briefly in hot lard, then in the tomatillo sauce. Fill the tortillas with strips of cheese and a bit more of the sauce. Roll and arrange in a baking dish. Cover with the remaining sauce and the sour cream. Bake at a low temperature until heated through.

FLAUTAS
(6 to 8 servings)

20 large tortillas

1 cup cooked and shredded lamb

1 cup cooked and shredded chicken breast

Corn oil

1 cup/250ml heavy cream

1 head romaine, shredded

½ pound/250g añejo cheese, crumbled (or parmesan)

RED SAUCE
12 guajillo chiles, roasted

1 or 2 garlic cloves, roasted

Salt

GREEN SAUCE
20 tomatillos

4 serrano chiles

1 garlic clove

Salt

1 avocado, peeled and mashed

Fill 10 tortillas with lamb and 10 with chicken. Roll tightly and fry in very hot oil. Drain on brown paper. Arrange the *flautas* on a serving platter. Top one end of the *flautas* with Red Sauce, the other end with Green Sauce; pour the cream in between—to resemble the Mexican flag. Garnish with lettuce and sprinkle with cheese.

To make the Red Sauce, soak the chiles in hot water for 15 minutes. Puree with the garlic, salt to taste, and as much water as needed to make a medium-thick sauce.

To make the Green Sauce, cook the tomatillos, chiles, and garlic in a small amount of salted water. Puree and mix with the avocado.

RED AND GREEN CHALUPAS

(8 servings)

3 pounds/1,500g masa harina

6 tablespoons lard

1½ chicken breasts, cooked and shredded

½ pound/250g añejo cheese, crumbled (or parmesan)

1 medium onion, finely chopped

GREEN SAUCE

1 small onion, finely chopped

15 to 18 tomatillos

¼ cup/30g chopped cilantro

4 serrano chiles

Salt

1 tablespoon lard

RED SAUCE

2 large tomatoes, roasted, peeled, and chopped

½ medium onion, finely chopped

1 garlic clove

4 serrano chiles, roasted

1 tablespoon lard

Shape the dough into 18 thin, somewhat oval tortillas. Cook on a griddle. Pinch a border all around the tortillas so they can hold a filling. Return to the griddle and top each chalupa with 1 teaspoon lard. Top half of the chalupas with Green Sauce; the rest with Red Sauce. Divide the chicken, cheese, and onion among them all. Remove from the griddle and serve piping hot.

To make the Green Sauce, puree all the ingredients except the lard. Heat the lard and add the puree. Sauté until the flavors are blended and the sauce has thickened.

To make the Red Sauce, puree the tomatoes, onion, garlic, and chiles. Sauté in hot lard until thickened.

Above: *Red and Green Chalupas served on a green pottery dish from Oaxaca.*

MACAROONS

(Makes about 40)

**2¼ cups/350g blanched
almonds, coarsely chopped**

½ cup/100g sugar

Egg whites as needed

Grind 2 cups/300g of the almonds with the sugar. Gradually stir in enough egg whites to form a soft dough. Drop by the tablespoonful on a baking sheet. Garnish with the remaining chopped almonds. Bake in a preheated 350°F/175°C oven for 10 minutes.

GAZNATES

(Makes 18 to 24)

4 egg yolks

½ teaspoon baking soda

⅓ cup/50g flour

***Aguardiente* (sugar cane
alcohol) or rum**

Egg whites

Lard or oil

Confectioners' sugar

Ground cinnamon

Beat the egg yolks thoroughly with the baking soda. Gradually add the flour, making a soft dough. Shape the dough into a ball. Moisten your hands with *aguardiente* and pat the dough. Repeat 3 times. Cover the dough with a cloth and let it stand for 10 minutes.

Pinch off a small amount of dough and roll it out as thin as possible (keeping the rest of the dough covered to avoid drying). Cut into medium-size squares. Moisten two opposite corners with egg white and press them toget[her] to make a tube. Fry in deep hot lard. Drai[n] brown paper and roll in a mixture of sugar [and] cinnamon. These cookies can also be fille[d] pastry cream or *cocada* (see page 198).

EGGNOG MOLD

(8 servings)

**4 envelopes/28g unflavo[red]
gelatin**

½ cup/125ml cold water

4 cups/1 l milk

**4 cups/1 l *rompope*
(Mexican eggnog)**

Sprinkle the gelatin over the cold water and let stand for about 6 minutes to soften. Bring the milk and *rompope* to a boil, stirring constantly. Remove from the heat and add the gelatin mixture. Stir until completely dissolved. Pour into a mold and refrigerate until set, about 2 hours. Unmold onto a round platter to serve.

Above: Eggnog Mold on a serving dish from Puebla. **Opposite:**
Gaznates *and Macaroons, on the table in the corner of the studio Diego
added on to the Blue House for Frida.*

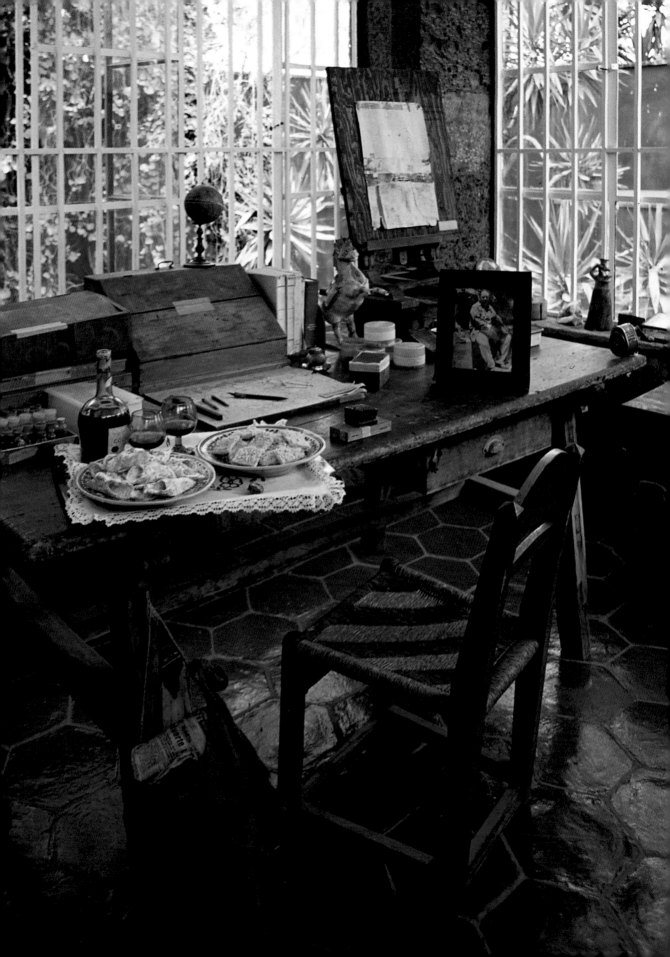

FEBRUARY

A Candlemas Baptism

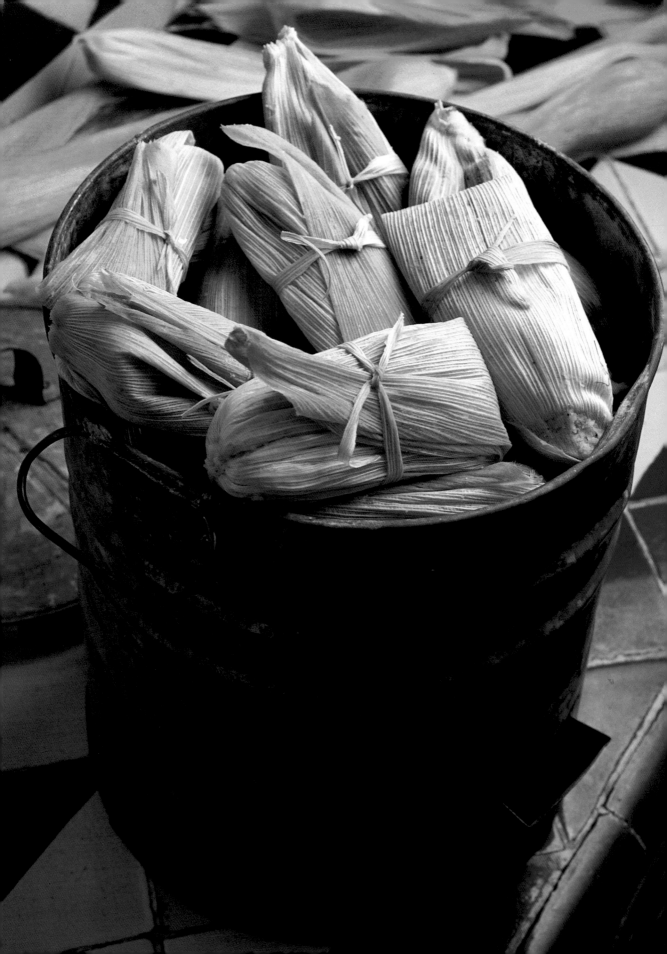

ne Sunday morning early in 1943 doña Micaela came to visit. She was the owner of a wattle hut located in the cornfield across Allende Street from the Blue House. During harvest time doña Micaela sold Frida fresh corn, squash blossoms, green chiles, and beans. She also brought fresh vegetables from the nearby lakeside town of Xochimilco, famous throughout the Valley of Mexico for its extraordinary flowers and vegetables,

which had been grown there since pre-Columbian times.

The purpose of doña Micaela's visit was to invite the "little boss," as she affectionately called Frida, to arrange for the baptism of a new baby. By her calculations, doña Micaela's was due to arrive before Candelmas—that is, before February 2—and she thought this would be a good day for the baptism. Frida was pleased to accept and suggested the names María Candelaria for a girl, Diego María for a boy. The following week doña Micaela gave birth to an adorable little girl.

Frida was on vacation at the time, as was I. We decided to pay a visit to the part of town called La Lagunilla, where we could find the best baptismal clothes and visit rare book stores, antique shops, and the stores that sold the most beautiful paper flowers in the city. These little shops were scattered among the colonial houses that still lined the boulevards of the quarter, one of the oldest in Mexico City.

After purchasing a huge bouquet of paper roses in pale yellow, pink, and off-white, we began searching for the gown, cap, shoes, and other items that the future godchild would need for her baptism. First we had lunch in a restaurant that had been recommended to us as "the best in the area." This turned out to be truer than expected, since the owner was a lady from Guadalajara who specialized in typical delicacies and dishes from that region.

To begin we had a smothered pork sandwich. Frida ordered one for General Wrong Turn, as she called the man who drove us around in my father's Ford station wagon. We sat down together and ordered three main courses—pork in green *pipián* sauce, for Frida, *birria* for General Wrong Turn, and *enchiladas tapatías* for me. Even the beans were delicious, since the cook had added kernels of corn and fried serrano chiles, just the way my own grandmother did.

After our meal we browsed in the rare book stores. In one of them we made an interesting discovery, an album of photographs taken by Frida's father, Guillermo Kahlo, in 1910 to commemorate the hundredth anniversary of Mexican independence. To our delight, we found that the photographs were in mint condition.

In the following days the godmother-to-be made more plans for María Candelaria's baptism. It would be a grand affair including, among other events, a special breakfast at the Blue House. Doña Micaela, meanwhile, was busy arranging matters with the Church of La Conchita, a tiny chapel in Coyoacán, where Hernán Cortés and his consort doña Marina la Malinche, were said to have heard mass in 1526. Frida loved this romantic story and

Page 127: Ninos *dressed for the* Candelaria *fiesta at the market in Coyoacán.* *Page 128:* A typical *tamalera. The Tamales with Chicken Picadillo (see recipe on page 136) are wrapped in corn husks.*

consequently found the religious service to her liking.

That night, when the baptismal ceremonies were over, we went to Adriana's house for the Candlemas celebration; she was responsible because the *niño de la rosca* had turned up in her slice of Epiphany cake. The origin of this ritual in the Valley of Mexico is the pre-Columbian cult of the Boy God named Pilzintecuhtli.

Most Mexican houses have a little altar dedicated to Pilzintecuhtli, who is represented by a carved wood statue that is passed on from grandmothers to their granddaughters. On Christmas Eve the statue is placed in a Nativity scene. On February 2 the Boy God then "rises" from the Nativity and is dressed in new clothes made of the finest white silk. The principal pieces are a robe and felt cap decorated with sequins and beads. As hostess of the celebration, Adriana brought out her own *niño* and sat him down on a special chair from which he presided over the tamale feast.

It was traditional to serve all kinds of tamales on Candlemas. They came in all sizes and colors—red, green, smothered in mole, stuffed with picadillo or fresh corn. Adriana served pineapple *atole* and *champurrado* (hot chocolatatole). Frida had no interest at all in eating "plain old tamales"; as godmother at a "first-rate

baptism," she did her part by bringing special dishes that Eulalia had prepared for the occasion. She made a show of uncovering a basket filled with a magnificent squash blossom *budín* and beans baked with cheese. For dessert there were cookies and fruit empanadas.

As always when "Friduchín" paid a visit, she overwhelmed the family with kisses and hugs and exclamations of delight, peppered with witty remarks and the occasional off-color expression.

Above: A Smothered Pork Sandwich (see recipe on page 135) on a hand-painted plate from Guanajuato. Overleaf: Items for sale in the Coyoacán market for the Candaleria festival.

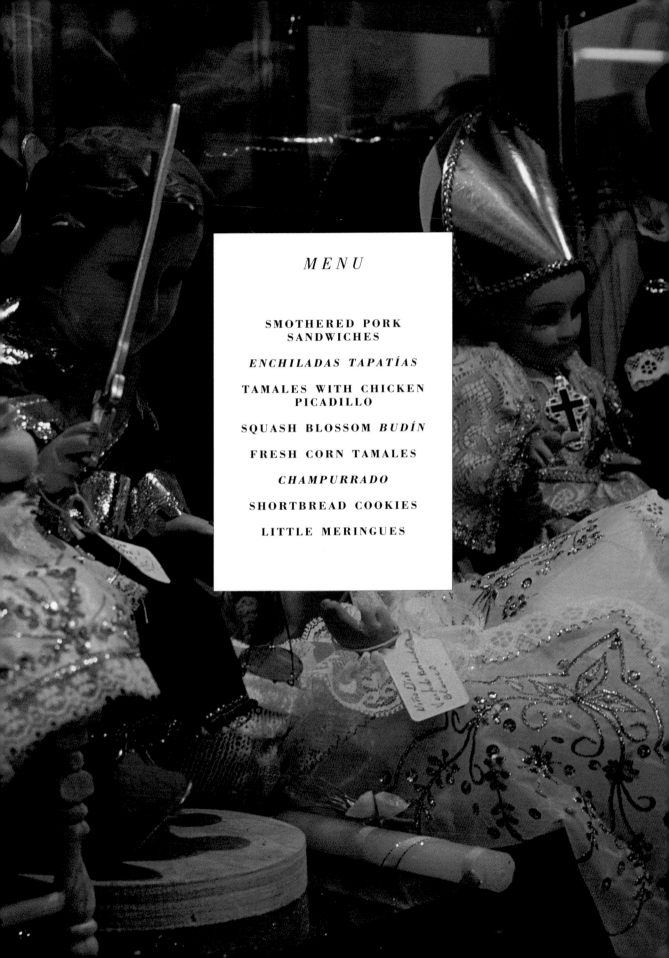

MENU

SMOTHERED PORK SANDWICHES

ENCHILADAS TAPATÍAS

TAMALES WITH CHICKEN PICADILLO

SQUASH BLOSSOM *BUDÍN*

FRESH CORN TAMALES

CHAMPURRADO

SHORTBREAD COOKIES

LITTLE MERINGUES

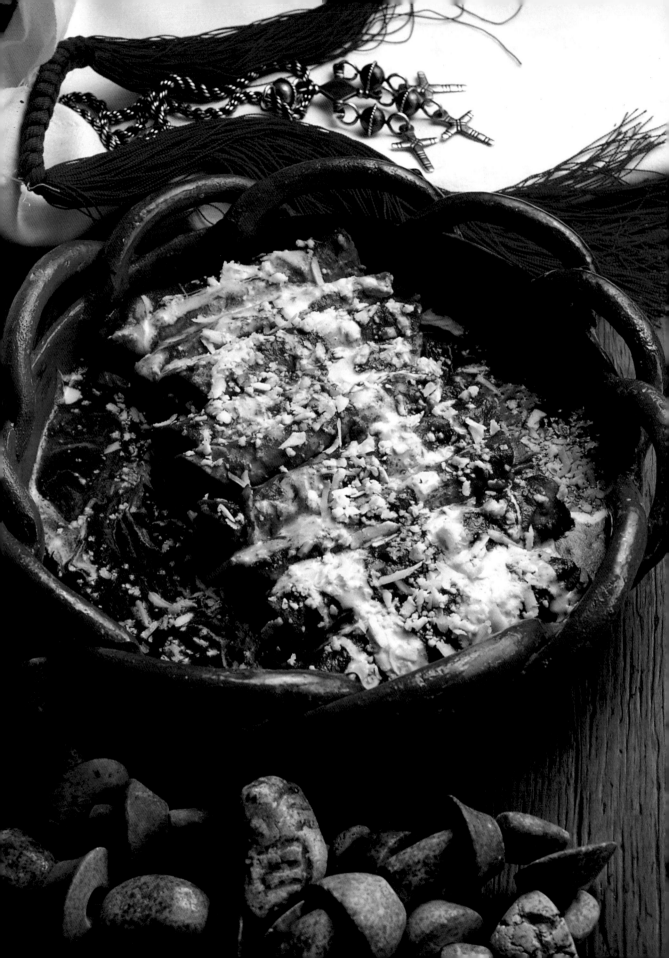

SMOTHERED PORK SANDWICHES

(8 servings)

1½ pounds/1,500g pork loin

1 carrot, cut in half

1 large onion, quartered

3 garlic cloves

3 teaspoons salt

8 crusty rolls

TOMATO SAUCE

4 pounds/2k ripe tomatoes

2 garlic cloves

3 medium onions, cut in thick slices

½ cup/125ml water

3 teaspoons salt

SPICY SAUCE

2 ounces/60g cascabel chiles

2 ounces/60g chiles de árbol

2 teaspoons dried oregano

3 teaspoons salt

1½ cups/375ml water

Place the meat in a large saucepan with water to cover. Add the carrot, onion, garlic, and salt and cook until tender, about 45 minutes. Let the meat cool, then cut in thin strips. Slice the rolls in half but not all the way through. Fill with the meat. Spoon Tomato Sauce over half of each sandwich. Add the Spicy Sauce to taste.

To make the Tomato Sauce, combine the tomatoes, garlic, onions, water, and salt in a saucepan and simmer for about 20 minutes, until the tomatoes and onions are cooked through. Remove from the heat and cool slightly. Puree and strain. Serve lukewarm or cold.

To make the Spicy Sauce, roast the chiles on a griddle and remove the stems. Puree the chiles with the oregano, salt, and water.

ENCHILADAS TAPATÍAS

(8 servings)

24 small tortillas

Oil

SAUCE

8 to 10 ancho chiles, roasted and deveined

2 cups/500ml boiling water

½ large onion, chopped

2 small garlic cloves

2 tablespoons oil

Salt

1½ chicken breasts, cooked and shredded

1 cup/250ml sour cream

½ pound/250g añejo cheese, crumbled (or parmesan)

Fry the tortillas very briefly in hot oil. Dip in sauce, fill with chicken, and roll up. Arrange on a serving platter, top with more sauce, then with sour cream. Sprinkle with crumbled cheese.

To make the sauce, soak the chiles in the boiling water for about 10 minutes. Puree and drain. Sauté the onion and garlic in hot oil until translucent. Add the puree and salt to taste. Cook for about 10 minutes to blend the flavors.

Opposite: Enchiladas Tapatías in a bowl with a scalloped rim from Oaxaca. The silver necklace is from Yalalag.

TAMALES WITH CHICKEN PICADILLO

(8 to 10 servings)

CHICKEN PICADILLO

¾ cup cubed cooked zucchini

¾ cup cooked peas

¾ cup cubed cooked carrots

¾ cup cubed cooked potatoes

¾ cup cut-up cooked
green beans

1½ chicken breasts, cooked
and shredded

1 tablespoon lard

¾ cup tomatoes pureed with
½ large onion and drained

3 jalapeño chiles pickled in
vinegar, chopped

¼ cup/30g blanched almonds,
chopped

¼ cup/30g raisins

2 tablespoons vinegar

1 tablespoon sugar

¼ teaspoon ground cinnamon

Salt

MASA

2 pounds/1k masa harina

2 cups/500ml chicken broth

6 tablespoons/90g sugar

Salt

1 pound/500g pork lard

40 to 50 dried corn husks,
soaked in cold water for
10 minutes and drained well

To make the picadillo, combine the cooked vegetables with the chicken. Heat the lard in a large skillet, add the pureed tomatoes, and sauté for 5 minutes. Stir in the vegetable-chicken mixture, the chiles, almonds, raisins, vinegar, sugar, cinnamon, and salt to taste. Cook for a few minutes to blend the flavors.

To make the masa, combine the masa harina with the broth, sugar, and salt to taste. Beat well for 10 minutes. In a separate bowl, beat the lard until spongy. Combine with the masa harina and beat for 2 minutes more.

Place a heaping tablespoonful of masa on each corn husk. Top the masa with picadillo. Fold the long edges toward the center to enclose the filling. Fold the ends of the husk to wrap the tamale and give it shape. If you like, tie the tamales with a strip of corn husk.

Place a bed of corn husks on the bottom of a *tamalera* or large steamer and pour in 4 cups of water. Stand the tamales upright around the edge. Cover and cook for 1 hour, until the tamales are cooked through and the filling pulls away easily from the husks.

SQUASH BLOSSOM BUDÍN

(12 servings)

CREPES

4 tablespoons/60g melted
butter

6 eggs

¾ cup/100g flour

¾ cup/180ml milk

Salt

2 tablespoons/30g butter

FILLING

1 medium onion,
finely chopped

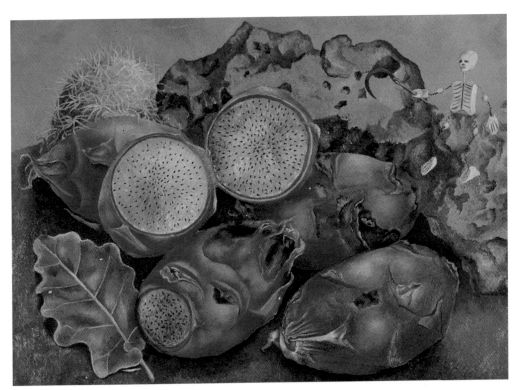

2 tablespoons/30g butter

2 pounds/1k squash blossoms,
stems and pistils removed and
discarded, blossoms chopped

Salt and pepper

1½ cups pureed and drained
tomatoes

10 ounces/300g panela or
Oaxaca cheese, grated
(or muenster)

1½ cups/375ml heavy cream

To make the crepes, whisk together all the ingredients except the unmelted butter. Strain. Let stand for 1 hour. Pour a tablespoon of crepe batter into a small buttered skillet or crepe pan and quickly rotate the pan to spread the batter all over the bottom. Turn the crepe, cook for a few seconds more, and remove from the pan. Crepes should be quite thin. Butter the skillet as needed while making the remaining crepes.

Complete the *budín* in a baking dish as follows: a layer of crepes, a layer of filling, a layer of cheese, ½ cup of cream. Repeat. Bake in a preheated 350°F/175°C oven for 25 minutes, or until the crepes are very hot and the cheese is bubbly and golden.

To make the filling, sauté the onion in butter until translucent. Add the squash blossoms, salt and pepper to taste, and cook for 4 minutes. Add the pureed tomatoes and simmer until the mixture is thick enough to fill the crepes.

Above: Frida's Pitahayas, *1938.* **Overleaf:** *Squash Blossom Budín
(recipe opposite) in a bowl from Patzcuaro. The pressed glass beer mugs
are from Puebla.*

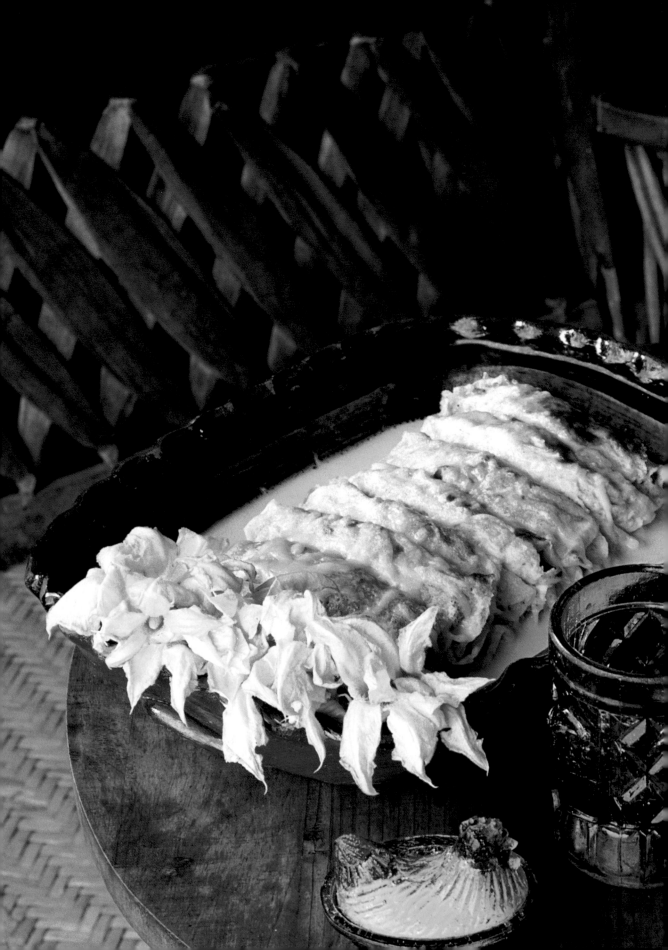

FRESH CORN TAMALES

(8 servings)

8 ears of corn

10 tablespoons/180g butter

3 tablespoons sugar

2 tablespoons flour

1½ teaspoons salt

Husk the corn, reserving the husks. Cut the kernels off the cobs and grind them. Beat the butter with the sugar, flour, and salt. Stir in the ground corn and continue to beat a few minutes more. Use this mixture as a filling for the reserved corn husks, wrapping tightly to make small, rectangular packages.

Make a bed of corn husks in a *tamalera* or large steamer. Cover with water and place the tamales upright around the edges of the pot. Steam for about 40 minutes.

CHAMPURRADO

(8 servings)

½ pound/250g masa harina

3 quarts/3 l water

3 ounces/90g *piloncillo*, crumbled (or ½ cup dark brown sugar)

½ pound/250g Mexican chocolate

Stir the masa harina in 1 quart of water and let stand for a few minutes. Strain and place the liquid in a large saucepan. Add the remaining water and the *piloncillo*. Bring to a boil and simmer until the sugar dissolves. Add the chocolate and simmer until the chocolate melts. Stir well and serve hot.

SHORTBREAD COOKIES

(25 to 30 cookies)

1 pound/450g flour, sifted

1 cup plus 2 tablespoons/300g lard

1 cup/190g superfine sugar

¼ cup/60ml rum

2 cups/160g confectioners' sugar

Mound the flour on the counter or in a bowl and make a well in the center. Fill the well with the lard, sugar, and rum. Mix well to make a smooth dough. Roll out ½ inch thick. Using a round cookie cutter of desired size, cut the dough into rounds and place on baking sheets. Bake in a preheated 350°F/175°C oven until golden, 12 to 15 minutes. Remove the cookies from the oven and toss with confectioners' sugar to coat well.

LITTLE MERINGUES

(30 to 40 meringues)

4 egg whites, at room temperature

½ teaspoon vanilla extract

1 cup/190g superfine sugar

Beat the egg whites until soft peaks form. Add the vanilla. Beat in the sugar, a tablespoon at a time, until stiff. Butter and flour baking sheets. Put the meringue in a pastry bag fitted with a plain or fluted tip. Pipe meringues of desired size on the baking sheets. Bake in a preheated 200°F/95°C oven for about 35 to 45 minutes, or until the meringues are completely dry.

Opposite: Little Meringues, on a green confectioner from Michoacán.

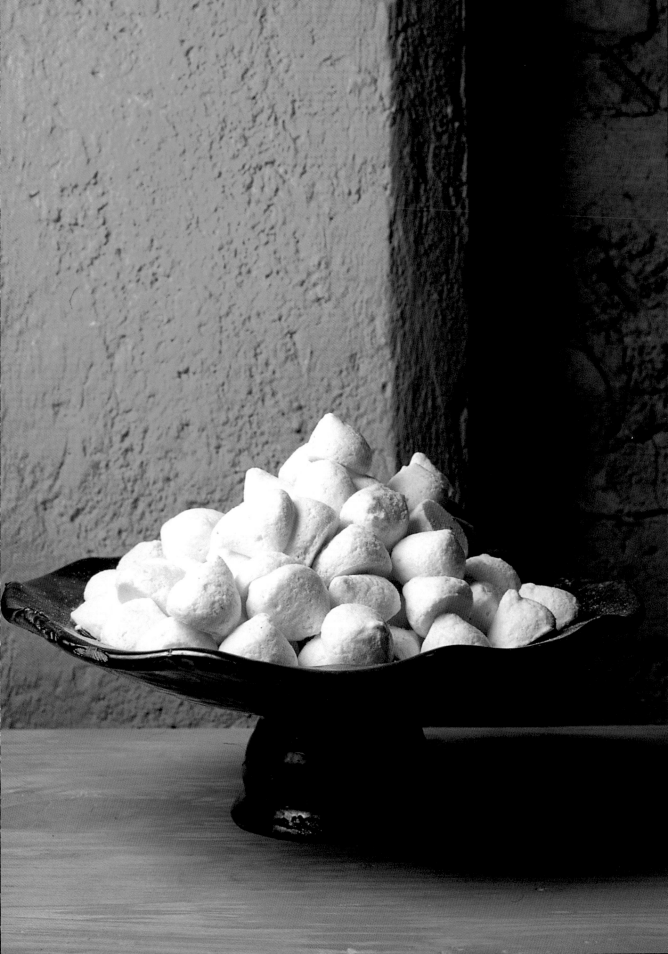

MARCH

Teotihuacán, Where Live the Sun and Moon

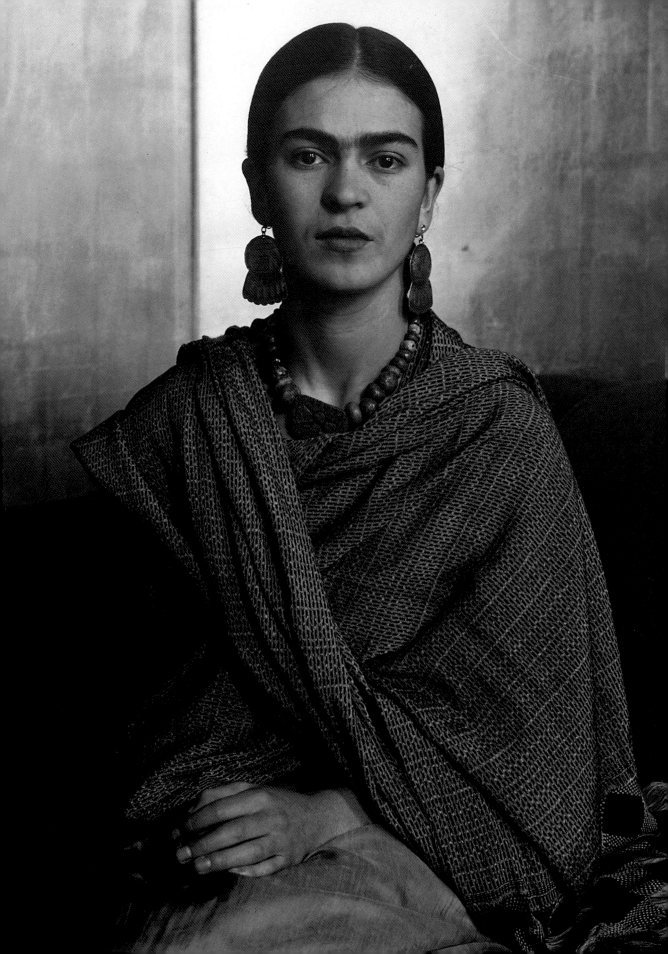

he hot winds of March had begun to blow when Ash Wednesday arrived and with it the meatless meals of Lent.

When we sat down to eat one Thursday, I noticed that Frida was very upset. She had just read a newspaper article that linked my father romantically with an attractive Hungarian painter. The reporter, who was a woman, declared that Rivera was going to marry the Hungarian as soon as he divorced his cur-

rent wife, the painter Frida Kahlo.

"At least this is between painters," Frida said. "I have to admit, Piquitos, that I'm not surprised. It won't be the first time your father has left one artist for another. Just remember how he abandoned Angelina Beloff for Marievna, when both of them were pregnant!"

Then she said, "Come on, let's go to the library. We can talk more comfortably there."

In the library she took out her hidden treasures to show me. There, in two wood-and-glass display cases, was the splendid pre-Columbian jewelry that my father had given her over the years. There also were her collection of folk toys and her *retablos* on votive themes. She showed me marbles made of old glass, in all sizes. The many-colored cat's eyes in the center made them seem like magical objects, whose shifting hues could predict the future.

We ended the afternoon consulting the work of Sigmund Freud. Frida had decided to paint something relating to the prophet Moses, about whom the Viennese master had written so brilliantly. She needed insight into Moses as a mythological figure. Her doubt about how much of Moses to see as human and how much as something else was reflected in her own work, where fantasy often substituted for reality, transforming it from a human ex-

perience into a superhuman or mythological one.

More evidence of Frida's search for identity was to be had the following day.

She was so angry at my father that she proposed we disappear. We left before daybreak the following day, with Cristina Kahlo in her little Ford. I had no idea where we were going. The only landmark I noticed, after we had driven the length of Insurgentes Avenue from south to north, was the road to Pachuca, capital of Hidalgo state. Then I realized we were going to San Juan Teotihuacán, a magical place not far from Mexico City.

In the ancient Nahuatl language Teotihuacán means "city of the gods." In those days the silence of a holy place still reigned over the site. When we arrived the sun was beating down on the pyramids and palaces of the city. Because at that hour the majestic Pyramids of the Sun and the Moon cast no shadows, they looked like two-dimensional drawings on a background of clear blue sky, as if we were gazing at a stage set lacking perspective or chiaroscuro contrast.

Frida was completely caught up in the spirit of the place. She reached automatically for the notebook she carried in her embroidered Otomi-style cloth handbag. Once again she sketched the silhouettes of the pyramids and the Temple of Butter-

Page 143: The Pyramid of the Sun, in Teotihuacán.
Page 144: Frida in San Francisco, 1931. Photographed by Imogen Cunningham.

flies, which stands next to the Pyramid of the Moon. She executed the sketch exactly as she had when she painted the portrait of Luz María, granddaughter of don Tomás Teutli and his wife Rosa, direct descendants of the builders of Teotihuacán.

In this portrait the girl wears a sweater made from local materials woven in a regional design. She is sitting in a chair; in the background we see a pale moon and a washed-out sun, celestial bodies half-extinguished by the child's presence, which boldly asserts her native identity. The pyramid's silhouette is also fuzzy, and the background is as somber as Frida's mood at the time of our visit.

Later Cristina drove us over a rough road to the edge of the holy city. Here was don Tomás's house, surrounded by magueys and organ cactus, agaves and prickly-pear plants. Don Tomás was standing in his doorway, and when he saw us, he cried, "Doña Frida! We've been waiting for you since yesterday afternoon! I felt the sadness that brings you to us. I'm very happy to see you have arrived safely. Please come in, come in to my home."

He gave us something to drink, then asked Frida to go with him through the hallway to the garden. When he had finished speaking and the talk turned to other things, that simple, quiet man was suddenly transformed into a menacing crea-ture like Quetzalcoatl, the Teotihuacán deity. A strange light shone in his eyes, and he spoke prophetic words.

"Niña Fridita," he said, "you have more suffering before you, but you will die sheltered and protected by the one who causes your present pain. You and don Diego will not be able to live apart. Sometimes you are united in love and affection, other times hatred keeps you apart. But you will die together and after your death be a single shining star, sun and moon in conjunction. Have no doubt, my dear girl; you are destined to live forever in this universe, each one merged with the other in eternal eclipse."

With these words his prophecy was finished, and he was once again the humble, mild-mannered peasant who had waited for us amid the agaves and magueys, in the doorway to his house, with the peace of time reflected in his face.

After offering us the traditional refreshment of *agua de chía*, doña Rosa invited us to eat. She had prepared a number of Lenten dishes typically served throughout the central Mexican plain, where the gods that Frida invoked in her paintings had once upon a time resided. As it turned out, doña Rosa and don Tomás extended their hospitality to us for three more days, days in which reality was inseparable from magic.

Overleaf: Lunch at the Teotihuacán house of Don Tomás Teutli and his wife, Doña Rosa.

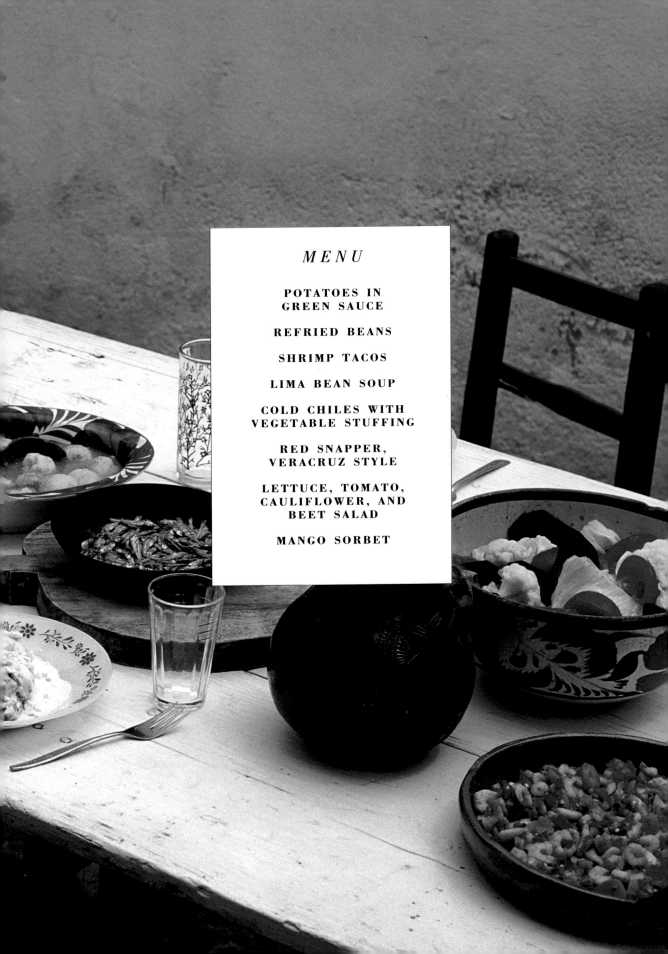

MENU

POTATOES IN GREEN SAUCE

REFRIED BEANS

SHRIMP TACOS

LIMA BEAN SOUP

COLD CHILES WITH VEGETABLE STUFFING

RED SNAPPER, VERACRUZ STYLE

LETTUCE, TOMATO, CAULIFLOWER, AND BEET SALAD

MANGO SORBET

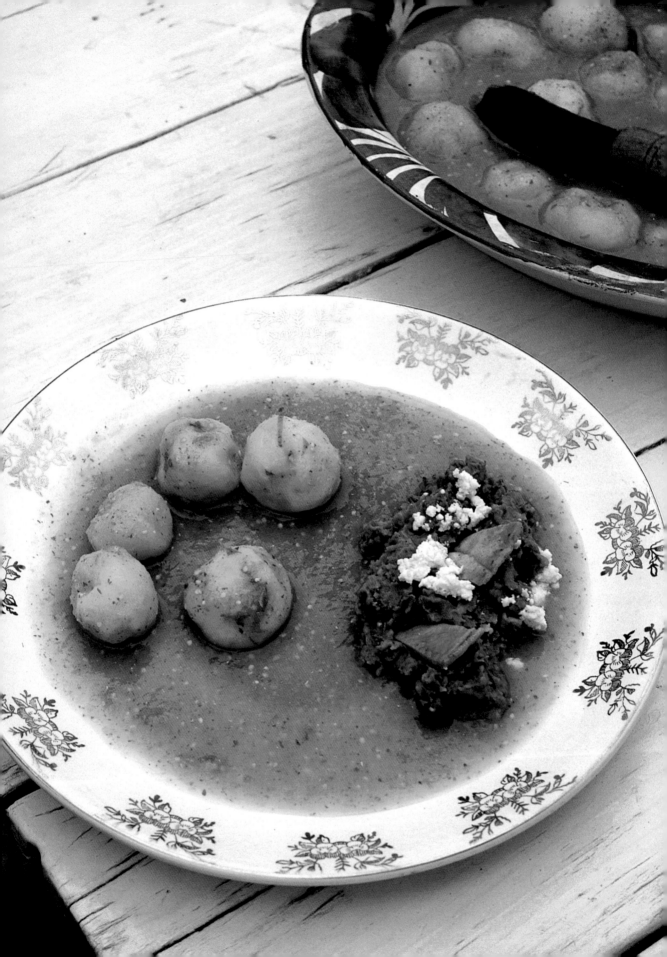

POTATOES IN GREEN SAUCE

(8 servings)

2 pounds/1k small potatoes

2 pounds/1k tomatillos, peeled

1 cup/250ml water

4 serrano chiles

Salt

¾ cup/100g coarsely chopped cilantro

2 tablespoons lard

1 large onion, finely chopped

Peel the potatoes and parboil them for 1 minute. Set aside. Simmer the tomatillos with the water, chiles, and salt to taste until tender. Let cool slightly, then puree with the cilantro. Heat the lard in a skillet and sauté the onion until translucent. Add the tomatillo puree and cook for 10 minutes. Stir in the potatoes and continue to cook until the potatoes are tender, about 15 minutes.

REFRIED BEANS

(8 servings)

½ pound/250g lard

1 onion, finely chopped

3 cups/500g cooked beans

1 cup/250ml cooking liquid from beans

Salt

Grated añejo cheese (or parmesan)

Totopos (fried small tortilla triangles)

Heat the lard in a skillet. When it starts to smoke, add the onion and sauté until golden. Add the beans and cooking liquid. Mash the beans to make a puree. Season with salt to taste. When the beans are well fried and pull away from the bottom of the pan when stirred, remove from the heat. Place the fried beans on a serving platter, shaping them into a log. Sprinkle with cheese and garnish with *totopos*.

SHRIMP TACOS

(8 servings)

1 medium onion, chopped

4 serrano chiles, chopped

4 tablespoons/65g butter

3 medium tomatoes, peeled, seeded, and chopped

Salt and pepper

1 pound/500g cooked shrimp

24 medium tortillas

Sauté the onion and chiles in butter until the onion is translucent. Add the tomatoes and salt and pepper to taste. Cook for 10 minutes, until the tomato is thoroughly cooked. If the sauce becomes too thick, thin it with a little chicken broth or water.

Add the shrimp and cook 2 minutes, just until they are heated through.

Fill the tortillas with the shrimp mixture and serve piping hot. Or serve the shrimp mixture with the tortillas on the side.

Opposite: Potatoes in Green Sauce and Refried Beans.

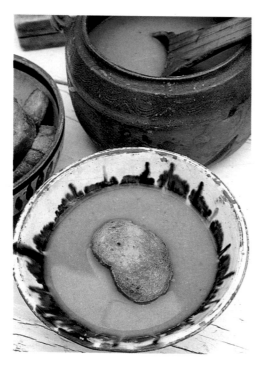

cook until tomatoes are thickened. Add the pureed beans and season with salt and pepper to taste. If necessary, add a small amount of chicken broth. Simmer for 15 to 20 minutes to blend flavors. Serve the soup piping hot, garnished with fried bread slices.

LIMA BEAN SOUP

(8 servings)

1 pound/500g dried lima beans

3 quarts/3 l chicken broth

4 tablespoons corn oil

1½ cups/450g tomatoes pureed with ½ onion and 1 garlic clove and strained

2 parsley sprigs

Salt and pepper

2 crusty rolls, sliced and fried

Soak the beans in cold water overnight. Drain and discard the water. Cook the beans in chicken broth until tender. Let cool slightly, then puree with their liquid. Heat the oil in a stock pot. Add the tomatoes and parsley and

COLD CHILES WITH VEGETABLE STUFFING

(8 servings)

16 poblano chiles, roasted, seeded, and deveined

2 medium onions, sliced

¼ cup/60ml white vinegar

1 tablespoon *each* fresh thyme, oregano, marjoram and cilantro

1 bay leaf

1 cup chopped cooked cauliflower

1 cup chopped cooked carrots

1 cup cooked peas

4 avocados, peeled and cut in cubes

2 scallions, finely chopped

½ cup/125ml olive oil

3 tablespoons vinegar

Salt and pepper

3 cups/750ml heavy cream

½ pound/250g añejo cheese, crumbled (or parmesan)

Place the chiles in a saucepan with water to cover. Add the onions, white vinegar, and herbs and cook until tender. Drain and let cool. Combine the vegetables with the oil, vinegar, and salt and pepper to taste. Stuff the chiles

Above: The Lima Bean Soup is garnished with a slice of fried bread.

with the vegetable mixture. Top with cream, sprinkle with cheese, and serve at room temperature.

RED SNAPPER, VERACRUZ STYLE

(8 servings)

1 red snapper (about
4½ pounds/2k)

Salt and pepper

6 medium tomatoes, sliced

20 pimento-stuffed olives

2 tablespoons capers, rinsed

1 tablespoon dried oregano

5 bay leaves

3 thyme sprigs

5 garlic cloves, peeled and
sliced

2 large onions, thinly sliced

8 güero chiles, pickled or
fresh

1 cup/250ml olive oil

Dry the fish thoroughly. Sprinkle with salt and pepper and arrange on a large baking dish. Top with tomato slices, olives, capers, oregano, bay leaves, thyme, garlic, onions, and chiles. Drizzle with the olive oil.

Bake in a preheated 375°/190°C oven for about 40 minutes, or until the fish is cooked, basting the fish with its juices 3 times during cooking.

LETTUCE, TOMATO, CAULIFLOWER, AND BEET SALAD

(8 servings)

1 head romaine, cut in chunks

4 medium tomatoes, peeled
and quartered

2 cups cooked cauliflower

2 beets, cooked and sliced

VINAIGRETTE

½ cup olive oil

2 tablespoons lime juice

1 teaspoon mustard

Salt and pepper

1 teaspoon honey

Arrange all the vegetables in a salad bowl. Dress with the vinaigrette.

To make the vinaigrette, combine all the ingredients in a jar with a tight-fitting lid. Shake to blend thoroughly.

MANGO SORBET

(6 to 8 servings)

½ pound sugar

½ cup water

2 cups mango pureed with
½ cup water

Combine sugar and water and heat until syrupy. Remove from heat. Stir in mango puree. Strain if desired. Chill, then place in an ice-cream maker and freeze according to the manufacturer's instructions.

APRIL

A Boat Ride in Xochimilco

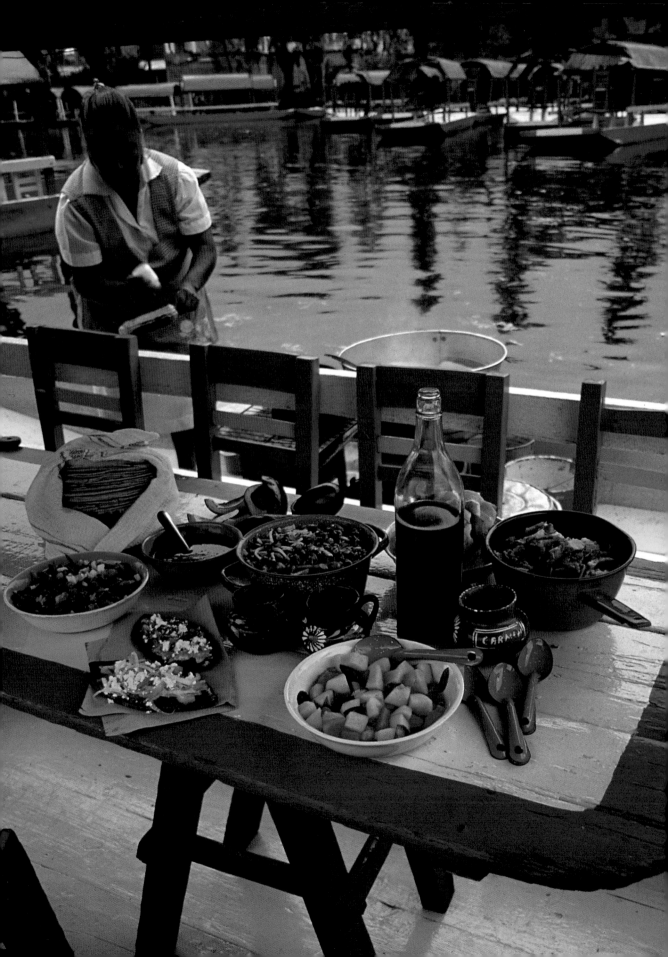

hat April was terribly hot, even in Coyoacán. To get away from the oppressive air that had taken over the house, Frida organized an outing to Xochimilco. At Xochimilco the water in the canals, the shade from the trees, and the freshness of the floating flower and vegetable gardens were certain to make the day more bearable. I thought it was an excellent idea. Frida invited Anita Misrachi, Lina Boytler, Milagros Carbajosa, and her

sister Cristina. The children who went along with us were Ruth and Aline Misrachi and my sister Ruth. It was a real adventure, even though all we had in mind was to spend a day in that incomparable spot, a true relic of ancient Mexico.

It turned out to be a real adventure because Frida decided that we should travel like the families with ten or twelve children who spent their Sundays boating on the lake's placid waters. And so instead of taking my father's Ford station wagon at Coyoacán, we caught the electric street car that would take us as far as the Tlalpan road; from there we went to the traffic circle at San Fernando, in the same town, where we transferred to the line that terminated at Xochimilco.

Frida thought it would be fun to sit in the second-class car so we could feel the wind in our faces. The only thing that separated us from the drivers of the other vehicles that sped along parallel to the street car rails and electric cables was a flimsy railing. The last stop of the Xochimilco line was in the garden in front of the huge church and marketplace of the legendary site. So at midday, after hours of travel— surrounded by the baskets of women on their way to buy vegetables and flowers at the floating gardens and the merchants themselves heading to market with their earthenware pots and pans and planters—

we arrived at our destination.

Flowers and plants from all over Mexico are still bought and sold at Xochimilco. In fact the Nahuatl word means "the place of the cutting gardens." Flowers and vegetables grown on the floating gardens can be bought freshly cut, while the market offers food prepared by the same people who from time immemorial have lived on the shores of the now almost vanished lakes that used to cover the floor of the Valley of Mexico.

These renowned cooks prepare a tremendous variety of stews that are native to the region, like *sopa aguada* and *sopa seca de tortillas*; beans with cheese, squash blossoms, and baby squash; *elote* stew with slivers of chile poblano; and other recipes that have been handed down for generations.

The fields at Xochimilco consist of countless plots built up out of highly fertile organic matter that the peasants have dredged from the bottom of the surrounding canals. The humidity rises into the soil and helps germinate the seeds. This soil is especially favorable for growing pre-Columbian plants like tomatoes, *huauzontles*, amaranth, corn, chayotes, Creole squash, and different kinds of chiles and beans, many of which Frida and Diego loved to eat. A number of plants introduced by the Spanish conquistadors are also grown

Page 155: *The* Viva Lupita, *one of the* trajineras *from Xochimilco.* **Page 156:** *The table is set with dishes for the picnic in the canal.*

there, including lettuce, radishes, onions, and carrots.

In other words, Xochimilco produces all of the vegetables that are commonly used in Mexican cooking. The farmers transport them in little boats called *chalupas*, selling them to passersby at the dock, or out of roofed flat-bottomed boats called *trajineras*, which ply the network of canals.

Arriving at the dock, visitors usually rent one of these skiffs. The bows are traditionally decorated with women's names, and the visitor has the chance to rent one named after his lady companion or someone dear to his or her heart. In honor of her friend Anita Misrachi, Frida chose a *trajinera* with "Anita" spelled in sunflowers, marguerites, and white and yellow carnations. She continued to observe local tradition by asking a group of marimba players to follow us in another boat so we could enjoy the romantic melodies they played on their fine wooden instruments. Mostly they sang love songs, like the one called "*María Elena*," the most typical of them all. The words go like this:

> Vengo a cantarte mujer
> mi más bonita canción,
> porque eres tú mi querer
> reina de mi corazón,
> no me abandones mi bien
> que eres todo mi querer,

> Tuyo es mi corazón
> ¡oh! sol de mi querer,
> mujer de mi ilusión,
> mi amor te consagré,
> mi vida la embellece
> una esperanza azul,
> mi vida tiene un cielo que le diste tú.

> Tuyo es mi corazón
> ¡oh! sol de mi querer,
> tuyo es todo mi ser, tuyo es mujer,
> ya todo el corazón te lo entregué,
> eres mi fé, eres mi Dios, eres mi amor.

After we had been rowing for some time on the lake's placid waters, a group of *chalupas* skippered by flower and vegetable merchants and people selling home-cooked food came up to us. They called to us to try their specialties, which at the time could only be found in that town. Today they are quite common delicacies—*tlacoyos* stuffed with squash blossoms, mushroom quesadillas, *huauzontles* stuffed with cheese in green-tomato sauce, and *romeritos* with sour prickly pears.

We had brought our own basket of delicacies: guacamole, seasoned pork sandwiches, *carnitas*, manzano chile sauce, red sauce, fruit salad, and, to make us even more festive, grenadine punch. We rounded out the menu with various items from "the *chalupa* merchants," as Frida called them, including tortillas, black bean soup with oregano and melted cheese, fresh lima bean salad, nopales salad, and

Overleaf: Trajineras *in the canals of Xochimilco, with vendors in their* chalupas. ***Pages 162–163:*** *A detail of the gaily painted* trajineras; *these were among Frida's favorite colors.*

refried beans with cheese and plum ta-
males. A peasant pulled up in his *chalupa*
with sweet maguey water, so fresh that it
had not yet fermented into pulque.

We were about to eat when the oars-
man brought the skiff to a sudden stop and
asked Frida, in a worried voice, if we had
any interest in joining the battle of flowers
that was taking place in the canal we were
traveling toward. In this event, local girls
took to the water in a flotilla of boats filled
with bouquets of flowers, which they
would throw at other boats piloted by boys
from the neighborhood and students who
had taken advantage of the weekend to go
rowing in the cool shadows of the trees
that lined the canals of Xochimilco.

Frida was delighted by the prospect.
To the surprise of the locals, who had no
idea who these odd people were, we threw
ourselves into battle. Flowers rained down
on us from all directions. Every time one
hit us in the face we broke into laughter,
wondering if the blow (which was more
like a caress) had come from a rose, a car-
nation, a marguerite, a lily, or a combina-
tion of the above. We shouted "Hit by a
rose!" or "Look where the lily landed!"

A marimba band played the whole time
we took part in the battle between girls
and boys. This was the end of our adven-
ture on the Xochimilco canals, surrounded
by flowers and music.

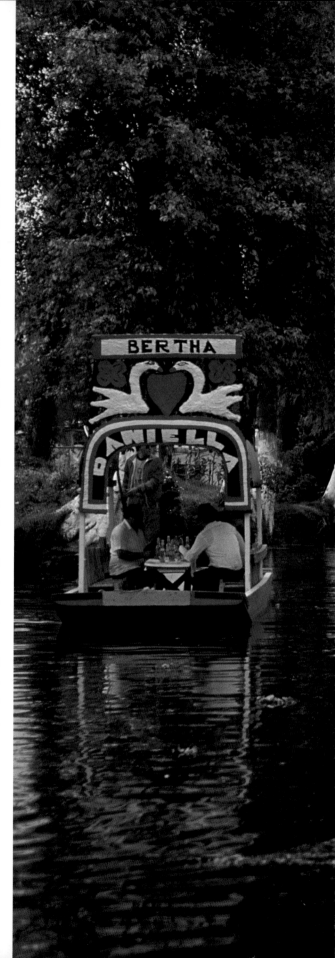

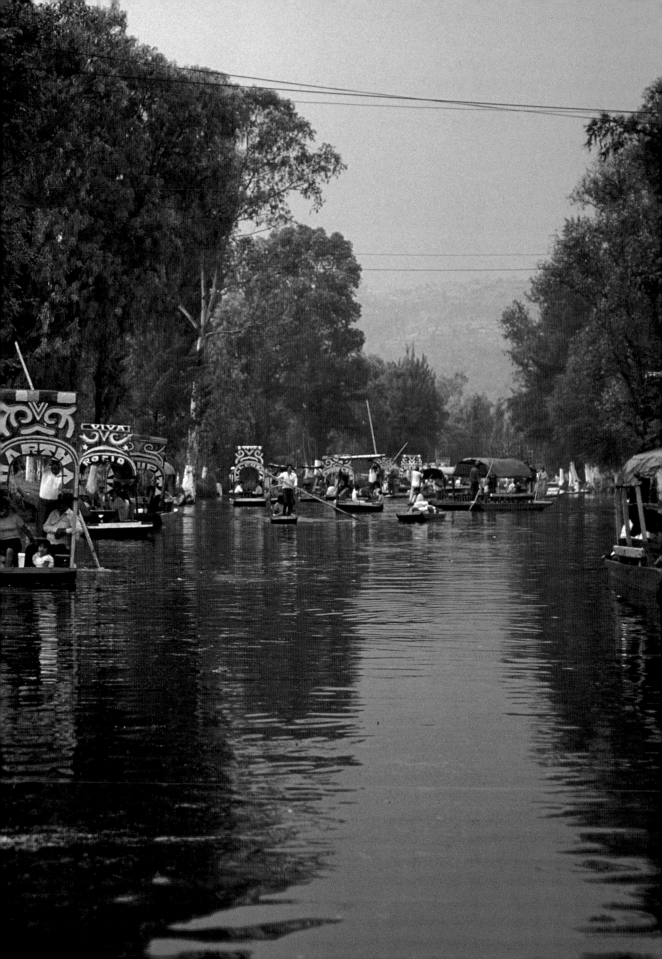

MENU
BLACK BEAN SOUP

FRESH LIMA BEAN SALAD

NOPALES SALAD

CARNITAS

SEASONED PORK ROAST

PORK SANDWICHES

GUACAMOLE WITH CHIPOTLE CHILES

FRUIT SALAD

COCONUT ICE CREAM

BLACK ZAPOTE ICE

GRENADINE PUNCH

BLACK BEAN SOUP

(8 servings)

2 tomatoes, roasted and peeled

½ onion

1 garlic clove

1 teaspoon dried oregano

Salt

2 tablespoons corn oil

3 cups/500g cooked
black beans

6 cups/1,5 l cooking liquid
from beans (or water)

GARNISH

Dried oregano

½ pound/250g
panela cheese, cut in small
squares (or muenster or
mozzarella)

3 tortillas, cut in small
squares, fried in oil,
and drained

Puree the tomatoes with the onion, garlic, oregano, and salt to taste. Sauté in hot oil until thickened. Puree the beans with their cooking liquid. Add the bean puree to the tomato mixture and cook for 5 to 10 minutes to blend the flavors. Serve the soup garnished with oregano, cheese, and tortilla squares.

FRESH LIMA BEAN SALAD

(8 servings)

6 pounds/3kg fresh lima
beans, shelled

Salt and pepper

1 onion, finely chopped

2 to 3 serrano chiles, finely
chopped

¼ cup/30g finely chopped
cilantro

½ cup/125ml olive oil

4 tablespoons vinegar

Rinse the lima beans. Place in a saucepan with water to cover and salt to taste. Cook for about 15 minutes, or until tender. Rinse in cold water and drain thoroughly. Combine the beans with the onion, chiles, cilantro, oil, vinegar, and salt and pepper to taste. Chill. Serve very cold.

NOPALES SALAD

(8 servings)

16 medium nopales, needles
removed, cut in strips, and
rinsed under running water

4 medium tomatoes, peeled,
seeded, and chopped

1 large onion, chopped

3 serrano or jalapeño chiles,
chopped

¼ cup/30g chopped cilantro

½ cup/125ml olive oil

2 tablespoons vinegar

Salt

Cook the nopales in plenty of water to remove the slippery coating. When tender, rinse in cold water. Soak a dish towel in cold water and wrap it around the nopales. Squeeze tightly and let stand 20 minutes so that any remaining slippery substance can drain through.

Combine the tomatoes, onion, chiles, cilantro, oil, and vinegar in a salad bowl. Season

with salt to taste. Stir in the nopales and mix well. Serve cold.

CARNITAS

(8 servings)

3 pounds/1,500g boneless pork from the leg, cut into 2-inch cubes

2 large onions, cut in half

4 garlic cloves

Salt

2 tablespoons lard

1½ cups/375ml milk

Place the pork in a saucepan with water to cover, the onions, garlic, and salt to taste. Cook for about 1 hour, until the pork is tender. Drain thoroughly and discard the onion and garlic.

Heat the lard and milk with salt to taste in a large saucepan. Add the pork pieces and cook, stirring often, until the milk cooks away completely and the meat is golden.

SEASONED PORK ROAST

(8 servings)

6 guajillo chiles or 3 ancho chiles, roasted, seeded, and deveined

2 cups/500ml water

1 cup/250ml vinegar

1 or 2 large garlic cloves

½ large onion

1 tablespoon dried oregano

Salt

3 pounds/1,500g boneless pork from the leg or butt

1 tablespoons lard

Bring the chiles and the water to a boil. Remove from heat and cool slightly. Puree the chiles and 2 cups cooking liquid with the vinegar, garlic, onion, oregano, and salt to taste.

Pierce the pork all over with a kitchen fork. Brown it in hot lard in a casserole. Pour the chile puree over the pork, cover, and roast in a preheated 375°F/190°C oven for 1 hour. Uncover and continue roasting for 30 minutes, or until the pork is tender and the sauce has reduced. Let cool completely, then slice very thin.

PORK SANDWICHES

(8 servings)

8 crusty rolls

2 avocados, mashed

1½ cups/100g refried beans (see page 151)

Seasoned pork roast, sliced thin (see preceding recipe)

8 chipotle chiles in marinade, chopped

16 tomato slices (optional)

16 onion slices (optional)

Salt

Cut the rolls in half and heat them in the oven. Spread mashed avocado on half of each roll, and refried beans on the other half. Top the beans with sliced pork, chiles, and tomato and onion, if you like. Sprinkle with salt. Close the sandwiches and place them in a preheated 350°F/175°C oven until heated through or serve them as is.

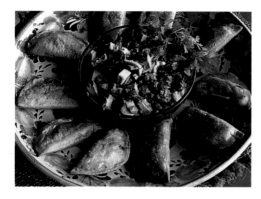

GUACAMOLE WITH CHIPOTLE CHILES

(8 servings)

4 ripe but firm avocados, peeled

½ medium onion, chopped

1 large tomato, peeled, seeded, and chopped

¼ cup/30g chopped cilantro

4 chipotle chiles in marinade, chopped

Salt to taste

Soak the chiles in hot water for 10 minutes, combine all the ingredients and mix well.

FRUIT SALAD

(8 servings)

3 cups watermelon cubes

3 cups cantaloupe cubes (or other melon)

Juice of 2 limes

½ cup/60g mint leaves

Sugar

Combine all the ingredients with sugar to taste and mix well. Refrigerate for at least 30 minutes before serving.

COCONUT ICE CREAM

(8 servings)

4 cups/1 l milk

1¼ cups/240 g sugar

fresh coconut, peeled and finely grated

1 teaspoon vanilla extract

Combine the milk, sugar, and coconut in a saucepan. Simmer for 30 minutes. Remove from the heat and let cool to lukewarm. Stir in the vanilla and puree. Refrigerate. When the mixture is cold, place in an ice-cream maker and proceed according to the manufacturer's directions.

BLACK ZAPOTE ICE

(6 to 8 servings)

1 cup/190g sugar

1 cup/250ml water

1½ cups black zapote pulp, strained

Combine the sugar and water in a saucepan. Bring to a boil and simmer for about 3 minutes. Let cool slightly. Stir in the zapote pulp. Place the mixture in an ice-cream maker and proceed according to the manufacturer's directions.

GRENADINE PUNCH

1 quart/1 l white tequila

Juice of 20 limes

1 quart/1 l grenadine syrup

Ice

Place all ingredients in a large bowl and mix well. Serve as an aperitif.

*Above: Guacamole with Chipotle Chiles. **Opposite:** Coconut Ice Cream and Black Zapote Ice.*

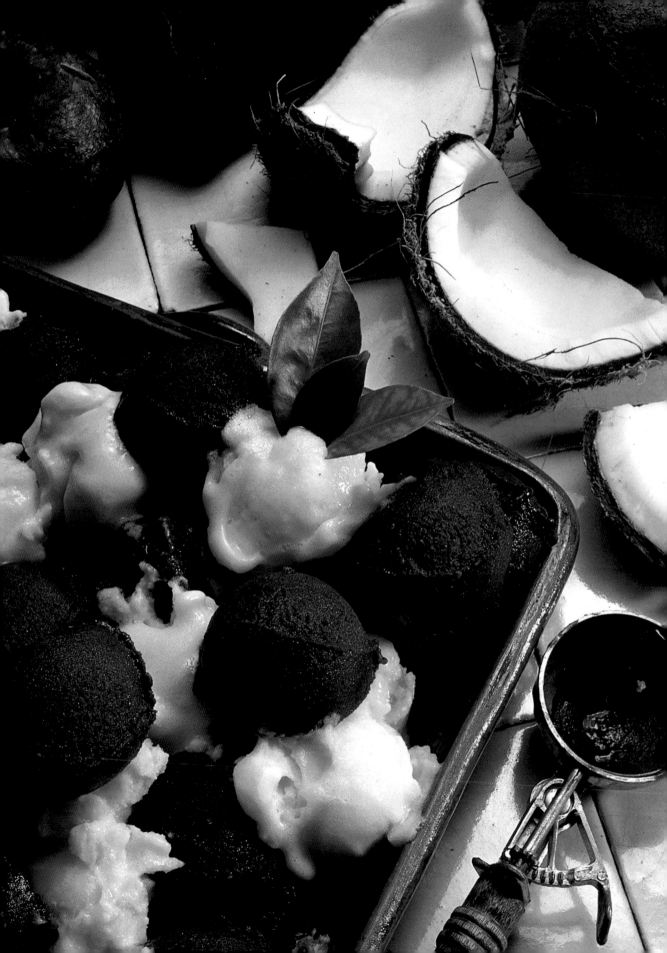

MAY

The Holy Cross

or the many months prior to my arrival at Coyoacán, Frida and Diego had been busy with plans to build two new studios where they could work in peace. San Angel, where their studios were then located, was becoming a high-priced neighborhood. The studios that Juan O'Gorman designed had been swallowed up by a sea of houses, bungalows, and mansions that stood where there once were plum and pear orchards.

Frida and Diego wanted nothing more than to work in peace and quiet. They decided to build a new studio for Frida on the terrace behind the Blue House and one for my father in the nearby village of San Pablo Tepetlapa. Diego's studio was to be built entirely of the local volcanic rock. They would call it Anahuacalli, which in Nahuatl means "Anahuac's house."

In those days San Pablo Tepetlapa was completely cut off from the metropolitan area, surrounded on the north, south, and west by lava fields, desert growth, and a scattering of scrub oaks, mesquite, coral trees, and pepper trees that managed to grow between the rocks. It was a gray landscape relieved by splotches of green and the blue of the sky, and it appealed to the imagination first of the Master Painter and later of the Master Painter Frida, who always shared his opinions, whether they were of politics or art.

My father remembered his lessons as an architecture student and threw himself enthusiastically into the project. He drew up plans for both studios and decided to have them built by a group of master masons belonging to the old San Pablo guild of stonecutters. Every night Frida and Diego would go over the blueprints; on Friday they counted their money to see if they had earned enough to meet the masons' payroll.

One night Frida mentioned to Diego that José Olvera, the master builder, had been looking for him so they could discuss plans for the upcoming Feast of the Holy Cross. Everyone knew that in Mexico, on May 3, construction workers and members of traditional dance groups called *concheros* pay homage to Christ's Cross. The masons and day laborers had a big fiesta in mind, and they hoped my father would sponsor the event. Don Diego had earned this honor by sharing his joys and sorrows with the workers, in addition to being the chief architect. Of course Master Rivera accepted the offer, and because Fridu had also endeared herself to the workers, they invited her to be cosponsor.

In the early morning of May 3 the masons, led by don José, began decorating a wooden cross they had made out of leftover building materials. They set it atop the highest wall at the construction site and covered it with orange, white, yellow, and red paper flowers spread on a bed of green leaves. They also affixed tiny reflecting mirrors to catch the sunlight.

Around noon, when Frida and Diego arrived with their friends and family members—(myself included)—the workers sent thousands of rockets into the air. The local band showed up, and people began helping themselves to a fine pulque from Iztapalapa. The food was traditional with

Page 169: The Holy Cross always protects construction sites. Page 170: The Anahuacalli, the studio Diego built of volcanic rock in San Pablo Tepetlapa.

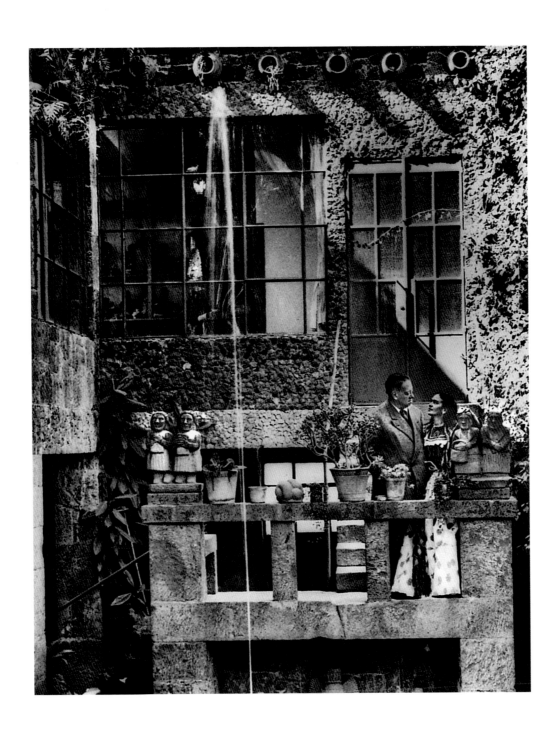

Above: *Diego and Frida on the terrace outside
her studio at the Blue House.*

the guild of masons and day laborers. Master Olvera contributed a duck that had been cooked in the way don Diego preferred, stuffed and garnished with lakeside herbs, packed in mud, and roasted in a specially prepared pit covered with maguey fronds.

Frida's gift to the workers was the songs that the mariachis sang nonstop. Not content with this—since she was a sponsor—she took it upon herself to sing some of the most popular tunes of the day. She made a point of singing one of her favorite songs especially for her famous husband. It is called "*La Chancla*" ("The Old Shoe"), and it tells of the pain and contempt that a wife feels for the husband who cheats on her. The words are as follows:

> You thought I'd never find
> A love like the one I've lost.
> But I've found one so fine
> I don't mind paying the cost.
>
> The king and queen of spades
> Thought to steal from me a trick,
> But I am not afraid
> For we all die pretty quick.
>
> I'll tell you something, friends,
> The way it really comes down:
> If they want me, pain ends;
> If they forget, I leave town.
>
> There's one favor, it's true,
> I am at a loss to ask:
> 'Cause if I fling this shoe,
> I will never take it back.

Instead of angering Diego Rivera, the song made him nearly die of laughter.

At the end of the party Frida brought out favors that she had had made for the masons, day laborers, and invited guests from Tepetlapa. Also handed out were little bulls made out of sticks and cardboard and rockets that don Diego had bought. The more daring boys held the rockets to their heads and chased the guests around and fought with boys who engaged them as if it were a bull fight. The bravest were rewarded with favors.

Leftovers from the earlier meal were reheated and served, including the lamb with "drunken sauce" (*salsa borracha*) made from fresh pulque, which Master Olvera had personally supervised; the meatballs in white broth and in chipotle sauce, provided by the day laborers; the beef and the beans prepared mason style; and, last but not least, the fritters in brown sugar syrup prepared on the spot by Romualda, the watchman's wife, and some of the women from Tepetlapa. Late that night, when the stars were out, we returned to Coyoacán.

*Opposite: Meatballs in Chipotle Sauce (see recipe on page 178),
Beans, Mason Style (see recipe on page 179), and Chilaquiles in Green Sauce
(see recipe on page 180), prepared with anafre and comal, as the
workers would. Overleaf: More dishes for the Lunch of the Holy Cross.*

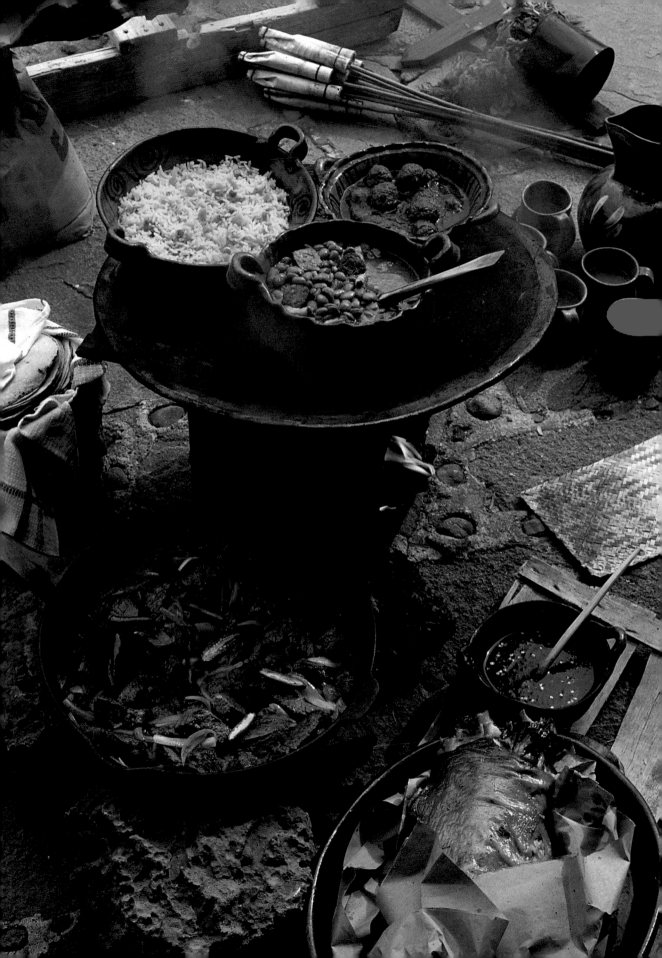

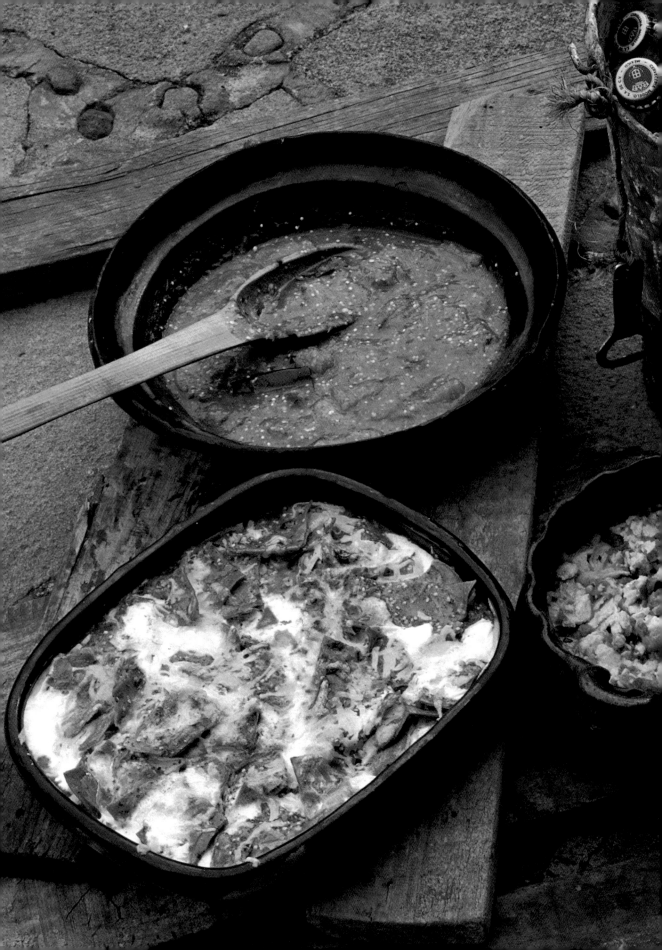

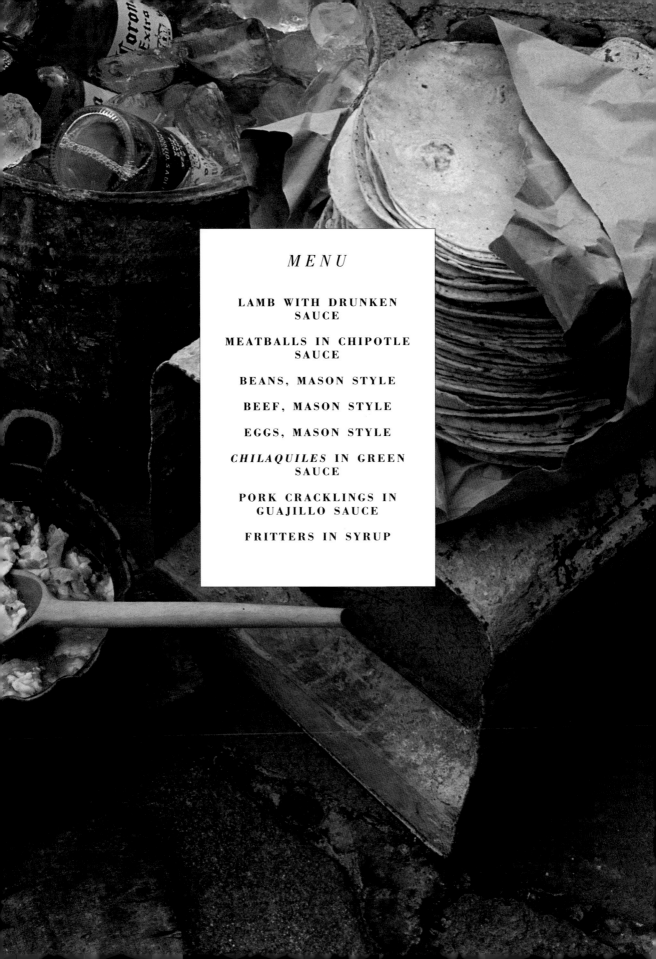

MENU

LAMB WITH DRUNKEN SAUCE

MEATBALLS IN CHIPOTLE SAUCE

BEANS, MASON STYLE

BEEF, MASON STYLE

EGGS, MASON STYLE

CHILAQUILES IN GREEN SAUCE

PORK CRACKLINGS IN GUAJILLO SAUCE

FRITTERS IN SYRUP

LAMB WITH DRUNKEN SAUCE

(8 servings)

1 large plantain (or banana)
leaf, toasted lightly to soften

3 pounds/1,500g lamb
rib chops in one piece or
leg of lamb

DRUNKEN SAUCE

15 guajillo chiles, toasted
and deveined

2 cups very hot water

4 garlic cloves

1 cup/250ml pulque (or beer)

Salt

Pour enough water into a *tamalera* or large steamer to cover the bottom of the pan. Place the plantain leaf on the steamer rack and top with the lamb. Fold the leaf over the meat to enclose it, then cover with a dish towel or cloth napkin. Cover the steamer and simmer for about 5 hours, being careful to keep enough water in the steamer to cover the bottom. Serve the lamb hot, accompanied by the Drunken Sauce.

To make the Sauce, soak the chiles in the hot water. Puree the chiles with 1 cup of the soaking liquid, the garlic, pulque, and salt to taste. If the sauce is too thick, thin it with as much of the soaking liquid as needed.

MEATBALLS IN CHIPOTLE SAUCE

(8 servings)

1 pound/500g ground pork

1 pound/500g ground beef

½ teaspoon ground cumin

2 garlic cloves, chopped

3 eggs

¼ cup/30g bread crumbs

Salt and pepper

CHIPOTLE SAUCE

6 chipotle chiles, pickled
or in marinade

6 medium tomatoes, roasted
and peeled

1 cup/250ml chicken broth

2 garlic cloves

3 cumin seeds

1 tablespoon dried oregano

2 tablespoons lard

Salt and pepper

Combine the pork, beef, ground cumin, garlic, eggs, bread crumbs, and salt and pepper to taste. Mix well. Shape the mixture into medium-size meatballs. Cook the meatballs in the Chipotle Sauce for about 25 minutes.

To make the Chipotle Sauce, puree the chiles, tomatoes, broth, garlic, cumin seeds, and oregano. Strain. Sauté the puree in hot lard and season with salt and pepper to taste. Bring sauce to a boil.

BEANS, MASON STYLE

(8 to 10 servings)

6 ounces/180g bacon, chopped

¼ pound/125g chorizo, sliced

½ onion, finely chopped

1 medium tomato, peeled and chopped

2 jalapeño chiles, roasted, peeled, and chopped

3 cups/500g cooked pinto beans

5 cups/1,25 l cooking liquid from beans

6 ounces/180g pork cracklings, cut in chunks

Salt

Cook the bacon over low heat until crisp. Add the chorizo and cook a few minutes more. Add the onion, tomato, and chiles. Sauté the mixture for a few minutes. Stir in the beans and cooking liquid. Bring to a boil, simmer for a few minutes, then stir in the pork cracklings. Simmer for 5 minutes to blend the flavors. Serve piping hot.

BEEF, MASON STYLE

(8 servings)

2½ pounds/1,250g beef sirloin, well trimmed and cut in 1-inch strips

4 tablespoons lard

Salt

2 large onions, sliced lengthwise

2 garlic cloves, chopped

4 jalapeño chiles, cut in strips and seeded

2 tomatoes, roasted, peeled, and chopped

Sauté the beef in hot lard until well browned. Season with salt to taste. Add the onions, garlic, and chiles. Simmer for about 2 minutes, stir in the tomatoes, and cook for about 10 minutes to cook through and blend the flavors. Serve piping hot.

EGGS, MASON STYLE

(8 servings)

5 large tomatoes, roasted and peeled

5 serrano chiles, roasted and peeled

1 garlic clove, roasted

½ onion, cut in half and roasted

Salt

12 eggs, lightly beaten

5 tablespoons lard

½ cup/125ml water

Puree the tomatoes, chiles, garlic, and onion. Season with salt to taste. Season the eggs with salt to taste and cook in hot lard to make soft scrambled eggs. Stir in the chile puree and water. Simmer the mixture for a few minutes to thicken it.

CHILAQUILES IN GREEN SAUCE

(8 servings)

24 medium tortillas, cut in triangles

Corn oil

1½ cups/375ml heavy cream

½ pound/250g Oaxaca cheese, shredded (or mozzarella)

SAUCE

30 tomatillos, peeled and chopped

½ cup/125ml water

½ cup/60 g chopped cilantro

5 or 6 serrano chiles

½ onion, chopped

Salt

2 tablespoons corn oil

Fry the tortilla triangles in hot oil until golden and drain on brown paper.

Cover the bottom of an ovenproof casserole with a small amount of sauce and cream. Top with half of the fried tortillas. Layer with half of the remaining sauce, half of the remaining cream, and half of the cheese. Top with the remaining tortillas, sauce, cream, and cheese. Bake in a preheated 350°F/175°C oven for about 20 minutes, or until the sauce is very hot and the cheese topping is puffy and golden.

To make the sauce, puree all the ingredients except the oil with salt to taste. Sauté the puree in very hot oil until the flavors blend and the sauce has thickened.

PORK CRACKLINGS IN GUAJILLO SAUCE

(8 servings)

6 guajillo chiles, roasted and deveined

30 tomatillos, peeled and chopped

½ cup/125ml water

Salt

½ cup/60g chopped cilantro

1 onion, finely chopped

3 tablespoons lard

½ pound/250g pork cracklings, cut in chunks

Cook the chiles, water, and salt for 20 minutes. Puree with the cilantro.

Sauté the onion in hot lard until translucent. Add the puree and simmer for about 5 minutes. Stir in the pork and cook for a few minutes.

FRITTERS IN SYRUP

(8 servings)

1 pound/500g *piloncillo*, cut in chunks (or 2½ cups dark brown sugar)

4 cups/1 l water

1 teaspoon star anise

1 recipe sugared fritters (see page 110)

Combine the sugar and water with the star anise. Bring to a boil and simmer for about 45 minutes, until thickened.

Make the fritters according to the recipe, cut thin into medium pieces before frying. Soak the fritters in hot syrup. Let cool.

Opposite: Fritters in Syrup, served in an earthenware casserole.

JUNE
The Meal of the Broad Tablecloths

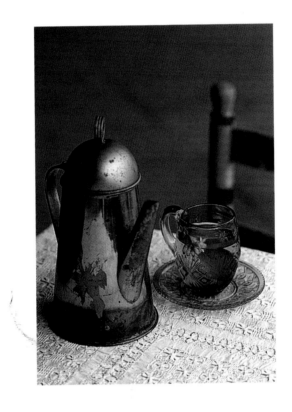

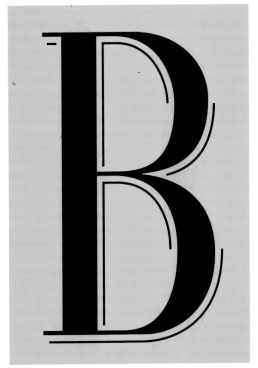

y June I had
been living in the Blue House for almost a year. One
day I came home from the university to find Frida
waiting for the arrival of some friends who were going
to advise her about an exhibit of her paintings. The
friends were Miguel and Rosa Covarrubias, Alberto
and Anita Misrachi, and Arcady and Lina Boytler. In
addition to being Frida's bosom buddies, these people
advised her on all matters pertaining to the sale and

display of her art. Don Alberto, my father's *marchand de Tableaux*, advanced him money when he could not meet his expenses. Anita, Rosa, and Lina—Frida's best friends—enriched her store of recipes with specialties of their own. These three ladies were in fact known nationally for their expertise in haute cuisine, be it international or Mexican. Rosa Covarrubias was especially famous for her Mexican food; an accomplished painter, she was also an innovative cook, an expert in the distinctive seasonings of the distant Mares del Sur, where she had lived for many years.

That afternoon Frida was also awaiting the arrival of Chabela Villaseñor, a friend with whom she used to spend rainy afternoons singing revolutionary anthems and popular songs of such great antiquity that virtually no one but Diego, Frida, and her chums remembered either the words or the tunes—although I must confess that I eventually learned them because they were such an important part of our life in the Blue House.

While the guests were arriving, Frida and I busied ourselves tasting all of the dishes that would be served at this "meal of the broad tablecloths," as Mexicans call such a special occasion. Frida seasoned each dish, remarking: "The *bacalao* must be absolutely spectacular or else my

bosom buddies Rosita, Anita, and Lina will ruin my reputation."

I was content to taste each of the dishes and hope that we could sit down soon and eat in earnest.

In the midst of these preparations my father arrived unexpectedly, whistling the opening bars of the "International." It was his password to let Frida know he was at the door. The three of us sat down at the kitchen table for a glass of tequila with salt and lemon, and Eulalia brought us a surprise appetizer of *pico de gallo* made of jícama, oranges, prickly pear, *xoconostle*, and piquin chile. It went well with the midday heat.

Soon the guests had all arrived, and something unforeseen happened. "The Covarrubias kid," as my father called the young painter, showed up with two elegantly attired gentlemen. They turned out to be the famous composer and conductor Carlos Chávez, a great friend of my father's and companion in artistic ventures, and Nelson Rockefeller, who had been a friend of the Riveras since their days in New York, in the early thirties. Frida was quite pleased to see them again and dashed immediately to the kitchen to "throw some more water on the beans," as we say, so that there would be enough for everyone to eat.

The meal was one hundred percent

Page 183: Orange blossom tea, a favorite of Diego's. Page 184: Tequila and Pico de Gallo Salad (see recipe on page 192) served before lunch in the kitchen of the Blue House. Opposite: Against the wall in the dining room of the Blue House are the shelves with Frida's collection of pottery. An arum bouquet sits on the table, covered with a lace cloth from Aquascalientes.

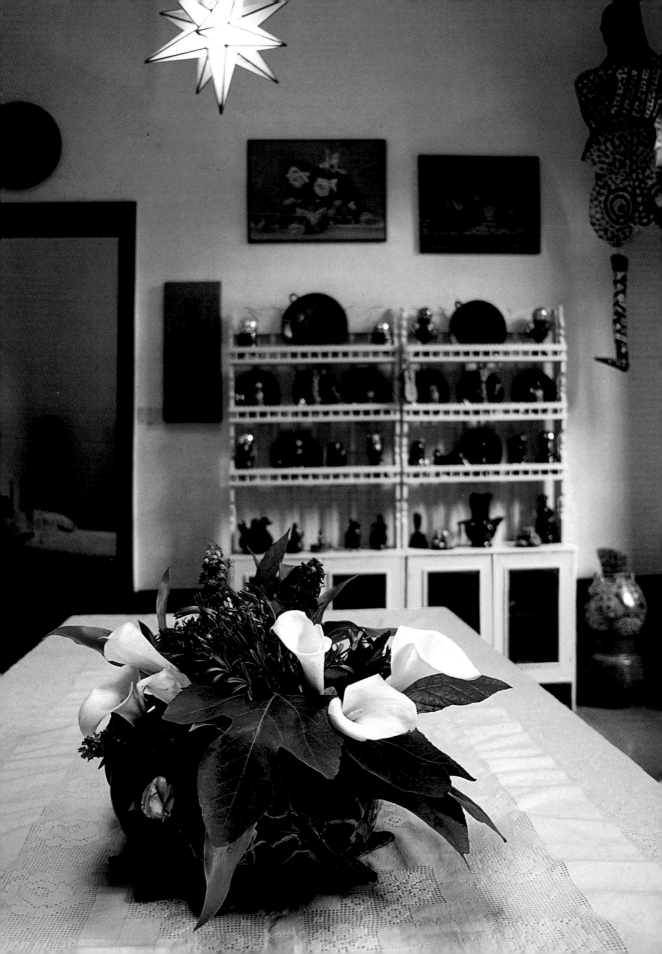

Mexican from start to finish. There were two kinds of soup, a succulent *bacalao* prepared according to a family recipe, pork ribs in sweet-sour sauce, potato tortitas, and zucchini salad. We also had the inevitable refried beans with cheese. A lime sorbet was served to refresh our palates before the dessert of stuffed pineapples and cat tongues, Frida's favorites. Some of the friends asked for coffee; my father drank orange-leaf and lemon-blossom tea. It was a truly splendid meal worthy of a kitchen that valued the best in traditional Mexican cuisine.

Master Rivera suggested to the guests that they take a stroll through the garden after dinner. He was proud of the way he had displayed several of his best archeological pieces in a small temple built for this purpose beneath a stand of old cypresses. One of the most beautiful and unusual pieces was a sculpture of Xilolen, goddess of young corn, who grasped two ears of fresh corn in her hands. Frida was in charge of providing frequent changes of sacrificial offerings to this goddess, as if she were actually presiding over the temple. There was also a gray stone coffer carved with scenes of homage to an important lord. My father took pride in explaining that the trunk had belonged to one of the lords of Mexico-Tenochtitlán, Axayucatl by name. According to my father, Ax-

ayucatl had conquered vast lands to the south of the Valley of Mexico and kept his most precious treasures in this same coffer. Rockefeller and Covarrubias, who were connoisseurs of this art, recognized the value of the collection and praised my father for his good taste and the authenticity of his display.

From there we went to Frida's studio, where she somewhat nervously showed us her latest painting: a very sensual still life of flowers and fruits on a round canvas smaller than the size she normally painted. The sexual connotations of these flowers and fruits were so strong that, arranged as they were side by side, they seemed to be making love. Frida and Diego's friends thought it a magnificent piece; they praised the colors and the brush work, but they were especially taken by the strange way in which Frida had expressed the sexual dimension of these objects, which for other painters were nothing more than the products of nature.

The following day, however, Frida sent the painting to the client who had commissioned it and got the opposite reaction. Doña Soledad Orozco de Avila Camacho, wife of the President of Mexico, General Manuel Avila Camacho, had commissioned the work for the dining room of the presidential palace, where it was to have had the place of honor. But when she saw

the work, the good lady found it to be indecent and, what is worse, personally offensive, and she ordered it returned to Frida at once.

Getting back to our dinner, or rather the end of it—our friends took their leave after toasting our surprise guests Carlos Chávez and Nelson Rockefeller. Papa, Frida, and Chabela walked them to the door singing the classic song of farewell, which goes, "I'm on my way to the port where a golden bark awaits to carry me away; I'm on my way, I've just come to say goodbye."

Above: Still Life *(tondo),* 1942. ***Overleaf:*** *A still life with corn, after a painting by Frida.*

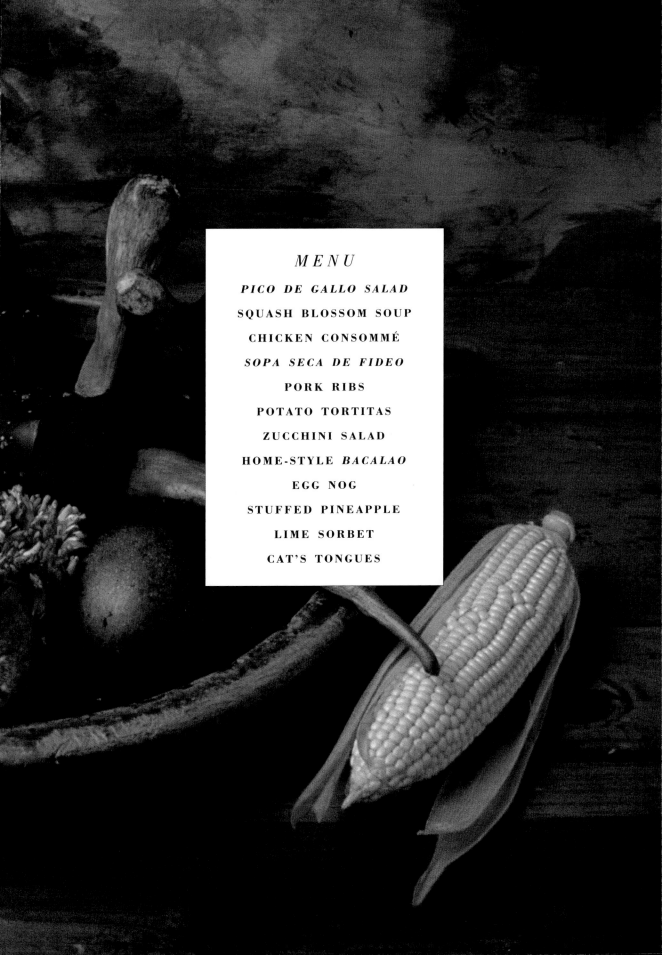

MENU

PICO DE GALLO SALAD

SQUASH BLOSSOM SOUP

CHICKEN CONSOMMÉ

SOPA SECA DE FIDEO

PORK RIBS

POTATO TORTITAS

ZUCCHINI SALAD

HOME-STYLE *BACALAO*

EGG NOG

STUFFED PINEAPPLE

LIME SORBET

CAT'S TONGUES

PICO DE GALLO SALAD

(8 servings)

2 medium jícamas, peeled
and sliced

6 white prickly pears, peeled
and sliced

4 *xoconostles* (sour prickly
pears), peeled and sliced

2 oranges, peeled and sliced

Salt

Piquín chile powder

Arrange the vegetable and fruit slices on a serving platter in an attractive design. Sprinkle with salt and chiles to taste.

SQUASH BLOSSOM SOUP

(8 servings)

1 large onion, finely chopped

4 tablespoons butter

2 ears corn, kernels
scraped off

3 poblano chiles, roasted,
peeled, seeded, and cut in
strips

1 cup/150g coarsely chopped
zucchini

2 cups/150g sliced mushrooms

4 cups squash blossoms, stems
and pistils removed and
discarded, blossoms coarsely
chopped

6 cups/1,5 l chicken broth

Salt

3 tortillas, cut in small
squares and fried

Heavy cream

Sauté the onion in butter until translucent. Add the corn, chiles, and zucchini. Cook for 2 minutes, then stir in the mushrooms and squash blossoms. Cook for 4 minutes, add the chicken broth, and bring to a boil. Simmer for 10 to 12 minutes and taste for salt. Serve the soup garnished with tortilla squares and heavy cream.

CHICKEN CONSOMMÉ

(makes 4 quarts/4 l)

5 quarts/5 l water

1 stewing hen, cut in chunks

1 pound/500g beef round

½ pound/250g veal

4 carrots

10 leeks

2 onions

Salt

Dry sherry

Chopped parsley

Chopped cilantro

Chopped serrano chiles

Heat the water in a stockpot. When it is lukewarm, add the remaining soup ingredients. Simmer for 4 hours.

Soak a napkin in cold water and wring it out. Spread the wet napkin over a strainer and strain the chicken broth through it. Return the broth to a saucepan and heat, stirring constantly, until it comes to a boil. Strain again through a napkin. To serve, add dry sherry to taste or garnish with chopped parsley or cilantro or serrano chiles.

Opposite: Squash Blossom Soup, served in a
decorated tureen from Puebla.

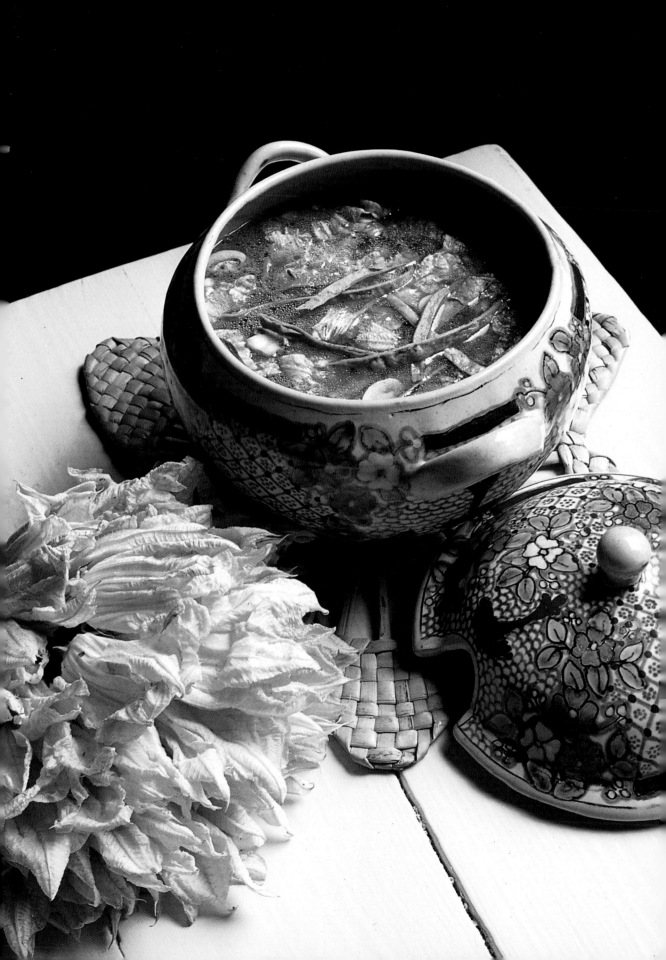

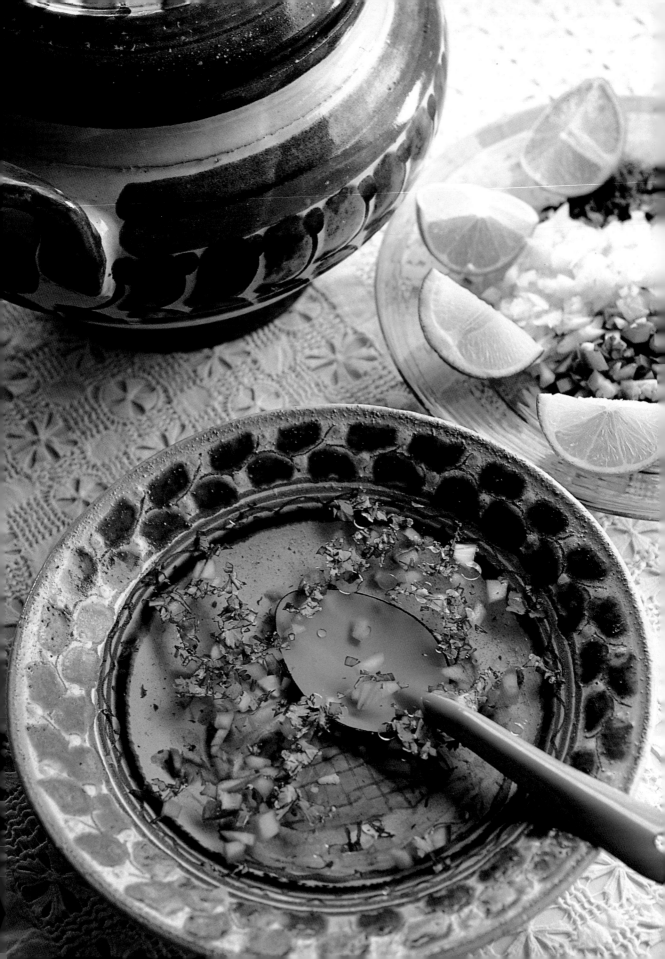

SOPA SECA DE FIDEO
(8 servings)

1 pound/500g thin noodles

Corn oil

10 medium tomatoes

1 medium onion

2 garlic cloves

Salt

3 parsley sprigs

2 cups/500ml chicken broth

Pasilla chiles, fried and chopped, to taste

2 avocados, peeled and sliced

1½ cups/375ml heavy cream

½ pound/250g añejo cheese, grated (or parmesan)

Sauté the noodles in hot oil in a saucepan until golden. Drain off all but 3 tablespoons of oil.

Puree the tomatoes with the onion, garlic, and salt to taste. Add the puree to the noodles and simmer together until the mixture has thickened. Add the parsley and chicken broth to cover. Cover the saucepan and simmer for about 20 minutes, until the noodles are tender and the broth absorbed; add more chicken broth if needed. Discard the parsley.

Pour the noodle mixture onto a heated serving platter and garnish with chiles, avocados, cream, and cheese.

Opposite: Chicken Consommé (see recipe on page 192), with garnishes.
Above: Sopa Seca de Fideo, with rings of avocado.

PORK RIBS

(8 servings)

8 pounds/4k pork spareribs
(1 rack)

1 lime

Salt and pepper

8 ancho chiles, roasted and
deveined

1 medium onion, coarsely
chopped

1 cup water

4 garlic cloves, peeled

2 tablespoons sugar

2 tablespoons lard

2 tomatoes, roasted, peeled,
and pureed

SWEET-SOUR SAUCE

3 large tomatoes, roasted,
peeled, and pureed

1 onion, finely chopped

¼ cup/60ml vinegar

2 tablespoons olive oil

2 teaspoons sugar

Salt

2 teaspoons dried oregano

1 cup/250ml canned pickled
jalapeño chiles, chopped with
the contents of the can

Rub the spareribs with lime, salt, and pepper.
Refrigerate overnight.

Simmer the chiles and onion in water for
about 8 mintues. Let cool slightly. Puree the
chiles and onion with the garlic, sugar, and salt
and pepper to taste. Drain.

Heat the lard in a skillet. Add the pureed
tomatoes and simmer until thickened. Add the
chile puree and simmer for 10 minutes to blend
the flavors.

Place the ribs in a deep baking dish. Cover
with the sauce and bake in a preheated 400°F/
205°C oven for 1 hour, or until the ribs are
golden brown and the sauce is reduced. Serve
with Sweet-Sour Sauce.

To make the Sweet-Sour Sauce, combine
all the ingredients in a saucepan. Bring to a
boil, then simmer for a few minutes to blend
the flavors. Serve the sauce lukewarm or cold.

POTATO TORTITAS

(8 servings)

2 pounds/1k potatoes, cooked,
peeled, and mashed

1½ cups/375ml boiling milk

4 tablespoons/30g flour

4 tablespoons/65g butter,
softened

Salt and pepper

Corn oil

Combine all the ingredients except the oil, mix-
ing well. Shape into patties. Fry the patties in
hot oil, turning once carefully, until golden on
both sides. Drain on brown paper and serve
piping hot.

ZUCCHINI SALAD

(8 servings)

6 small zucchini, rinsed well,
cooked, and sliced

2 avocados, peeled and sliced

Salt

2 tablespoons chopped
cilantro

3 ounces añejo cheese,
crumbled (or parmesan)

VINAIGRETTE

6 tablespoons olive oil

3 tablespoons vinegar

1 teaspoon salt

½ teaspoon sugar

Arrange the zucchini and avocado slices in a salad bowl. Salt to taste. Sprinkle with the cilantro, cheese, and vinaigrette.

To make the vinaigrette, place all the ingredients in a jar with a tight-fitting lid. Cover the jar and shake well to blend.

HOME-STYLE
BACALAO

(8 to 10 servings)

3 pounds/1,500g *bacalao*
(dried cod)

1 cup/250ml olive oil

3 onions, thinly sliced

8 garlic cloves, thinly sliced

2 pounds/1k tomatoes,
roasted, peeled, and pureed

½ cup/60g chopped parsley

½ cup/120g pimento-stuffed
olives

¼ cup/30g capers, rinsed

¼ cup/30g blanched almonds,
coarsely chopped

¼ cup/30g raisins

2 pounds/1k potatoes, peeled,
cooked, and cut in cubes

5 canned roasted red peppers

1 8-ounce can güero chiles

Salt

Soak the *bacalao* in cold water for a day and a half, changing the water frequently.

Drain the fish, place in a saucepan and add water to cover. Simmer about 30 minutes, until tender. Let the fish cool, then finely shred it.

Heat the oil and sauté the onions and garlic until the onions are translucent. Add the pureed tomatoes and parsley. Simmer for about 10 minutes. Add the olives, capers, almonds, raisins, and potatoes. When the sauce has thickened, add the fish and simmer for a few minutes more. Stir in the red peppers and chiles, either whole or cut, and taste for salt.

Above: *Homestyle* Bacalao.

EGGNOG

(8 to 10 servings)

2 quarts milk

4 cinnamon sticks

1 teaspoon freshly grated nutmeg

2½ cups sugar

6 large egg yolks

½ teaspoon baking soda

2½ cups rum or *aguardiente*

Combine the milk, cinnamon, and nutmeg. Bring to a boil, reduce the heat, and simmer for 20 minutes. Add the sugar, stirring constantly until dissolved. Simmer for 30 minutes, let cool, and strain.

Beat the egg yolks until thick and stir into the milk. Add the baking soda and bring to a boil. Remove from the heat and let cool, stirring occasionally to prevent a skin from forming on the surface. When thoroughly cool, add the rum or *aguardiente*.

STUFFED PINEAPPLE

(8 servings)

1 large ripe pineapple

1 cup/250ml heavy cream

6 tablespoons/30g confectioners' sugar

12 cherries in syrup, chopped

½ cup/100g pine nuts, finely chopped

Keeping the leaves intact, cut a slice off the top of the pineapple and reserve. Scoop out the pulp, core it, and finely chop it.

Whip the cream with the sugar until stiff. Gently fold in the chopped pineapple, cherries, and pine nuts. Spoon back into the pineapple shell and refrigerate for at least 2 hours until the filling sets slightly.

LIME SORBET

(8 servings)

4 cups/1 l water

2 cups/380g sugar

1 tablespoon grated lime zest

1 cup/250ml lime juice

Combine the water, sugar, and zest. Bring to a boil, then simmer for about 3 minutes. Let cool to lukewarm, then add the lime juice. Chill thoroughly. Place the lime mixture in an ice-cream maker and proceed according to the manufacturer's instructions.

CAT'S TONGUES

(50 to 60 cookies)

8 tablespoons/120g butter

scant ⅔ cup/120g sugar

3 egg whites

1 teaspoon vanilla extract

¾ cup/120g flour, sifted

Cream the butter and sugar together. Add the egg whites, one at a time, stirring well after each addition. Stir in the vanilla, then the flour.

Place the dough in a pastry bag fitted with a round tip. Butter and flour several baking sheets. Pipe strips about 2 to 3 inches long and as thick as a pencil onto the baking sheets, leaving enough space for the cookies to expand while baking. Bake in a preheated 425°F/220°C oven for 6 to 8 minutes. Remove and cool on a rack. Store in an airtight container.

Opposite: A dish of Cat's Tongues and Eggnog in a glass carafe from Guadalajara.

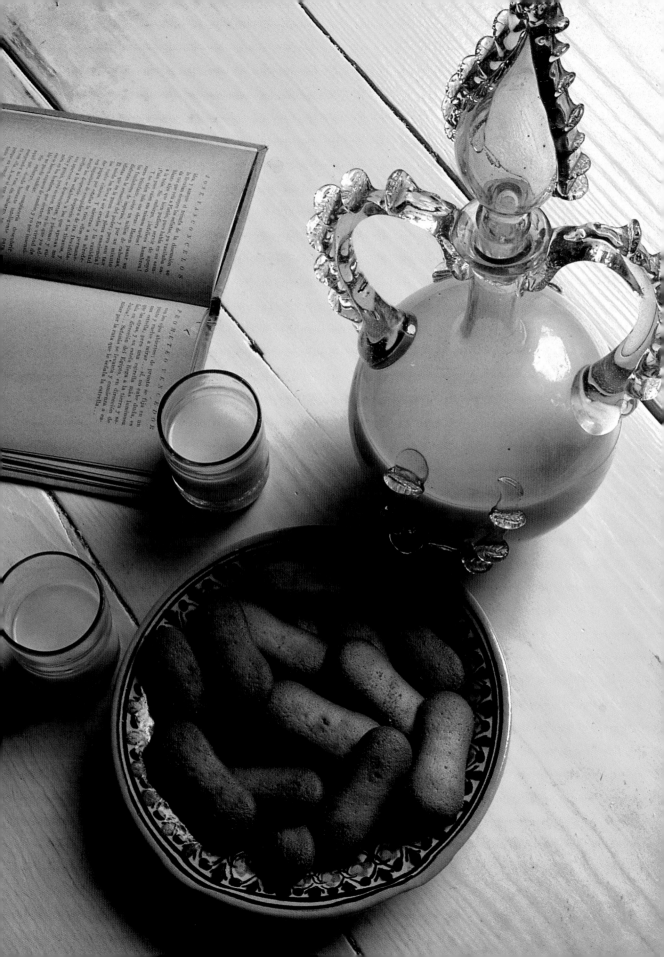

JULY

Frida's Birthday

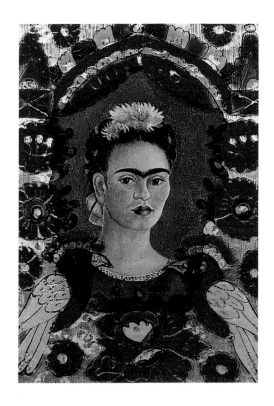

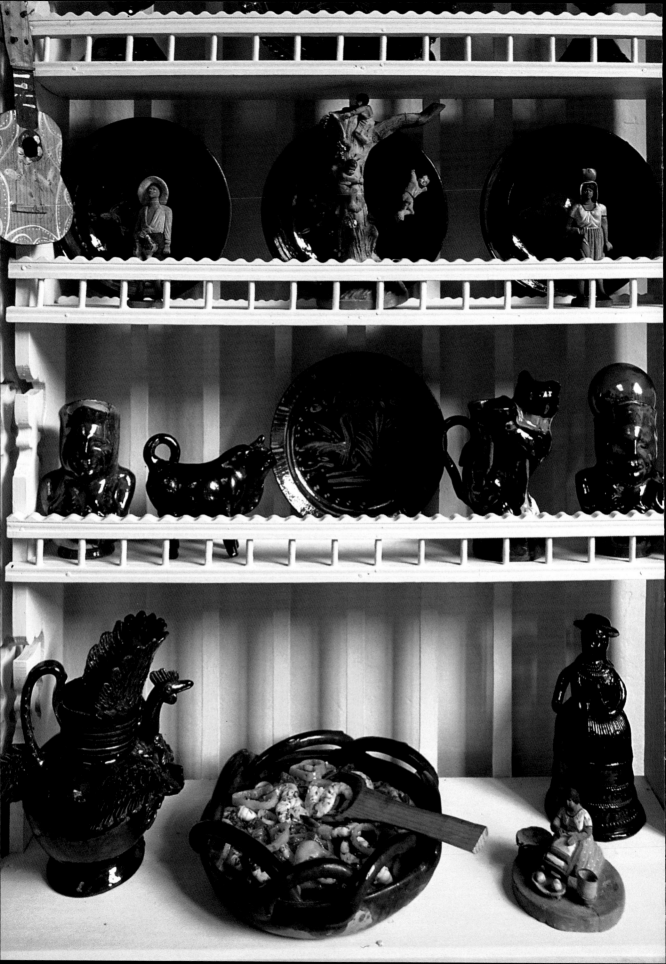

iving with Frida was an education in itself. I learned about cultural values I had been ignorant about until then. Frida would talk about Freud and psychoanalysis or García Lorca and poetry as easily as she spoke of painting and music. In order to keep up with her, I had to read quite a few of the books in her library and others that she and my father gave me. She accepted me without reservation into the heart of her daily life,

teaching me how to get along with the people who took care of the house, people like Eulalia, Chucho, Rosenda, and Inés the carpenter. She also introduced me to the people who came to visit her from Paris, London, and New York. It was a world of contrasting feelings and emotions.

A few days before her birthday on July 6, Frida decided to give a big dinner party. As was often the case, she did not have much money to spend on the celebration, so the first thing she did was finish a painting that Marichu Lavin had commissioned, a magnificent portrait in which Marichu appears in the center of a great medallion-like frame, dressed in a *huipil* embroidered with brilliantly colored flowers. This is the style of the Yucatec mestizo women of southern Mexico who embroider their clothes and are famous for their dancing. Marichu was from that part of the country.

With the payment in her pocket, Frida invited half of Mexico to the party. She hired mariachis and asked Concha Michel and Chabela Villaseñor to arrive dressed like Tehuana women, guitars in hand. The guests were advised to come "ready to eat every kind of food, to let their hair down and to sing their hearts out," since the party would last well into the night.

It was as much fun preparing the menu as drawing up the guest list. There were of course many kitchen consultations. Frida

loved to hear Eulalia talk about what people were eating that day in Ixtapalapa, a town famous for its game, especially duck, turtledoves, and *chichicuilotes*, which were hunted along the lake. Chucho described what his family used to eat in his home town in southern Oaxaca, while Rosenda spoke of how corn was used in Michoacán cuisine. I contributed recipes from my grandmother Isabel. We were all talking about Mexican cooking and Frida showed me *The New Mexican Cook*, with its dictionary format. It had belonged to doña Matilde, her mother. Frida read a few of the recipes out loud, selecting delicacies for the birthday party.

At one o'clock in the afternoon of July 6, the guests started arriving, loaded down with presents. Rosenda and Chucho greeted them at the door of the Blue House and handed them their choice of a glass of tequila, a mug of beer, or a jug of almond-cured pulque. At two o'clock Concha, Chabela, and the mariachis made their appearance, shattering the calm of the Carmen district with their rendition of "*Las Mañanitas*," played in honor of the birthday girl. At three we began helping ourselves to the contents of the endless pitchers, platters, plates, and bowls, large and small, that filled the tables beneath the trees of the garden. There was pulque, tequila and other refreshments; the red

Page 201: Self-Portrait *(The Frame), c. 1938.* *Page 202:* Shrimp
Escabeche *(see recipe on page 209) in the dining room of the Blue House.*

oilcloth tablecloths had been decorated with arrangements of pears, grapes, apples, bananas and oranges, and colorful paper napkins with fringes had been chosen to complement the fruit.

Frida kept the tables supplied with shrimp broth as a taste teaser and enormous rustic pots filled with pork stew, pork and nopales in green *pipián* sauce, and mole poblano. There were huge platters laden with chicken escabeche and pig's feet. There were also salad bowls, one of which contained beans, radishes, and panela cheese and the other, watercress, tomatoes, and avocados. Earthenware bowls held a variety of sauces.

The desserts had been placed in the middle of their own table. In addition to the sweet potato–pineapple dessert, mamey mousse, and pine nut flan, there were platters of traditional Mexican sweets of the kind that are still sold in the La Merced market. Frida was especially fond of the meringues, nougats, and taffies because they reminded her of her childhood, when after school, with just a few pennies in hand, she would play heads-or-tails with her favorite sweetshop owner and come away with a nice sampling of sweets. It came as no surprise, then, that there were nougats in abundance that day; Frida had decided to give them to herself as a birthday present.

After eating their fill, the guests wandered around the house, the majority of them gravitating toward the mariachis. The yells that went with the revolutionary songs could be heard all over the house— only Frida's laughter was loud enough to rise above them. There was a downpour, but still the party went on. When the rain finally tapered off well after dark, people began to leave. Concha, Chabela, and the mariachis said their farewell, singing tunes like *"Las Golondrinas,"* which speak of love and the pain of farewell.

Before we went to bed Frida opened the presents she had not been able to open earlier. Her friends and family were well versed in her preferences, which I suppose is why she received two bottles of Schiaparelli's "Shocking," her favorite perfume. She was also given two turn-of-the-century dolls still wearing their original silks, velvets, and laces, and many other gifts including a handbook of magic and witchcraft from someone with wicked intentions. The gifts she treasured the most, however, were two necklaces from my father, one made of jade beads and the other of marvelous hand-carved coral, from Teotihuacán. She was so fond of these necklaces that she wore them when she posed for several self-portraits. These were her real birthday present, worthy of her and her illustrious husband.

***Overleaf:** Tortillas being prepared on the kitchen range in the Blue House.*

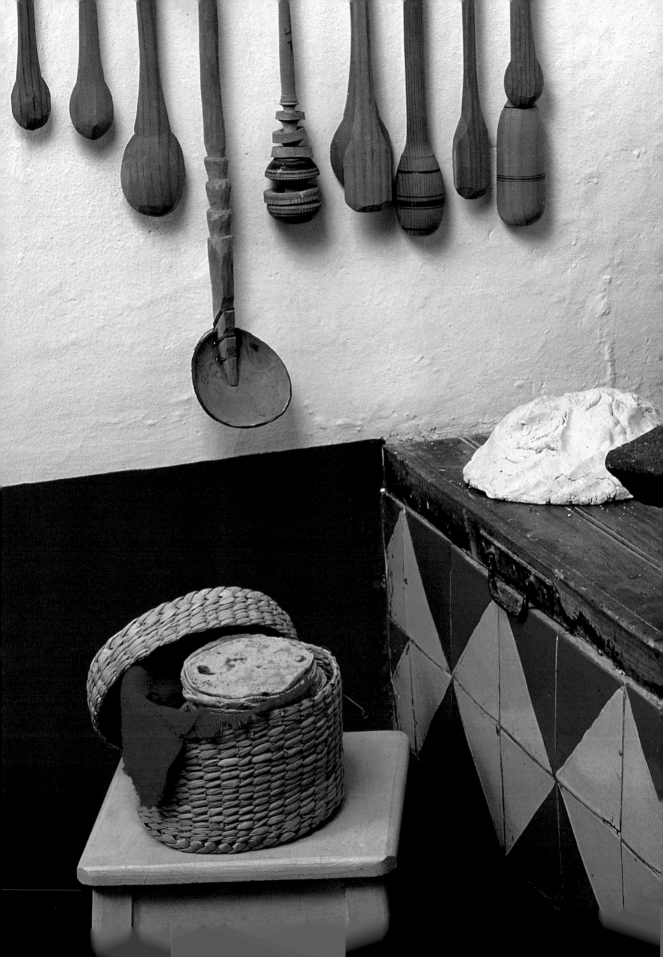

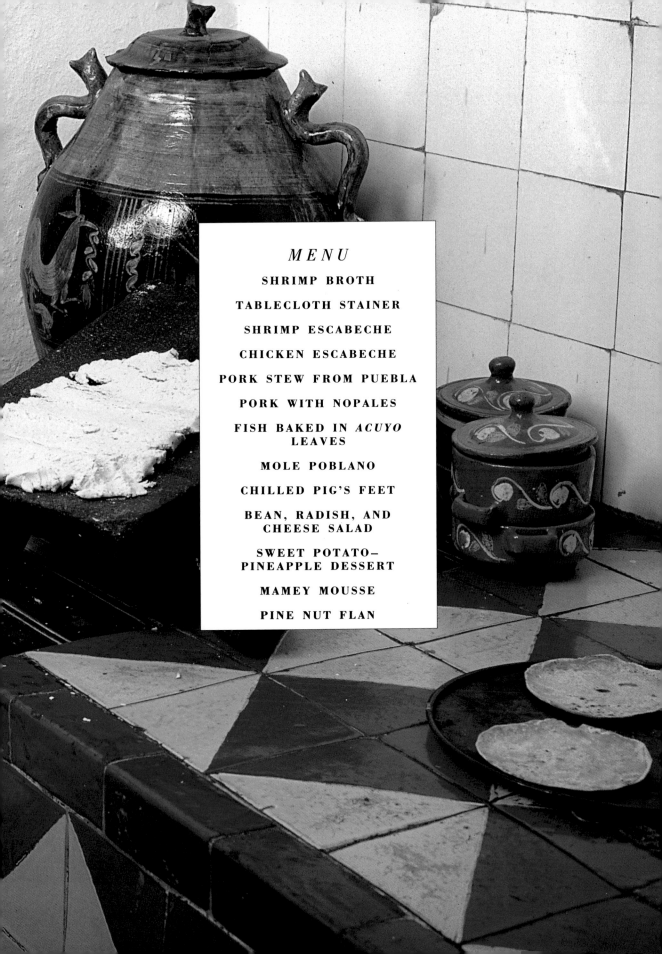

MENU

SHRIMP BROTH

TABLECLOTH STAINER

SHRIMP ESCABECHE

CHICKEN ESCABECHE

PORK STEW FROM PUEBLA

PORK WITH NOPALES

FISH BAKED IN *ACUYO* LEAVES

MOLE POBLANO

CHILLED PIG'S FEET

BEAN, RADISH, AND CHEESE SALAD

SWEET POTATO— PINEAPPLE DESSERT

MAMEY MOUSSE

PINE NUT FLAN

and set aside. Strain the broth and return it to a boil. Add the potatoes, carrots, and parsley. Simmer for 10 minutes.

Strain the chiles and puree them with the onions. Add the chile puree and shrimp to the broth. Simmer for 10 minutes to blend the flavors. Serve with limes cut in quarters.

SHRIMP BROTH

(8 servings)

½ pound/250g dried shrimp

Salt

2 quarts/2 l water

4 potatoes, peeled and diced

6 carrots, peeled and diced

2 parsley sprigs

5 ounces/150g guajillo chiles, toasted, seeded, and soaked in very hot water for 10 minutes

2 medium onions, peeled and cut in chunks

6 limes

Simmer the shrimp in salted water for 15 minutes. Remove the shrimp with a slotted spoon

TABLECOTH STAINER

(8 servings)

1 pound/500g pork loin

1 pound/500g pork neck bones or country ribs

1 bouquet fragrant herbs (bay leaf, thyme, and marjoram)

Salt

3 ancho chiles, deveined and softened in hot water

3 mulato chiles, deveined and softened in hot water

1 large onion, chopped

2 pounds/1k tomatoes, roasted and peeled

2 tablespoons lard

1 tart apple, peeled and cored

1 pear, peeled, cored, and sliced

1 quince, peeled and sliced

2 peaches, peeled and sliced

1 thick slice pineapple, peeled and cut in pieces

1 plantain, sliced

1 tablespoon sugar

3 tablespoons white vinegar

Place the pork and bones in a large saucepan with water to cover. Add the herbs and salt to

Above: Little mugs from Michoacán hold delicious Shrimp Broth.

taste. Simmer until the pork is tender. Remove from the heat, strain the broth, discard the bones, slice the meat, and set both broth and meat aside.

Puree the chiles with the onion and tomatoes. Drain the puree and sauté it in hot lard. Add the pork broth and simmer for 10 to 15 minutes to blend the flavors. Add the meat and all the fruit except the plantain. Simmer for 5 minutes. Add the plantain, sugar, and vinegar. Simmer for 2 minutes, correct the seasoning, and serve very hot.

SHRIMP ESCABECHE

(8 servings)

1 medium onion, sliced vertically

5 garlic cloves

2 cups/500ml olive oil

4 manzano chiles, seeded and cut in rounds

4 bay leaves

2 teaspoons dried oregano

2 thyme sprigs

10 black peppercorns

1 cup/250ml white vinegar

Salt

3 pounds/1,500g shrimp, peeled and deveined

Sauté the onion and garlic in hot oil until the onion is translucent. Add the chiles, bay leaves, oregano, thyme, peppercorns, vinegar, and salt to taste. Mix well and simmer for 10 minutes. Stir in the shrimp and cook for 5 minutes. Remove from the heat and let cool. Refrigerate for at least 2 hours before serving.

CHICKEN ESCABECHE

(8 servings)

5 whole chicken breasts

1 cup/250ml vinegar

2 medium onions, cut in half

3 carrots

1 celery stalk

1 bay leaf

1 thyme sprig

1 oregano sprig

3 teaspoons salt

MARINADE

2 onions, peeled and sliced

5 carrots, peeled and sliced

10 garlic cloves

1 cup/250ml olive oil

3 bay leaves

4 oregano sprigs

3 thyme sprigs

2 cups/500ml white vinegar

½ cup/125ml water

Combine the chicken breasts with the remaining ingredients, add water to cover, and cook until nearly tender. Strain the chicken let it cool, then skin and bone it. Cover it with the marinade for at least 2 hours.

To make the marinade, sauté the onions, carrots, and garlic in the oil until the onion is translucent. Add the herbs and sauté a minute longer. Add the vinegar and water and simmer for 10 minutes to blend the flavors. Add the chicken breasts, bring to a boil, and simmer for 5 minutes. Remove from the heat and let cool completely.

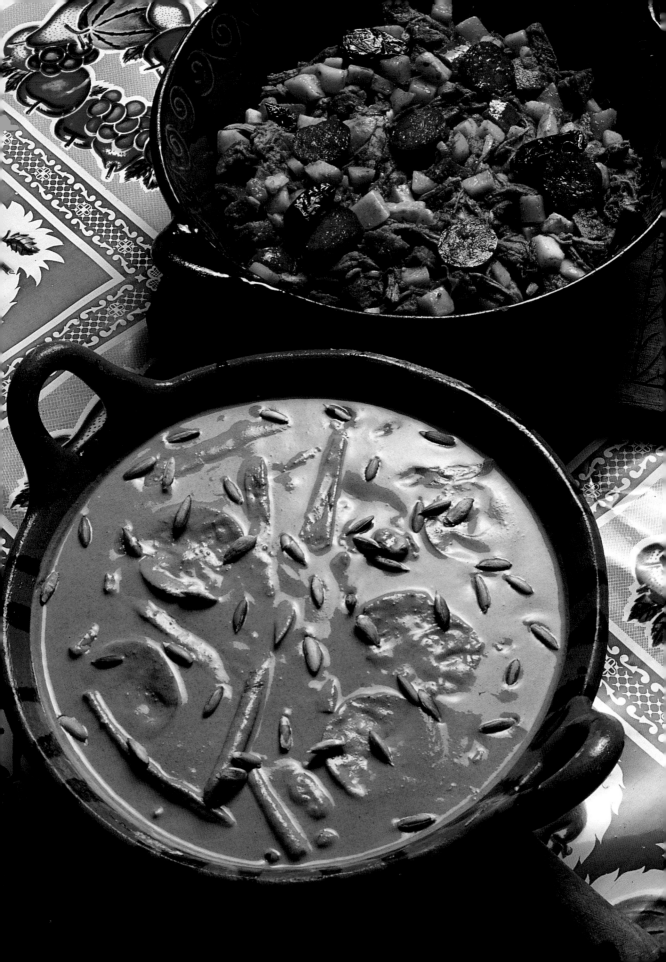

PORK STEW FROM PUEBLA

(8 servings)

2 onions, chopped

3 tablespoons lard

4 chorizos, peeled and sliced in rounds

6 large tomatoes, roasted, peeled, and seeded

6 chipotle chiles in *adobo*, chopped and drained

2½ pounds/1,250g pork shoulder, cooked in water with 1 halved onion, 1 garlic clove, and salt to taste

3 medium potatoes, cooked and cubed

Salt

Sauté the onions in hot lard, until translucent. Add the chorizo and fry until well cooked. Drain, discarding excess fat. Return the chorizo to the pan.

Puree the tomatoes with three of the chiles. Add this puree and the remaining chiles to the chorizo in the pan. Simmer for about 10 minutes. Shred the cooked pork and add to the pan. Add the potatoes and salt to taste and mix thoroughly. Simmer for a few minutes. Serve piping hot.

PORK WITH NOPALES

(8 servings)

2½ pounds/1,250g pork loin, cooked in water with 2 onions, 2 bay leaves, 1 oregano sprig, and salt to taste

2 pounds/1k tomatillos, peeled and chopped

4 serrano chiles

2 garlic cloves, peeled

1 onion, peeled and chopped

1¼ cups/150g pumpkin seeds, toasted

3 tablespoons corn oil

1 cup/150g cut-up green beans

8 small zucchini, cut in quarters

5 nopales, cooked, drained, and cut in strips

Remove the pork from its broth and slice it. Set the meat and broth aside.

Simmer the tomatillos with 1 cup of the pork broth, the chiles, garlic, and onion. When thoroughly cooked, remove from the heat, let cool slightly, and puree with the pumpkin seeds.

Heat the oil in a heavy saucepan and add the puree. If the sauce is too thick, thin with some more pork broth. Stir in the green beans, zucchini, and nopales. Add the meat to the pan. Season with salt to taste and simmer just until the vegetables are cooked through.

Opposite: Pork Stew from Puebla and Pork with Nopales. Overleaf: The table is set in honor of Frida's birthday with just the kind of brightly colored plastic tablecloth she would have loved.

FISH BAKED IN *ACUYO* LEAVES

(8 servings)

8 snapper or sea bass fillets

8 large *acuyo* (*hierba santa*) leaves

SAUCE

¾ cup/90g coarsely chopped *acuyo* (*hierba santa*) leaves

½ cup/30g *epazote* leaves

1 cup/60g cilantro leaves

2 or 3 garlic cloves, peeled

½ large onion

4 cups/1 l chicken broth

¼ cup/60ml olive oil

Salt

Place each fish fillet on a large leaf and wrap well. Arrange in a buttered baking dish. Cover with the sauce and bake in a preheated 350°F/ 175°C oven for 30 minutes.

To make the sauce, puree all the ingredients until smooth.

MOLE POBLANO

(10 servings)

½ pound/250g mulato chiles, deveined and seeded

¾ pound/375g pasilla chiles, deveined and seeded

¾ pound/375g ancho chiles, deveined and seeded

½ pound/250g lard

3 garlic cloves, peeled

2 medium onions, chopped

2 tortillas, coarsely chopped

½ hard roll

½ cup/60g raisins

¾ cup/120g almonds

6 tablespoons pumpkin seeds

4 ounces sesame seeds, toasted

1 teaspoon anise seeds

2 cloves

1 cinnamon stick

1 teaspoon black peppercorns

9 ounces/270g Mexican chocolate

¼ pound/125g tomatoes, peeled and chopped

Sugar

Salt

1 large turkey, cut in pieces and cooked in water with a carrot, leek, onion, celery stalk, garlic clove, and a few parsley sprigs

Sauté the chiles in 5 ounces of hot lard. Remove from the skillet and place in a heavy saucepan. Cover with very hot water, bring to a boil, and simmer until tender. Drain.

In the same hot lard, sauté the garlic and onions until the onions are translucent. Add the coarsely chopped tortillas, roll, raisins, almonds, pumpkin seeds, half of the sesame seeds, the anise seeds, cloves, cinnamon, peppercorns, chocolate, and tomatoes. Sauté all the ingredients well, add the chiles, and cook for a few minutes more.

Puree the mole mixture with some of the turkey broth and strain. In a large pot, heat the remaining lard. Add the chile mixture and simmer for 5 minutes. Season to taste with sugar

and salt—it should be slightly sweet. Add more turkey broth if needed, but the sauce should be thick. Simmer for 20 to 25 minutes, add the turkey pieces, and simmer for 5 minutes more.

Serve the mole from the pot, sprinkled with the rest of the sesame seeds.

CHILLED PIG'S FEET

(8 servings)

8 pig's feet, washed and
cut in half

½ onion, studded with 2 cloves

2 garlic cloves

10 peppercorns

1 teaspoon salt

2 bay leaves

2 cups vinegar

1 teaspoon ground white
pepper

1 teaspoon dried thyme

Salt

1 tablespoon dried oregano

SAUCE

4 pounds very ripe tomatoes,
quartered

Salt

1 large onion, peeled and
finely chopped

1 tablespoon dried oregano

Sugar

Place the pig's feet in a large saucepan with the onion, garlic, peppercorns, salt, bay leaves, and water to cover. Cook until tender. Remove from the heat and let cool. Rinse well and re-move the largest bones.

Combine the vinegar, white pepper, thyme, and salt to taste. Place the pig's feet in this mixture and marinate for at least 2 hours. Drain off the marinade, cover the meat with the sauce, sprinkle with the oregano, and serve very cold.

To make the sauce, cook the tomatoes, covered, with salt to taste (but no water), for about 5 minutes, or until cooked through. Let cool slightly, puree, and drain. Add the chopped onion, oregano, and salt and sugar to taste.

BEAN, RADISH, AND CHEESE SALAD

(8 servings)

5 cups/320g cooked black
beans, drained

10 radishes, cut in quarters

¾ pound/375g panela cheese,
cut in cubes (or muenster)

½ cup/60g chopped cilantro

DRESSING

⅔ cup/160ml olive oil

⅓ cup/80ml red wine vinegar

2 teaspoons chopped cilantro

2 teaspoons salt

To make the salad, combine the vegetables and cheese in a salad bowl and toss with the dressing.

To make the dressing, whisk all the ingredients together.

SWEET POTATO–PINEAPPLE DESSERT

(8 servings)

4½ pounds/2,250g yellow
sweet potatoes

1 medium pineapple, peeled
and chopped

2 cups/380g sugar

¾ cup/150g pine nuts

Cook the sweet potatoes until tender. Let cool, peel, and mash into a puree. Measure out 3 cups.

Puree the pineapple. Drain and measure out 3 cups. In a large saucepan, combine the pineapple with the sugar. Simmer until the mixture is thick and syrupy (220°F/104°C on a candy thermometer). Stir in the sweet potato and cook, stirring, until it pulls away from the pan.

Pour onto a serving platter and garnish with pine nuts. Serve at room temperature.

MAMEY MOUSSE

(8 to 10 servings)

3 envelopes/21g unflavored
gelatin, softened in ¾ cup
cold water

2 cups/500ml boiling water

3 mamey fruits, peeled
and pureed

2 cups/500ml heavy cream

Confectioners' sugar

2 mamey fruits, peeled
and cubed

When the gelatin has softened, mix it well with the boiling water to dissolve completely. Stir in the pureed mamey and let cool. Whip the cream with sugar to taste. Fold the cream into the gelatin mixture. Pour into a 2-quart ring mold and refrigerate until set. To serve, hold the mold over steam or dip it in hot water for a second to unmold easily. Turn out on a serving platter and fill the ring with the mamey cubes.

PINE NUT FLAN

(8 servings)

½ cup/100g sugar

1 cup/180g pine nuts

1 cup/250ml sweetened
condensed milk

4 egg yolks

2 whole eggs, beaten

1 cup/250ml milk

Heat the sugar in a 1-quart baking dish, stirring constantly, to caramelize.

Puree three-quarters of the pine nuts with the condensed milk. Mix with the egg yolks, whole eggs, and milk. Pour into the prepared dish. Place in a larger pan of hot water. Bake in preheated 350°F/175°C oven for 30 to 40 minutes or until a toothpick inserted in center comes out clean. Remove from the oven, let cool, and garnish with the remaining pine nuts.

Opposite: Mamey Mousse. The view is of the patio from the dining room of the Blue House.

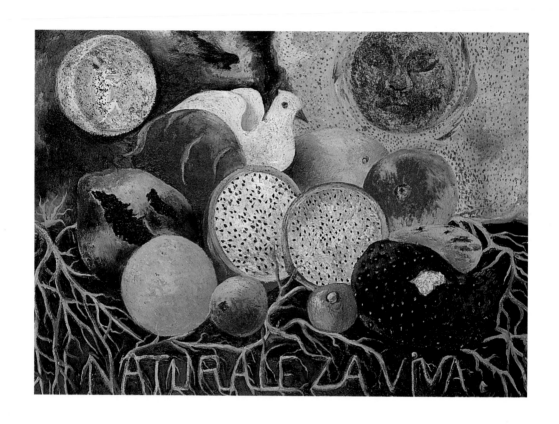

Above: Naturaleza Viva, *1952*

EPILOGUE

In this ambience of magic and ritual Frida lived for many years, but due to the accident of 1925 and the many health problems that resulted little by little she became less able to entertain guests.

Nevertheless, her way of life was always the same. The time I lived at the Blue House passed; but as a consequence of my own maturation—finishing my university degree, marriages, caring for my children—visits to Coyoacán continued to be regular and frequent.

Any encounter started stories and conversations just where we had left them.

Frida's world was always a ritual. Because of the demands of her egocentric personality she played both icon and devotee. Her clothes created the Frida Kahlo style; nobody had similar jewelry: what my father gave her was always unique; only Frida and the women of Oaxaca wore their hair in that style.

For still life paintings, Frida selected her favorite flowers and fruits; for portraits, her best friends; and her sorrows and thoughts were interpreted in small tableaux.

The greatest part of Frida's art was dedicated to self-portraits. With her own image in a mirror Frida painted ritualized icons surrounded by magic.

With the purpose of offering my readers a different aspect of Frida's way of life, the joyous one, in which we the participants, including my father Diego Rivera, were involved, I write this book.

Rio Caliente, Jalisco
Easter Sunday, 1993

INDEX

PHOTOGRAPH CREDITS

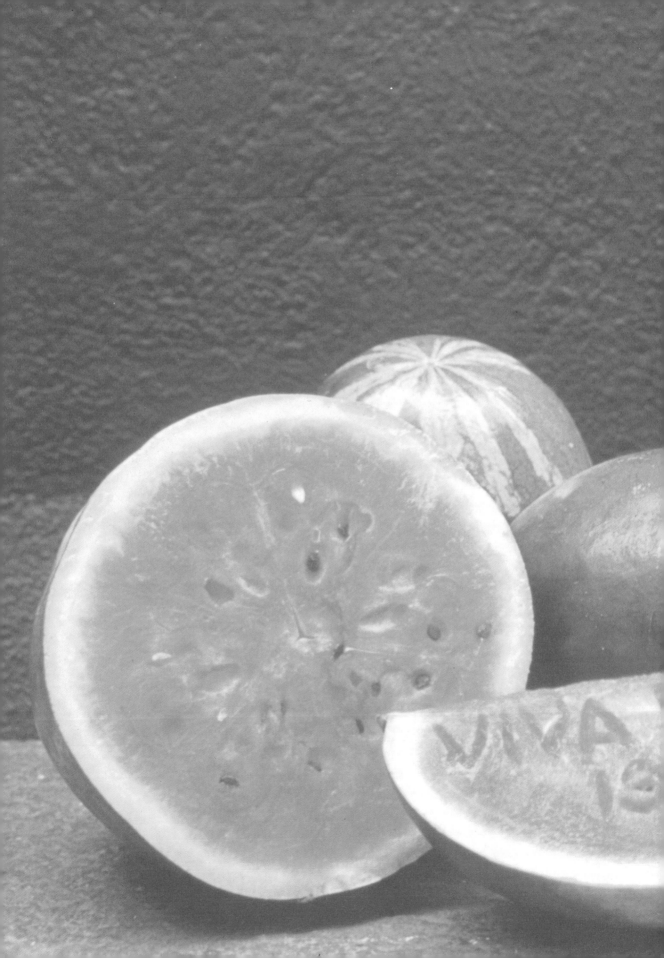